Also by Sam Stephenson

Dream Street: W. Eugene Smith's Pittsburgh Project
W. Eugene Smith 55

The Jazz Loft Project

The Jazz Loft Project

Sam Stephenson

PHOTOGRAPHS AND TAPES
OF W. EUGENE SMITH
FROM 821 SIXTH AVENUE
1957–1965

ALFRED A. KNOPF, NEW YORK

CENTER FOR DOCUMENTARY STUDIES, DUKE UNIVERSITY,
DURHAM, NORTH CAROLINA

2009

This Is a Borzoi Book
Published by Alfred A. Knopf

Library of Congress
Cataloging-in-Publication Data
Smith, W. Eugene, 1918–1978.
The jazz loft project : photographs and tapes of
W. Eugene Smith from 821 Sixth Avenue,
1957–1965 / [compiled by] by Sam Stephenson.
 p. cm.
ISBN 978-0-307-26709-2
1. Jazz—New York (State)—New York—
1961–1970—Pictorial works. 2. Jazz—
New York (State)—New York—1951–1960—
Pictorial works. 3. Jazz musicians—New York
(State)—New York—Portraits.
I. Stephenson, Sam. II. Title.
ML3508.8.N5S65 2009
779'.978165097471—dc22 2009020875

Manufactured in Singapore
First Edition

For my wife, **Laurie Cochenour,** as always,
and the Stephenson family, all twelve,
especially my father, **Dr. Henry Louis Stephenson Jr.,**
who plays trumpet, and my mother,
Frances Hampton Stephenson, piano

SOUNDCRAFT

PLUS 50

(50% EXTRA PLAYING TIME)

magnetic recording tape

DU PONT
MYLAR®
POLYESTER FILM

FOR EVERY SOUND REASON

REEVES SOUNDCRAFT CORPORATION
GREAT PASTURE RD., DANBURY, CONNECTICUT

MONAURAL 3/26/60

REEVES
SOUNDCRAFT PLUS 50 RECORDING TAPE
Manufactured by — Reeves Soundcraft Corp., Great Pasture Rd., Danbury, Conn.

SIDE # ONE	DATE	SPEED	
TITLE	ARTIST	LENGTH	REMARKS

PIANO — ?? EDDIE COSTA
THEN HALL
FREE, & TAKAS

SIDE # TWO	DATE	SPEED

HALL, ROUNING & TAKAS
ENDS WITH BAUBLES, WHICH
CONTINUES ON 3RD SIDE

GOVT. TYPE NO. — TOR 1800 AH 250 NA PATENT NUMBER 2-688567

Playing Times of
Soundcraft Plus 50
Magnetic Recording Tapes

For dual track recordings,
the recording time is doubled.

REEL			SPEED IN INCHES PER SECOND			
CODE	SIZE	FEET	1⅞	3¾	7½	15
PL-2	3″	225	24 min.	12 min.	6 min.	3 min.
PL-9	5″	900	1 hr. 36 min.	48 min.	24 min.	12 min.
PL-18	7″	1800	3 hr. 12 min.	1 hr. 36 min.	48 min.	24 min.
PL-36	10½″	3600	6 hr. 24 min.	3 hr. 12 min.	1 hr. 36 min.	48 min.
PL-72	14¼″	7200	12 hr. 48 min.	6 hr. 24 min.	3 hr. 12 min.	1 hr. 36 min.

"In case of defect in packaging, labeling or manufacturing, this recording tape will be replaced.
Except for such replacement, this recording stock is sold without warranty or any liability of any kind."

In the fall of 1977 two eighteen-wheel trucks hauled twenty-two tons of W. Eugene Smith's materials from New York City to the Center for Creative Photography (CCP) at the University of Arizona. The shipment included the photographs and tapes that form the basis of this book and the Jazz Loft Project at the Center for Documentary Studies (CDS) at Duke University. In 1998 I picked through all 1,740 of Smith's reels of tape and I noted 129 names of jazz musicians chicken-scratched by Smith on the labels. I was hooked. Since then I have visited the archive more than two dozen times and followed ensuing leads to uncover the story of Smith and 821 Sixth Avenue, New York City. I offer my deepest gratitude to CCP and to the Heirs of W. Eugene Smith for making this book possible. Special appreciation and honor are also due the Reva and David Logan Foundation of Chicago for their integral support of this project.

March 26, 1960.
Musicians include Eddie Costa, Hall Overton, Ronnie Free, and Bill Takas. Photographer and Smith's assistant, Jim Karales, are talking. Tunes played are "Off Minor" by Thelonious Monk, "Just You, Just Me" from the 1929 film *Marianne,* and "Baubles, Bangles, and Beads" from the 1953 Broadway musical *Kismet.*

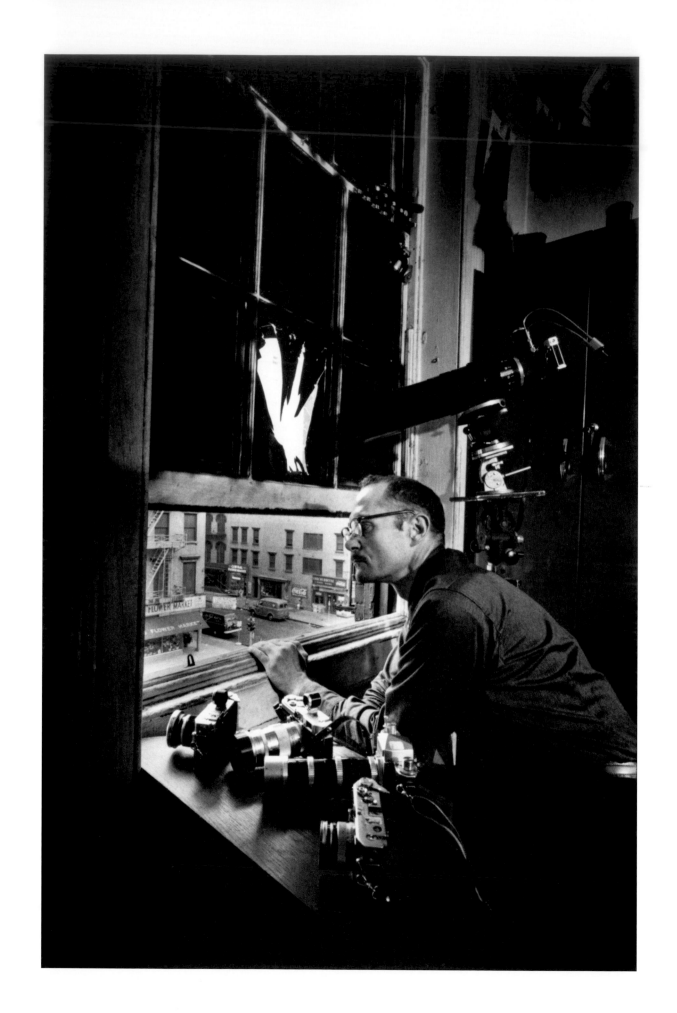

Prologue

January 29, 1960

W. Eugene Smith sits at the fourth-floor window of his dilapidated loft at 821 Sixth Avenue, New York City, near the corner of Twenty-eighth Street, the heart of Manhattan's wholesale flower district. He peers out at the street below, several cameras at hand loaded with different lenses and film speeds. His window faces east from the west side of Sixth Avenue. The dawn light begins to rise behind the Empire State Building and other Midtown skyscrapers looming over the modest neighborhood. Three musicians stand together on the sidewalk talking and laughing. One holds an upright bass in its case, another has a saxophone case slung over his shoulder, and the other is smoking a cigarette.

It is six o'clock in the morning; the temperature is a moderate thirty degrees. The musicians are going home after a nightlong jam session. Smith snaps a few pictures.

Across the street flatbed trucks unload fresh blooms for the shops that are preparing for daily business. At this time of year the local farms in Long Island, New Jersey, and Pennsylvania's Dutch country grow roses in the greenhouse while spider mums, lilies, carnations, orchids, chrysanthemums, and birds-of-paradise are imported from Florida. Smith snaps a few more pictures. Then he hears the familiar sound of quarter-inch recording tape flapping at the end of a reel on the tape machine sitting in his nearby darkroom. He walks into the darkroom and turns off the machine. He places the reel in a box and labels it "Zoot Sims, Roy Haynes, Ronnie Free, Eddie DeHaas, Dave McKenna, Henry Grimes, John Mast, Fred Greenwell. January 29, 1960." He loads a new tape into the machine and presses Play and Record. The only sounds in the loft now come from a transistor radio in the corner tuned to the morning news (supporters of Fidel Castro clashed with dissenters in Central Park the day before; fifteen of New York's hospitals teetered on the brink of bankruptcy). Sounds from the awakening city—honks and chugs of taxis and the Sixth Avenue bus—waft through Smith's open window.

January 20, 2009

It isn't necessary to imagine too much of what happened inside 821 Sixth Avenue from 1957 to 1965. Smith documented the goings-on with more than

one thousand rolls of film (roughly forty thousand exposures), both inside the building and through his fourth-floor window. He also wired the building from the sidewalk to the top (fifth) floor and made 1,740 reels of audio recordings.

For thirteen years I have been researching Smith's life and work. Once enough money was raised (more than half a million dollars) to transfer Smith's analog tapes to digital files (resulting in 5,089 compact discs of material), my colleague Dan Partridge and I began listening to them for the first time. We've traveled to nineteen states and the District of Columbia and interviewed 330 people who passed through the loft building. We played these recordings for as many loft participants as was practical and affordable.

On December 8, 2000, I visited the saxophonist Lou Orensteen in his apartment on Fifty-fifth Street, New York City, between Eighth and Ninth avenues, where he'd lived for four decades. He shared two bedrooms, a kitchen, and a small living room with his wife, Ingrid, their young daughter, LouLou, and their cat, Nadine. I took the elevator to the ninth floor and knocked on his door. Before I sat down, Orensteen handed me a slip of paper torn from a pocket-sized spiral notebook. "I've racked my brain," he said, "and these are the people I keep remembering being at the loft."

Orensteen was sixty-eight years old when I visited him. He stood a lean, muscular six feet, and his considered movements, strong jaw, and squinty eyes made him seem like a retired longshoreman. He said that he suffered from Dupuytren's disease, which causes fixed flexion contracture in the hands. He'd undergone surgery three times to free up

some movement, but holding the saxophone and executing the fingerings were no longer possible. Aside from some occasional teaching and arranging, his jazz career existed mostly in the recesses of his memory.

Orensteen was born in Los Angeles, and at age eight he moved with his family to Ann Arbor, Michigan, where he graduated from high school in 1950. After playing with military bands in the Korean War, he moved to Chicago and met musicians such as Johnny Griffin, Ira Sullivan, Clifford Jordan, John Gilmore, and Chris Anderson. Everyone was moving to New York in those days, though, so Orensteen followed suit and made the move in 1957. It didn't take long for him to find the jam-session scene at 821 Sixth Avenue.

Orensteen's small scrap of paper stands outside jazz history. It flattens the hierarchy of the normal jazz story. Three icons are listed—drummer Elvin Jones, pianist Chick Corea, and saxophonist Eric Dolphy—and two other musicians of historical significance, pianists Al Haig and Sonny Clark. But they are no more important in Orensteen's memory than Tom Wayburn, Gary Hawkins, Ed Levinsohn, Al Levitt, and Jimmy Wormworth—five obscure drummers.

James Baldwin once said, "History is not a procession of illustrious people. It's about what happens to a people. Millions of anonymous people is what history is about." Orensteen's list represents Baldwin's kind of history. Everyone is worthwhile, like characters in a Eugene O'Neill or August Wilson play.

Among Orensteen's thirteen names are six drummers and five piano players. Drums and pianos can't be carried

GIL COGGINS
b. 1928, Harlem, New York

AL HAIG
b. 1922, Newark, New Jersey

ELVIN JONES
b. 1927, Pontiac, Michigan

GARY HAWKINS
b. 1930, Boston, Massachusetts

ED LEVINSOHN
Philadelphia, Pennsylvania

HOD O'BRIEN
b. 1936, Chicago, Illinois

TOM WAYBURN
b. 1934, Detroit, Michigan

LIN [Lindall] **HALLIDAY**
b. 1936, De Queen, Arkansas

CHICK COREA
b. 1941, Chelsea, Massachusetts

AL LEVITT
b. 1932, New York, New York

ERIC DOLPHY
b. 1928, Los Angeles, California

SONNY CLARK
b. 1931, Herminie No. 2, Pennsylvania

JIMMY WORMWORTH*
b. 1937, Utica, New York

*Orensteen added Wormworth's name at the end with a different pen, having remembered him later.

around town easily. The lofts at 821 had tuned pianos and tuned drums set up all the time. Word got around.

The thirteen names also represent birthplaces in at least eight different states.

The loft building was a kind of funnel, with people from all over the country finding their way to the dank stairwell of the building. Of these fourteen musicians (including Orensteen), we know, as of this writing, that at least eight are recorded on W. Eugene Smith's tapes: Orensteen, Coggins, Hawkins, Levinsohn, Wayburn, Halliday, Corea, and Clark.

If Smith had not moved to 821 Sixth Avenue in 1957 and turned his quixotic documentary fevers toward his new home, I never would have traveled to visit Orensteen. I wouldn't even know his name.

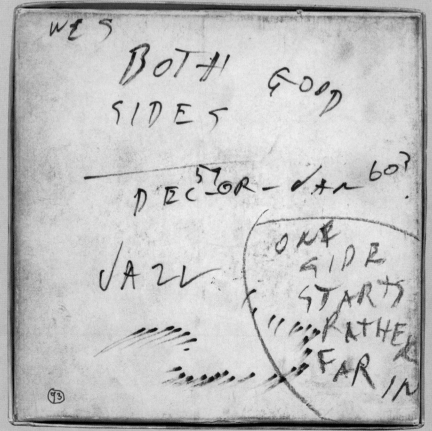

December 1959 or January 1960.

Both sides good. Jazz. Saxophonists Zoot Sims and Steve Lacy are the only identified musicians on this recording, with guitar, piano, bass, drums. Among the tunes played is "I Got Rhythm," composed in 1930 by George Gershwin.

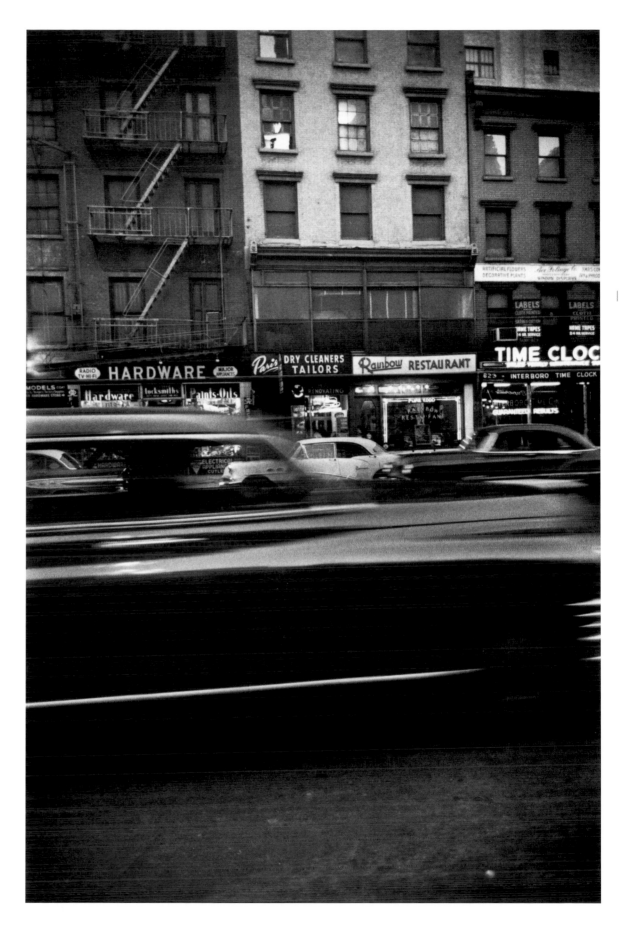

821 Sixth Avenue, with Smith's tripod in the fourth-floor window, circa 1957. Smith made several hundred photographs through the broken windowpane above the tripod in this picture. The cracked glass was a kind of aperture, and a metaphor.

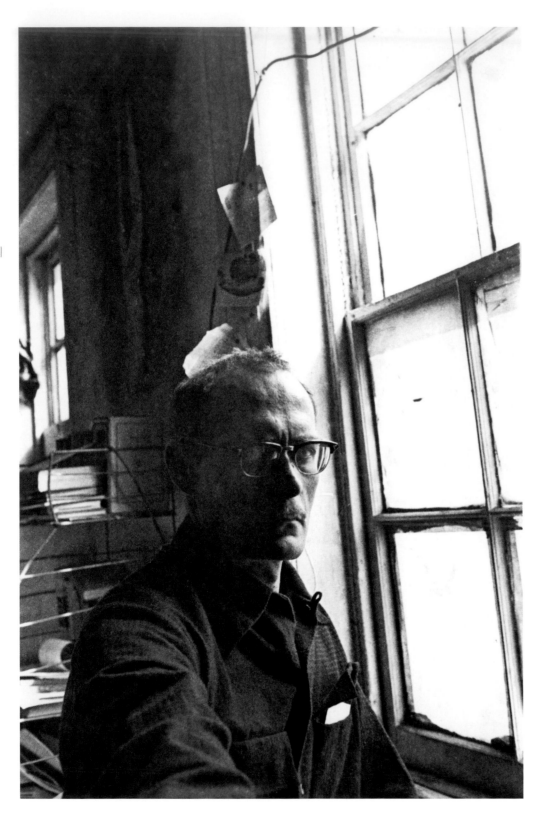

W. Eugene Smith at the window of 821 Sixth Avenue. The window frame served as a crop of Smith's view of the outside world.

Opposite: 821 Sixth Avenue. Experimental image with silhouette cutouts. Circa 1965.

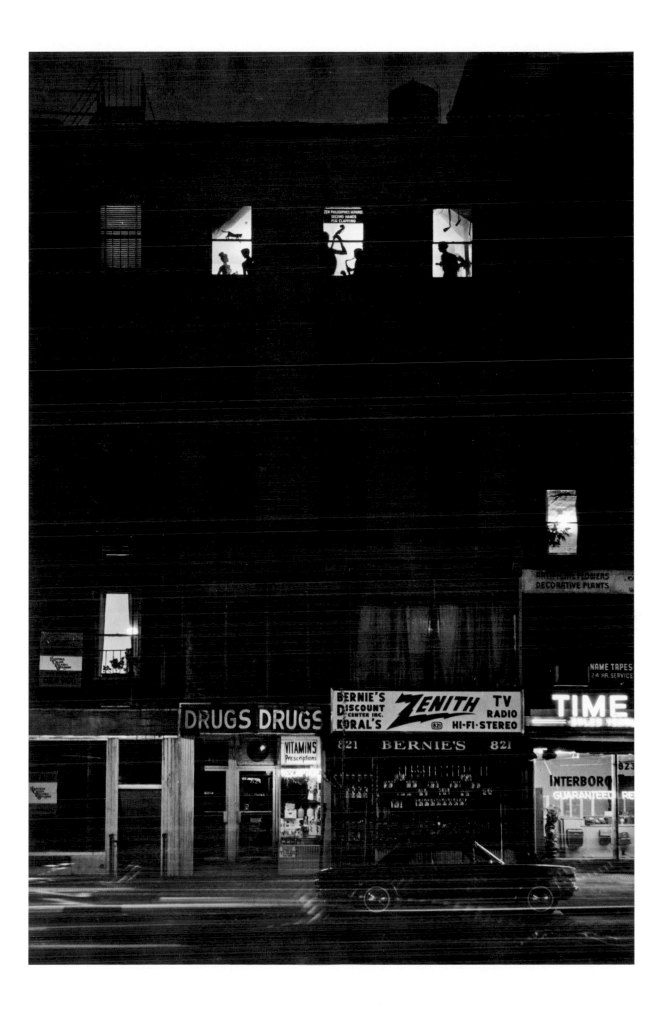

March 11, 1960.

Jazz. I don't kno[w] who nor of what. Zoot Sims, Warne Marsh, Pepper Adams, Ronnie Free, Bob Brookmeyer, Peter Ind, Lin Halliday, Bill Takas, Dick Scott. Among the tunes played is the 1926 composition by Ray Henderson "Bye, Bye Black-bird," with saxophonist Adams on piano.

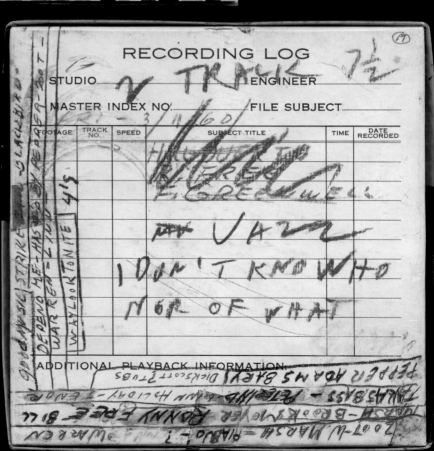

The Jazz Loft Project

1955 Sanborn Map (Plate #55): 821 Sixth Avenue,
New York, New York (outlined in white)

821 Sixth Avenue

See, actually I'm doing a book about this building itself . . . out the window and within the building, because it's quite a weird, interesting story.
—W. EUGENE SMITH,
recorded on his loft tapes, ca. 1960

Eight twenty-one Sixth Avenue, a nondescript five-floor loft walkup, was built in 1853 for commercial purposes by someone named George E. Hencken. Today, the narrow building is slightly wider than the length of the parking space in front of it. Its bricks are painted gray and layered with decades of accumulated scum and grime. High-rise condo towers, which have sprouted since the neighborhood was rezoned residential in the late 1990s, loom over the building. In a matter of time 821 Sixth Avenue will be sold and demolished to make way for more condos. Meanwhile, the Chinese-American owners, the Chang family, import and sell wigs there, very successfully. They bought the building in 2002 from Bernie's Discount Center, which sold televisions, microwave ovens, air conditioners, and other appliances in the space for four decades. It is an unprepossessing place, bearing no clues of the crossroads of jazz, art, and postwar urban-American lore that it used to be. The Chang family never heard about it.

For ten years, beginning in 1954, jazz musicians by the hundreds climbed the creaky, mildewed wooden stairs for sessions—both impromptu and formal—in the middle of the night. Many of the biggest names in jazz hung their hats there, for at least a few hours, if not for several years.

Thelonious Monk and Hall Overton rehearsed the music for Monk's legendary big-band concerts at Town Hall in 1959, at Lincoln Center in 1963, and at Carnegie Hall in 1964. Miles Davis, Charles Mingus, and Teddy Charles honed the sound heard on the record *Blue Moods* there. The place drew such prime players as Bill Evans, Roland Kirk, Zoot Sims, Jimmy Giuffre, Roy Haynes, Sonny Clark, Stan Getz, Jim Hall, Don Cherry, and Paul Bley, who formed ad hoc ensembles that often included veteran stars like Buck Clayton, Vic Dickenson, and Pee Wee Russell. Ornette Coleman went there to play the beat-up, idiosyncratic Steinway B piano on the fifth floor by himself. Alice Coltrane and Joe Henderson rented rooms on the fifth floor for a few months after moving to New York from Detroit in 1961.

Musicians from other genres frequented the place, too: minimalist composer Steve Reich, conductor Dennis Russell Davies, and folksinger Nehama Hendel. Photographers Diane Arbus, Robert Frank, and Henri Cartier-Bresson went there, as did painter Salvador Dalí and writers Anaïs Nin and Norman Mailer.

For every renowned musician who visited 821 Sixth Avenue, however, there were dozens who were obscure. Strangers—unproven newcomers—wandered into the place: if you could play an instrument, you were okay. Fifteen-year-old pianist Jane Getz came in from Texas, pianist Dave Frishberg from Minnesota, and bassist Jimmy Stevenson from Michigan. But this was no romantic oasis of "cool" acceptance and warm fellow feeling. If you couldn't play—if you weren't good enough—there was no reason for you to be there, unless you had other assets. There was dope to be smoked, and sometimes heroin or methadrene to shoot up, and every once in a while there was sex to be had. The door facing the sidewalk could be unlocked or completely missing—a cave or mine shaft in the dead center of Manhattan—and junkies snuck in, climbed the stairs, and stole things to pawn. Roaches and mice and rats and stray cats loved the place, too.

During the daytime the smell of flowers wafted through the neighborhood and the open windows of the loft building. Growers from Long Island had begun ferrying and carting their flowers to the intersection of Sixth Avenue and Twenty-eighth Street sometime around the Civil War. Before refrigeration, perishable merchandise required a central distribution point, and this corner was perfect for burgeoning Manhattan. The same location was also good for vice. The flower shops closed down late in the afternoon, and the Sixth Avenue elevated train canopied the street. Before World War I the neighborhood was known as "the Tenderloin," the primary red-light district in New York. The notorious dance hall the Haymarket was at Sixth Avenue and Thirtieth Street, and the upper floors of many of the flower shops turned into brothels or gambling joints after dark. The artist John Sloan documented the seedy scene with numerous paintings and drawings.

Sex, gambling, and flowers—fleeting pleasures; it made sense for them to find a home here. A few decades later, the real estate cheapened by its legacy and made affordable for artists, the flower district was the place to hear some of the best after-hours jazz in New York City. The unorthodox rhythms of the music meshed with the daily patterns on the street. At dawn the flower growers would arrive to peddle their blooms in the neighborhood markets as musicians were stumbling out of the building. Then, after midnight, with the shops closed and quiet again, the jazzmen (and a few women) resurfaced for a night of full-tilt blowing.

W. Eugene Smith moved into the building in 1957, during a period in his life that he later called "the worst"—a relative term, given his always stormy affairs. The scene anchored and inspired him. It was an intersection of people that could have occurred nowhere other than New York. Jazz musicians were flocking there from all over the country, along with many others aspiring to new lives. Suddenly this building, which had been abandoned for decades, became a spot

where you could stop by and see an icon, or see unknown junkies strung out on the fourth-floor landing, or see nobody at all, only empty Rheingold bottles, hundreds of cigarette butts, and tin cans of half-eaten food. Some nights, from the sidewalk, you'd hear transporting saxophone solos coming out of the fourth- or fifth-floor windows. Other nights, the only sound would be the periodic throttle of the Sixth Avenue bus, which had a stop at the corner of Twenty-eighth Street.

Somewhere floating on the premises, or peering out his fourth-floor window, the furtive Smith and his camera clicked away. In a November 1958 letter to his friend Ansel Adams, Smith wrote: "The loft is a curious place, pinned with the notes and proof prints . . . with reminders . . . with demands. Always there is the window. It forever seduces me away from my work in this cold water flat. I breathe and smile and quicken and languish in appreciation of it, the proscenium arch with me on the third stage looking it down and up and bent along the sides and the whole audience in performance down before me, an ever changing pandemonium of delicate details and habitual rhythms."

The last phrase well describes the loft music, too, which Smith recorded from his fourth-floor darkroom. He had wires reaching like roots through walls and floors to microphones all over the place. He once called the story of the loft scene a "unique piece of Americana." From his photos and tapes and from interviews with participants, we can document 589 people (as of this writing) who passed through the dank stairwell of this building in the 1950s and 1960s. The true number could be twice as high. From all

walks of life all over the map, only a dozen or so of these people went to college. What building in twenty-first-century America—that is not an enterprise or institution—has this kind of diverse traffic? Is there one? Anywhere?

A Congenial Haunt— Word Gets Around

After the Sixth Avenue elevated train tracks were razed in 1939, Lewis Mumford wrote in *The New Yorker*, "The dreary mess of buildings that loitered beside the old 'L'—much of it dating back to the 1870s—has long been ready for demolition." In 1954, when David X. Young, a twenty-three-year-old artist from Boston, first saw 821 Sixth Avenue, it still was a dreary mess. Young needed a large, low-rent place in which to paint. Through his friend Henry Rothman, an artist who ran a frame shop on Twenty-eighth Street between Broadway and Sixth Avenue, Young found a space in 821 Sixth Avenue along with musicians Hall Overton and Dick Cary. They each paid forty dollars per month to landlord Al Esformes, who had a check-cashing business across the street. Young took the fifth floor, Overton the fourth, and Cary the third. Soon, photographer Harold Feinstein and his wife, pianist Dorrie Glenn, took over half of Overton's space on the fourth floor.

"The place was desolate, really awful," said Young, who later lived in a loft on Manhattan's Canal Street for four decades before dying in 2001. "The buildings on both sides were vacant. There were mice, rats, and cockroaches all over the place. You had to keep cats around to help fend them off. Conditions were beyond miserable. No plumbing, no heat, no toilet, no electricity, no nothing.

By David X. Young

| 5

My grandfather loaned me three hundred dollars and showed me how to wire and pipe the place."

As a teenager, Young developed a passion for jazz. He was a regular at Boston jazz clubs like the Savoy and the Hi Hat, and he made friends with many musicians. The improvisational energy of jazz inspired his abstract expressionist paintings. When he moved to New York, Young helped to pay his bills by designing jazz album covers for Prestige Records. He did covers for Jimmy Raney, the Modern Jazz Quartet, Miles Davis, Sonny Rollins, Teddy Charles, and Art Farmer. Privy to many recording sessions, Young found himself hanging out with musicians.

"One of the problems they always had," Young said of the musicians, "was finding places to rehearse where they wouldn't bother anybody with noise. I went with Bob Brookmeyer and Jimmy Raney to some of their practice sessions at Nola's studio, where everybody would chip in fifty cents or something for a room. But that wasn't good. A lot of them didn't have any money, and there'd be a time limit on the rental. So I thought about my loft. I realized I had the ideal space for these sessions. I checked around and found a good piano for fifty dollars, delivered. Some movers, huge guys, brought the piano over to my loft, hoisted it with ropes up this side of the building, and brought it in through my front window. I got Billy Rubenstein to come over and tune it, and we were in business."

Cary also brought a Steinway B piano into his third-floor loft, and Overton moved two upright pianos into the fourth floor. Cary and Overton were both married, with permanent residences in the city. They rented their loft spaces for practice sessions, but they frequently stayed overnight. Cary worked as a pianist, arranger, and horn player in Dixieland- and New Orleans–style bands, including a few with Louis Armstrong. In Young's mind, he was the ideal tenant. "Cary couldn't have cared less about the terrible conditions," Young said. "His way of dealing with the mice and cockroaches was to set up little plates of food in the corners. He said if you fed them they wouldn't bother your real food."

Overton was a dashing, six-foot-four suit-and-tie man who at first glance seemed out of place in the squalor of 821 Sixth Avenue. After carrying stretchers in combat in France and Belgium in World War II, he taught classical composition at Juilliard and, later, at Yale and the New School for Social Research. His wife, Nancy Swain Overton, was a successful singer, first in a group called the Heathertones and later in the iconic Chordettes, of "Mister Sandman" fame, and they shared a nice house in Forest Hills, Queens, with their two young sons. Overton was revered and beloved as an innovative teacher and arranger. He had a knack for finding and nurturing the unique qualities inside all of his students, rather than imprinting his methods on everyone. He worked with Charles Mingus, Oscar Pettiford, Teddy Charles, and Stan Getz, and forged a long-standing relationship with Thelonious Monk based on deep mutual respect— not an easy task. Minimalist groundbreaker Steve Reich studied with Overton in the loft once a week for two years in the late 1950s, an experience Reich calls pivotal to his career. From Monk to Reich, the sweep of Overton's

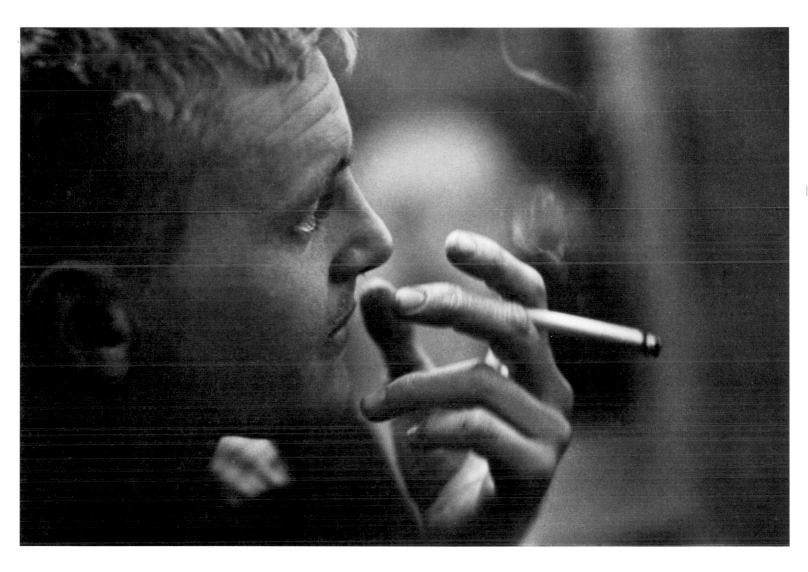

David X. Young, a member of a generation of
postwar painters who found affordable lofts in
Manhattan, perhaps the last generation to do so

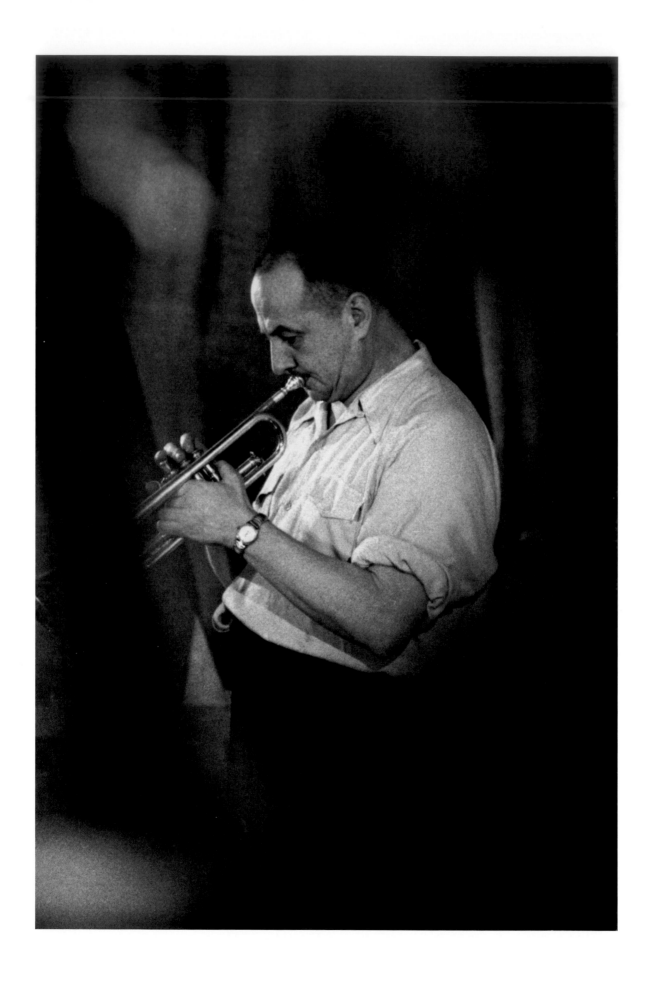

behind-the-scenes influence may be unsurpassed in American music history. But he seemed to care nothing about acknowledgment. He preferred the obscurity of his studio loft to the hallowed halls of Juilliard.

At night and on weekends, Overton gave lessons to a range of folks such as the billionaire tobacco heiress Doris Duke, Marian McPartland, seminal conductor Dennis Russell Davies, and composer Carman Moore. Jazz legends would stop by without an appointment and pick Overton's brain and soul, friendship and camaraderie the medium of exchange. His substantial yet unassuming presence at 821 Sixth Avenue was critical to the scene.

Word spread in the jazz underground that 821 Sixth Avenue was a congenial haunt.

"We were always looking for spacious places to play late at night," the bassist Bill Crow says, "especially places with tuned pianos. This place was perfect."

The location in the center of Manhattan made it easy for people to drop by on their way to and from somewhere else. It drew both established stars and young players eager to prove themselves on one or another of the upper three floors. "Charlie Mingus and I started going [to the loft] a lot in 1954 and 1955," Teddy Charles says. "We had some wild, free sessions over there: Art Blakey, Miles Davis, Art Farmer, Gigi Gryce, Mal Waldron, Jimmy Knepper, Oscar Pettiford, and dozens of other guys. I remember Bill Evans coming into the loft sometime around 1955 or '56. He looked like a school kid. But within a few months or a year he'd taken the whole city by storm. Nobody knew who the hell he was when he first came in there."

Pianists Paul Bley and Freddie Redd remember seeing Charlie Parker in the loft sometime before he died in March 1955.

The saxophonist Leroy "Sam" Parkins remembers New Year's Eve in 1959, when he was playing with the drummer Louis Hayes, the bassist Doug Watkins, the saxophonist Zoot Sims, the guitarist Jimmy Raney, and the pianist Sonny Clark. "We were playing and having a good time," Parkins says. "Then the door flew open and Lee Morgan, Pepper Adams, and Yusef Lateef walked in. The whole scene changed immediately, and the music reached an unreal level. The sessions didn't gel every night, but this time the damn place nearly exploded."

Bill Takas was one of the regular bass players; he and Sonny Clark and the drummer Ronnie Free made up the rhythm section for many sessions. "Because basses, pianos, and drums are so much harder to move, any place with a rhythm section would attract horn players from all over town," Takas says. "We'd put the word out and you never knew how many would show up—two, three, or twenty-five horn players. The masters might be there, or cats you'd never seen before."

In 1960 Dick Cary and David Young moved out and a series of young musicians moved in: drummer Gary Hawkins, bassist Hal Bigler, drummer Tommy Wayburn, bassist Dave Sibley, and drummer Frank Amoss. In 1961 a young bassist from Detroit, Jimmy Stevenson, and his wife, Sandy, took over the fifth floor from Amoss, and the scene began to change. Free-jazz players such as Ornette Coleman, Alice McLeod (Coltrane), Don Cherry, Charlie Haden, Roswell Rudd, Joe Henderson, Chick Corea, Joe Farrell,

Dick Cary, a prolific composer and arranger, whose traditional style left him out of the canon of midcentury groundbreakers but who was deeply appreciated by fellow musicians and sustained a long career

Henry Grimes, Roland Kirk, Paul Plummer, Albert Ayler, and Steve Swallow joined the fray. Their penchant for less structure, fewer stated chords, and soloing without limits altered things. The common musical repertoire fragmented somewhat. But the camaraderie held up to a remarkable degree. The noncommercial atmosphere of the loft and the acceptance of strangers was a break from clubs and studios, which preferred established stars. Ronnie Free, for example, is credited by many with having propelled some of the loft's greatest sessions ("Sometimes it was like he was burning, he was so hot," the bassist Steve Swallow says), but his name registers hardly a trace in official jazz histories today.

The pianist and composer Dave Frishberg, who discovered 821 soon after leaving the air force in 1957, found it liberating to be "playing in a free atmosphere all night long without anybody complaining or hearing you except the guys you were playing with." But, he adds, "it wasn't pressure-free. If you didn't play well, you'd hear about it." And even though mice were running around the floor, a social etiquette prevailed. "It was generally understood," Swallow says, "that you could drop by any night after eleven o'clock. It was considered rude to show up earlier."

"There was more than one loft. There were several in the area. But this was a main one, where Jimmy Stevenson lived," says baritone saxophonist Ronnie Cuber. "Guys like Joe Farrell and Chick Corea used to go jam there. Henry Grimes, Gil Coggins, and Lin Halliday, and Walter Davis Jr., and Vinnie Ruggiero and Nico Bunink. Guys coming in from everywhere. Joe Henderson. He

came in from Detroit. Guys like Blue Mitchell, you know. Elmo Hope. I remember Danny Richmond being up there."

Regulars debate how much the loft's relaxed attitude toward drinking and drugs attracted musicians and scenesters. Marijuana and alcohol had long been staples in the jazz diet, and both were freely available at the loft, as were, occasionally, heroin, peyote, and methamphetamines. A go-all-night lifestyle doesn't encourage normal eating and sleeping habits. Swallow remembers one session in particular: "Zoot Sims was drinking and playing his ass off, as he always did. He kept a coffee can nearby and spit blood into it all night. He had an incredible constitution." Swallow—who had left Yale University at age eighteen, in 1958, to play jazz full-time in New York—often jammed into the early hours with Sonny Clark, who, unbeknownst to Swallow at the time, was a serious drug abuser. "Sonny would hit me up for loans, and I'd give him a buck or two. I didn't know the junkies hit up the younger guys because the older ones were tired of loaning them money. I was naive. But to me, shelling out a couple of bucks to Sonny Clark was like paying tuition. He taught me a lot about music that I could not have learned anywhere else."

In the summer of 1961, Clark, strung out on heroin, collapsed in the loft and his heart stopped beating. A sixteen-year-old girl from Delaware by way of Chicago and Cincinnati, Virginia McEwan, saved Clark with amateur CPR. She and her boyfriend, saxophonist Lin Halliday, had been squatting in the loft stairwell since May of that year. In saving Clark, McEwan also saved the

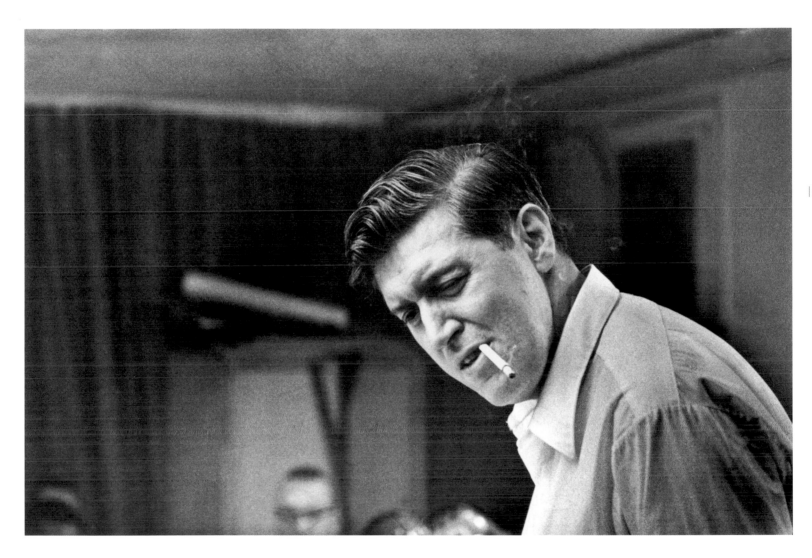

Hall Overton, with ever-present cigarette. He never
actually inhaled; he just kept it there, blowing out to
keep it burning.

building from the scrutiny of the police. She also allowed Clark to live for another eighteen months, a period in which he recorded several classic albums on the Blue Note label, before he suffered an overdose and died after playing at Junior's Bar in the Alvin Hotel, on Fifty-second and Broadway, in January 1963. Today, McEwan lives in Port Townsend, Washington, with her husband, bassist Ted Wald, whom she originally met at 821 Sixth Avenue.

The Red-Hot Eugene Smith

In 1957 Smith moved into the space on the fourth floor next to Hall Overton. The space was previously occupied by Smith's longtime friend and assistant, photographer Harold Feinstein. A legendary photojournalist since he photographed combat in World War II in his early twenties, Smith was thirty-eight years old and at the top of his profession. But he was suffering through a harrowing stretch in his personal life. His misery made many of those closest to him miserable in turn. He had four children and a wife living at his home in Croton-on-Hudson, New York, and another child living with a lover in Philadelphia. He virtually abandoned all of them when he moved into 821. He had been desperately trying to complete the most ambitious project of his life: a kaleidoscopic study of the city of Pittsburgh.

Smith had quit a steady, high-paying position with *Life* in early 1955 and had gone to Pittsburgh for a seemingly routine three-week freelance assignment. He was to make one hundred scripted photographs for a book commemorating the city's bicentennial. He stayed for a year and made some twenty-two thousand photographs of the city. Aided by two

successive Guggenheim grants, Smith spent three more years making prints and devising layouts of an essay he compared to Beethoven's late string quartets, Joyce's *Ulysses*, and Rilke's *Duino Elegies*. He said that two thousand negatives were valid for his essay, and he had them pinned up in 5x7-inch work print form all over the loft's walls, up and down the stairwell. He eventually brought more than six hundred of the images to a master print form, roughly 11x14 inches in size. It was a herculean accomplishment. But it fell short of completion, an unfinished symphony. His magnum opus may have existed on the walls of 821 Sixth Avenue—5x7's pinned up in rhapsodic sequences—but a public presentation would be impossible.

Life and *Look* magazines each offered Smith $20,000 ($154,000 in 2009 dollars) for the rights to the Pittsburgh prints, but the magazines would not agree to his demands for editorial control, and Smith rejected their offers, despite his family's nearly desperate financial situation. He never finished the Pittsburgh project. It was, he said in a letter to his friend Ansel Adams, an "embarrassment" and "debacle."

The loft at 821 Sixth Avenue became Smith's refuge during these years of escalating desires and diminishing results. His financial problems mounted, and his manic highs and suicidal lows were aggravated or produced—it was hard to say which—by addictions to alcohol and amphetamines. But Smith never stopped working. In a 1976 interview he recalled the time around 1958 as his peak as a photographer but his nadir as a human being: "My imagination and my seeing were both—I don't know if I can think of the right term—red hot or

something. Everywhere I looked, every time I thought, it seemed to me it left me with a great exuberance and just a truer quality of seeing. But it was the most miserable time of my life."

Smith's documentary goals in the loft were a departure from his previous journalistic work. He made his name photographing soldiers on the front lines of the Pacific theater of World War II, a physician in rural Colorado ("Country Doctor," 1948), an African-American nurse-midwife in poverty-stricken South Carolina ("Nurse Midwife," 1951), and a peasant village in Spain ("Spanish Village," 1951). In each case, he went out into the world and returned with powerful, sensitive images. Then he fought bitterly with *Life*'s editors for control of the work. Each published essay was preceded by threats to quit, even threats of suicide. It was unbearable for both sides. Then, after the photos were published, *Life*'s enormous readership would weigh in—coffee tables, waiting rooms, barbershops all over America—and everything would be okay. At *Life* Smith had created a legend for himself: compassionate photographer as indomitable hero.

In the loft, Smith was devastated and depleted by the unfinished Pittsburgh project. Nobody would hire him for fear of triggering another quixotic odyssey. He had no assignments to document the outside world. So he turned his documentary fevers to the space and time right around him, 821 Sixth Avenue and the flower-district neighborhood. Says his friend, photographer Robert Frank: "Gene went from a public journalist to a private artist in the loft. I'm sure the intensity was still the same, but there weren't the goals of changing the world

with this body of work, at least not like before."

The musicians who visited the loft—staying up all night, tuning out the workaday world, driven by passion or pathologies and a commitment to craft—inspired Smith and provided focus for his energy. He loved music. In World War II he had amazed soldiers by carrying boxes of records and a portable phonograph to the front lines. When he died, in 1978, he had only eighteen dollars in the bank but he owned more than twenty-five thousand vinyl records, mostly classical and jazz. He especially admired music that revealed beauty in dissonance—late Beethoven, Bartók, and Thelonious Monk were favorites—and he wanted his photography, especially his Pittsburgh project, to achieve that same rarefied state.

Smith left evidence of himself in stacks of prints all over 821, even if he was not always visible in person. Zoot Sims affectionately nicknamed him Lamont Cranston, after the character in the radio serial *The Shadow*. ("Who knows what evil lurks in the hearts of men? The Shadow knows!") Musicians sensed that Smith was a comrade, a fellow outcast.

The image of Smith maintained by the loft musicians contrasts with the one that still prevails today in many photography circles, where his compulsions are judged to have been driven by megalomania and lunacy. Freddie Redd says, "Gene Smith is just a sweet memory. He was this quiet person who was, you know, just nice to be around. He always had his cameras around his neck. He never bothered anybody."

The guitarist Jim Hall remembers a night when he and Jimmy Raney had a gig at the Village Vanguard jazz club.

Their wives attended and took snapshots of the band. When Hall and Raney made their late-night rounds at 821 Sixth Avenue, they asked Smith to help with their film. "We were a bit uncomfortable asking the master to help us with our piddly photographic work," Hall says, "but he responded with kindness and generosity. He took us into his darkroom and treated our film like it was his. You'd have thought he was making pictures for *Life*. He was extremely particular about it. That's how he always was."

Ronnie Free, the tireless drummer said to have propelled many of the loft's best jam sessions, says he has "no memories of Gene sitting down," and adds, "I have no memories of him eating or sleeping. He was like a mad scientist. He had all these tables spread out all over the loft with slides, negatives, prints, and all his equipment and cameras and lenses everywhere. He worked day and night. He always had an assistant or two around, and I never knew where he got the money to pay them. He was as broke as I was."

In addition to photographing the jam sessions, and despite his shrinking bank account and ballooning drug habits, Smith managed to obtain an array of mobile audio equipment, and with the same fanatical devotion that he gave to his photography he began to wire the top three floors of the loft with microphones. "One time we were playing in a session in Dave Young's fifth floor," Bill Crow recalls. "We kept hearing this buzzing noise and didn't know what it was. It sounded like a grinding noise. We finished a tune and all of a sudden this puff of sawdust pops up out of the floor, right between Freddy Greenwell's feet. It was Gene Smith drilling holes for his microphones. He had the place wired like a studio."

Smith's collection of 1,740 reel-to-reel mono and stereo tapes from the loft years, organized at his death, filled fourteen cardboard boxes. The tapes that have labels list the names of 129 different musicians. In total there are more than 300 musicians recorded on his tapes. In addition to the jazz sessions, Smith recorded random loft dialogues, street noise, telephone calls, and a remarkable cornucopia of things off radio and television. He recorded late-night Long John Nebel talk shows with callers claiming to have seen UFOs or have been abducted by aliens. He recorded John F. Kennedy giving speeches and Walter Cronkite reading Cold War news reports. There are speeches by Martin Luther King Jr. and roundtable discussions on civil rights with King, James Baldwin, and Malcolm X. There is the 1960 World Series, and the first Cassius Clay–Sonny Liston fight. There is Jason Robards reading Fitzgerald's *The Crack-Up* on the radio and *Waiting for Godot* and *The Treasure of the Sierra Madre* on TV. There is Shakespeare being performed in Central Park. And there is music, a lot of it: Met Opera performances of Britten's *Peter Grimes*, von Karajan conducting Verdi's *Requiem* in Salzburg, and Penderecki's *Threnody for the Victims of Hiroshima* taped from New York City's WNYC radio.

But Smith's main challenge was to record the people in the loft. He once asked a visitor, "Do you mind if I turn on my recorder in case something brilliant happens?" He gained sustenance from the musicians and identified with their need to test themselves in a noncommercial setting. "They were searching for

Circa August 7, 1963.
Wendell Harrison, Paul Plummer, Don Cherry, Jimmy Stevenson, Earl McKinney. Cherry leads the group through arrangements of several tunes, including "Solar" by Miles Davis and "Ruby, My Dear" by Thelonious Monk, with Cherry on piano for the latter tune.

1963.
Henri Cartier-Bresson and Smith at loft after symposium. Miscellaneous radio programs including Zero Mostel, Billie Holiday, Nina Simone, and Frank Sinatra. Recipes from nuns who were held in Japanese prisons (Chinese cooking). Radio Theater Classics: Tennessee Williams's *Summer and Smoke* with Geraldine Page.

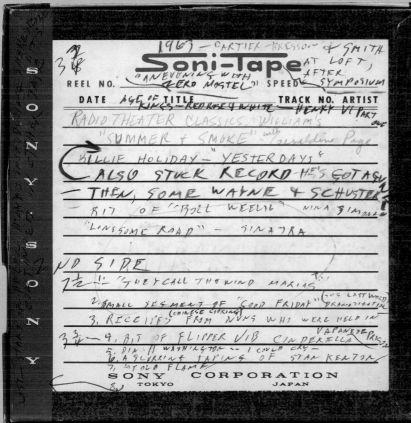

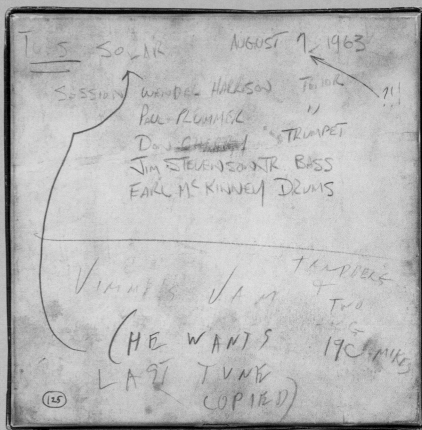

something they can't find in their club dates," he said in a 1965 lecture at the Rochester Institute of Technology. "One night a saxophonist named Freddy Greenwell came in after midnight on a Sunday night. A drummer named Ronnie Free was there. They started jamming together, and they continued to play until Friday, almost without stopping. Ronnie was a brilliant young drummer, and he drove the session along with tremendous fury and grace. He was working on something, searching for something, and he kept playing until he found it. Many different musicians dropped in throughout that week and played. They'd leave, and Ronnie and Freddy kept right on playing. It was an amazing show of determination. I was inspired by it. I try to put that level of determination in my own work."

The Smell of Flowers

In his 1969 *Aperture* monograph Smith wrote: "The loft I live in, from the inside out. A dirty, begrimed, firetrap sort of place, with space. My pictures from this loft have claimed more film than I have ever given to any project. The reasons: On the outside is Sixth Avenue, the flower district, with my window as a proscenium arch. The street is staged with all the humors of man, and of weather, too."

Theater obsessed Smith throughout his life. Along with music, he claimed theater as his most important influence, specifically citing the work of O'Neill, Williams, and O'Casey. He said these playwrights helped him "solve problems" in his photography. The visual sequences of literary and staged drama—the buildup of tension and the release—he sought to achieve in his

photojournalism. It was a blend of pure documentary work and Smith's romantic, melancholy, sometimes melodramatic cast of mind. His friend the photographer Robert Frank remembers him fondly today: "He was an astonishing man, his passion and his belief in whatever he would do. Since then, I haven't met anyone that comes near that passion and belief in what he does and what it should do and the effect of his work. He believed it would change the world, and nobody today of the younger people think like that. I haven't met them."

After Jimmy Stevenson moved out of the building in 1964, Smith took over all three top floors of the building, except for Hall Overton's space on half of the fourth floor, and made them the base of his photographic operations. During the opening night of his legendary 642-picture retrospective at the Jewish Museum, in 1971, Smith was still frantically making prints and having his assistants carry them from 821 Sixth Avenue to the museum. He lived in the loft until later in 1971, when he was evicted, just as he was setting off for Japan to photograph the mercury-poisoned fishing village of Minamata, a project that would bring him the most acclaim of his career.

Smith and Overton shared a wall in that building for fourteen years, two combat veterans from World War II— two exceptionally creative minds—side by side in a decrepit building in the center of Manhattan. These guys were the opposite of the suburbanites that John Cheever and Richard Yates portrayed in devastating fashion in their fiction of the period. But they weren't self-conscious rebels or beatniks, either. They worked too hard, cared too much,

were too sincere. They both died too early, of self-destruction.

In letters written in 1978, not long before his death, Smith expressed a wish to put together a book of photographs from his years at 821 Sixth Avenue. But nothing ever happened. He once remarked that legendary producer John Hammond from Columbia Records planned to visit the loft to hear a selection of Smith's tapes, but there is no indication that Smith tried to do anything commercial with his tapes. The tapes were part of a twenty-two-ton archive that was deposited at the Center for Creative Photography (CCP) at the University of Arizona in 1978. Coming to terms with Smith's mammoth photographic collection—negatives, contact sheets, and prints from his nonstop life's work—was in itself a daunting challenge for the photography archivists at CCP. The tapes sat waiting to be preserved and cataloged. Working with the Center for Documentary Studies at Duke University, we raised and spent more than half a million dollars simply to transfer Smith's tapes to digital files. By the summer of 2008 the transfers were completed. The 1,740 reels of tape yielded 5,089 compact discs.

"Hearing these tapes today is like being taken back half a century in an H. G. Wells time machine," says Ronnie Free, who is seventy-three years old today and plays drums at a secluded resort in the mountains of Virginia. "I'm able to hear myself playing jam sessions in 1959 or 1960, hanging out with dear friends who are long gone, passed away . . . Zoot Sims, Hall Overton,

Fred Greenwell, Pepper Adams, Sonny Clark, Eddie Costa, Gil Coggins . . . Gene Smith's tapes bring these people alive for me. To hear myself playing with them in these sessions, it's an opportunity I never dreamed I'd have again."

Bassist Jimmy Stevenson left New York and disappeared into obscurity in the 1970s. It took three years and the serendipitous help of a friend to find Stevenson and his wife making and selling wind chimes on the side of the road in California's wine country in 2003. "You can't imagine," says Stevenson, "somebody calling you up out of the blue and telling you that they've got tapes— many, many hours of tapes—of you talking and playing music forty-five years ago. Hearing these tapes is like somebody playing back your memories for you, only these are memories you forgot you had. But these aren't just memories, this is real!"

Today the smell of flowers after a sweaty night of jamming is still alive in the memories of many of the loft's habitués. "I remember coming out of that loft in the morning and being overwhelmed by the aroma of fresh flowers," Dave Frishberg says. "It was ironic," Steve Swallow says. "Here were the dregs of the 1950s jazz scene, on their way home at dawn, mixing with the flower-shop owners who were unloading fresh flowers off of flatbed trucks. Dawn was always the best time to smell those flowers. The streets were quiet. The light and the air seemed new. I loved coming out of that loft and smelling those flowers."

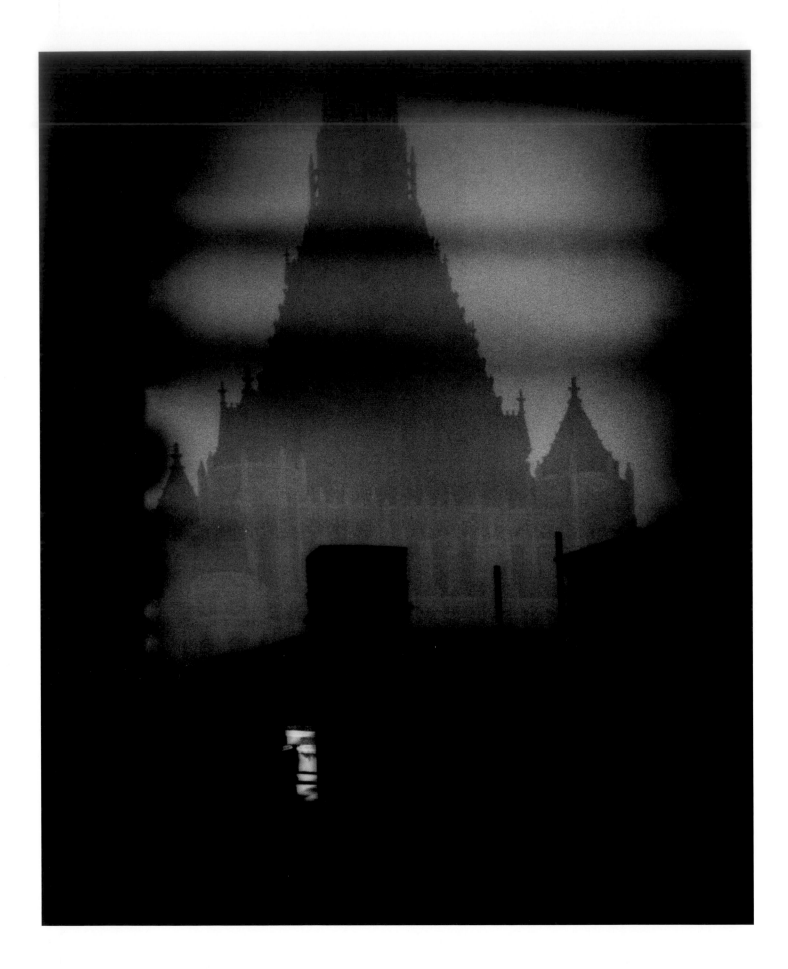

Circa 1960

A telegram from W. Eugene Smith to the Long John Nebel late-night radio show on WOR is read on the air and taped by Smith.

LONG JOHN NEBEL: All right, this is good, this is from Gene Smith, one of the greatest photographers [*reading Smith's telegram*], "While my cats for various reasons record Dr. King, and all, I'm busy photographing out of my window and within the building adding to a present nine thousand or so photographs. Some are fuzzy, and so am I. But I still find the challenge exciting. As usual I'm enjoying and arguing the show. Personal regards, Gene Smith." Isn't that nice? I'll tell you, he got so hot one night, he went forty-three bucks for a telegram. He got so steamed. I don't know if I said something or if somebody said something, and, he, you know, boom, he fired it right up. Forty-three dollars. We checked it because it was so long.

UNIDENTIFIED VOICE [*on Nebel's show*]: He did a thing on a midwife in a rural, Negro section of the South . . . it was one helluva story.*

NEBEL: This man, he can do no wrong with a camera. Just great, a fantastic photographer.

*"Nurse Midwife: Maude Callen Eases Pain of Birth, Life and Death," *Life*, December 3, 1951.

A Sample of Smith's Audio Recordings from Radio and TV, 1957–1965

Sources and broadcast dates are listed if known as of this writing.

The Romance of Tristan and Iseult, by Joseph Bédier, read by Claire Bloom
Porgy and Bess, by George Gershwin
Tribute to Frank Lloyd Wright, WNYC radio, upon his death, 1959
Antony and Cleopatra, by Shakespeare, WCBS-TV
The Black Ships (Kurofune), opera by Kosaku Yamada, WBAI radio
Mr. Magoo cartoons
Poems of William Blake

News coverage of John F. Kennedy's election in 1960, assassination and funeral in 1963

Newscasts of Fidel Castro and Nikita Khrushchev visiting New York and the United Nations, 1960

A Midsummer Night's Dream, by Shakespeare, circa 1960, WNYC radio
Petrouchka, by Igor Stravinsky, WBAI radio
Salome, by Richard Strauss, WBAI radio
Camino Real and *The Yellow Bird*, by Tennessee Williams, 1964
Strange Interlude and *The Iceman Cometh*, by Eugene O'Neill
Death of a Salesman, by Arthur Miller

Numerous newscasts on Martin Luther King Jr. and Birmingham, Alabama, in 1963 and Selma, Alabama, in 1965

Many news stories on the Cuban Missile Crisis, with discussions ranging from Cold War politics to steel and concrete bomb shelters for the backyard

Dozens of recordings of WOR radio talk shows hosted by Long John Nebel, Jean Shepherd, and James "the Amazing" Randi

The Crack-Up, by F. Scott Fitzgerald, WNYC radio, read by Jason Robards
Krapp's Last Tape, by Samuel Beckett
Symphony No. 10, by Henry Cowell
Peter Grimes, an opera by Benjamin Britten
Requiem, by Verdi, performed by Herbert von Karajan with Leontyne Price, Salzburg, 1962
Atmospheres, by György Ligeti
The Grass Harp, adapted for stage by Truman Capote from his novel
Poems and an excerpt from *Ship of Fools* by Katherine Anne Porter
Sidney Poitier reading the poetry of James Weldon Johnson and Langston Hughes
Dorothy Parker speaking on Jack Kerouac and the Beats
No Exit, by Jean-Paul Sartre

The Negro and the American Promise, hosted by Dr. Kenneth Clark, with James Baldwin, Malcolm X, and Martin Luther King Jr., WNET-TV Channel 13, 1963

World Series, 1960, Game 1, from Forbes Field, Pittsburgh
World Series, 1963, Game 7, from Dodger Stadium, Los Angeles
First match, Sonny Liston versus Cassius Clay, 1964
Several radio and television appearances by Jackie Robinson

1964 radio symposium on the film *Dr. Strangelove*
Luchino Visconti's 1943 film *Ossessione*
John Huston's 1948 film *The Treasure of the Sierra Madre*
Waiting for Godot, by Samuel Beckett, TV adaptation featuring Zero Mostel and
 Burgess Meredith, 1963
The Fugitive Kind, a film by Sidney Lumet based on a play by Tennessee Williams, with
 Anna Magnani, 1959

Newscasts of the first American orbit of the earth, by astronaut John Glenn, 1962

A radio documentary called *Poverty and the American Space Program*

La Création du Monde, by Darius Milhaud
Blood Wedding, by Federico García Lorca
The Wild Duck, by Henrik Ibsen
The Petrified Forest, by Robert E. Sherwood
The Seagull, by Anton Chekhov
Dialogues, by Plato
Tosca and *La Bohème*, operas by Puccini
Who's Afraid of Virginia Woolf?, by Edward Albee
The Dark Lady of the Sonnets and *Pygmalion*, by George Bernard Shaw
Gertrude Stein on WBAI radio, 1963
The Dharma Bums, by Jack Kerouac, read by Charles Laughton, 1962
Cavalleria Rusticana, by Giovanni Verga

WBAI radio programs: Corsican folk songs, folk songs of the Philippines, Yugoslav folk
 songs, Pakistani folk songs, and Korean folk songs

WOR radio talk shows hosted by Jean Shepherd and James "the Amazing" Randi

Memorial tribute to Edward R. Murrow, 1965
Dylan Thomas reading *King Lear* and sonnets of Shakespeare, 1963
Interview with Eudora Welty, 1963
Tribute to Woody Guthrie, 1957
Readings of Sigmund Freud's letters
Poetry and biography of Gerard Manley Hopkins
Poetry of e. e. cummings
Numerous broadcasts of James Baldwin interviewed or speaking on radio and TV

Many episodes of CBS-TV's program *Look Up and Live*
Much music by Billie Holiday, Sister Rosetta Tharpe, and Marian Anderson

1963

Smith recorded a radio advertisement for a new three-way lightbulb by General Electric, with voice by the cartoon character Mr. Magoo, performed by actor Jim Backus, who later became known as Thurston Howell III on the TV show *Gilligan's Island*.

MR. MAGOO: Oh, it was certainly nice of the kiddies to pick me as their chaperone for the school dance tonight. [*Sound of car wheels skidding on the road.*] Oh, I never saw the old gym so gaily decorated. Heh, look at those youngsters' crazy new dance steps. [*Music.*] Ho, ho, what a lucky girl. Your program's all filled up. Boys, boys, don't be wallflowers. Hmmn? Oh, you look tired, hollow-eyed. You need better light in here: a soft white light, a General Electric three-way bulb in a snug new package. Bright [*click*], right for reading, no glare; medium [*click*] for sitting one out and just talking; low [*click*] for dancing cheek-to-cheek. Come on everybody. The floor's empty. Let's dance. Can you spare a dance with the chaperone, little miss? [*Sound of bowling ball crashing into pins.*] Ow! Whippersnapper didn't even ask to cut in. [*More bowling pins falling.*] But it's easy to see, the best bulbs are GE. *General Electric: Three-Way.*

Dorothy Parker on the Beats

In July 1960, WBAI radio broadcast a 1958 symposium cosponsored by the University of Iowa Writers' Workshop and *Esquire* magazine featuring Saul Bellow, Leslie Fiedler, Wright Morris, and Dorothy Parker under the title "The Writer in a Mass Culture."

Parker's comments, stumbling over her notes at times:

Sorry, I can't read my writing—it's an affliction I share with the critics [*laughter*] . . .

To me, there are only two kinds of writers: those who write badly and those who write well. I admit it's pretty stiff to divide them. I'm enabled to say entirely aside that works of the beat generation is not bad writing. Old as I am, I don't think so at all. I don't think it's bad writing. I just think it isn't writing. Many things it may be, but writing, to me, it ain't. I know, reading the works of Mr. Kerouac and all the other Kerouacs—they extend the reader, if they care. Sure, sure, sure, they're about the gorgeous new times that are here, but I am unable to fling myself into them. Of course you can say, "Yes, yes, yes; go, man, go," but it seems to me those glorious, those right—they, they, oh god I skipped a page. Never mind— I don't know what they mean. I think, if you don't mind, their lives with their "Go, man, go" and all that are simply monotony.

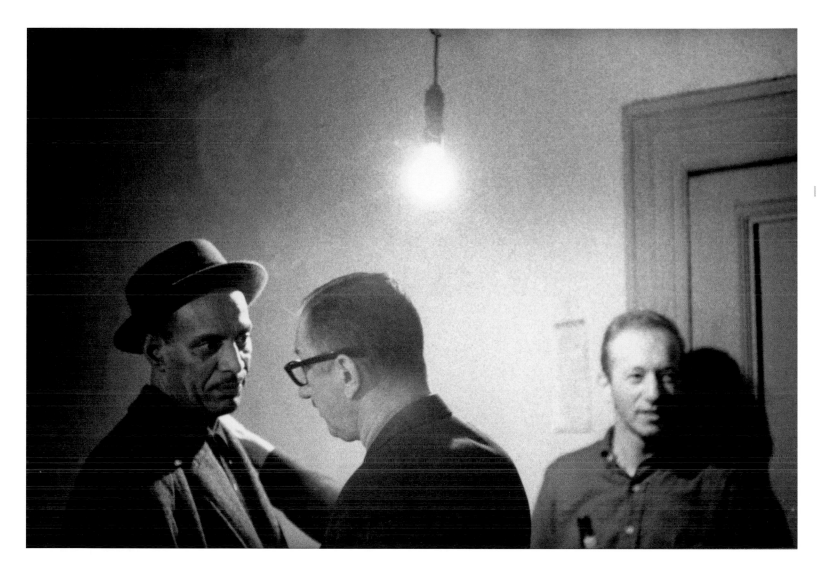

Left to right: Vic Dickenson, Pee Wee Russell,
Ronnie Bedford. Despite the uncovered lightbulb
hanging from a wire, Smith was still able to achieve
detail on the shaded sides of Dickenson's and
Russell's faces.

? Halls Apt session –
(Zoot Sims) + solo Guitar)
 tenor)(Jimmy Raney)

2 Pianos – Hall + Eddie Costa
(not sure) – ? DRUMS ? TRUMPET ?

1·SIDE – BLUES – LADYTRAMP
VERYGOOD BARY ? – TWO PIANOS
GOOD RECORDING + SESSION

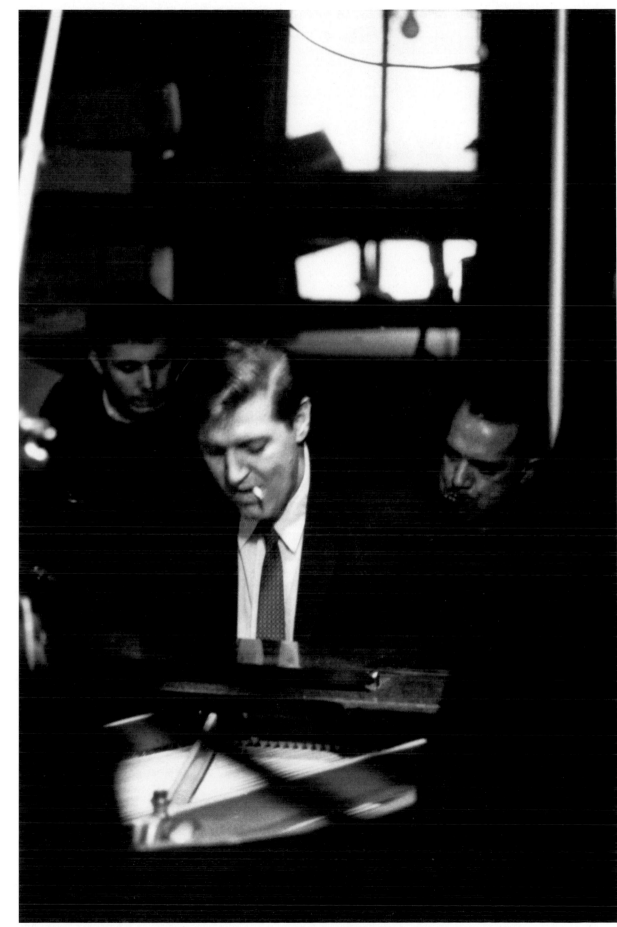

Opposite: *Halls apt session.*
Zoot Sims, Jimmy Raney, Hall
Overton, Eddie Costa, unknown
drummer and trumpeter. Circa
1960. The 1937 show tune
"The Lady Is a Tramp," written
by Rodgers and Hart for the
musical *Babes in Arms,* is
played, along with Ann Ronell's
1932 jazz standard "Willow
Weep for Me."

Right: Ronnie Free,
Hall Overton, unidentified
saxophonist

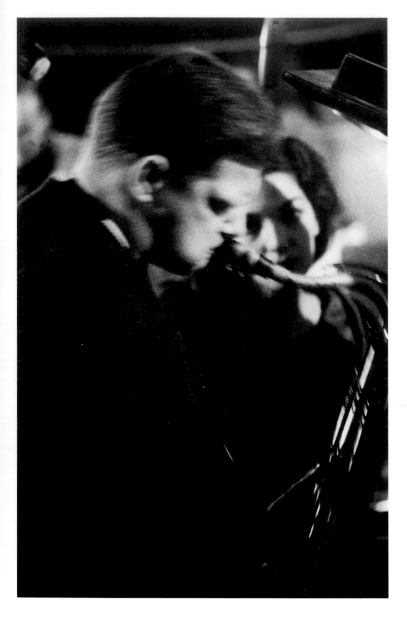
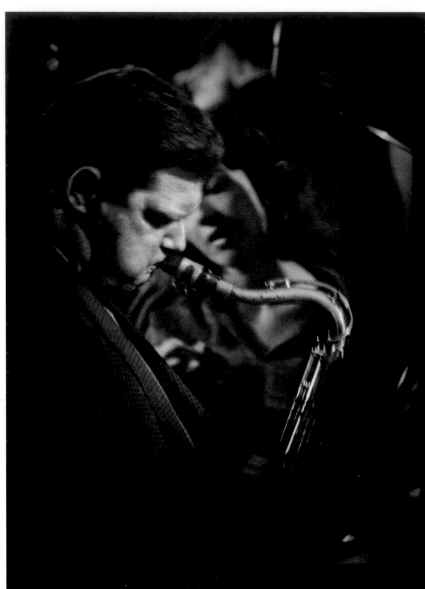

Zoot Sims

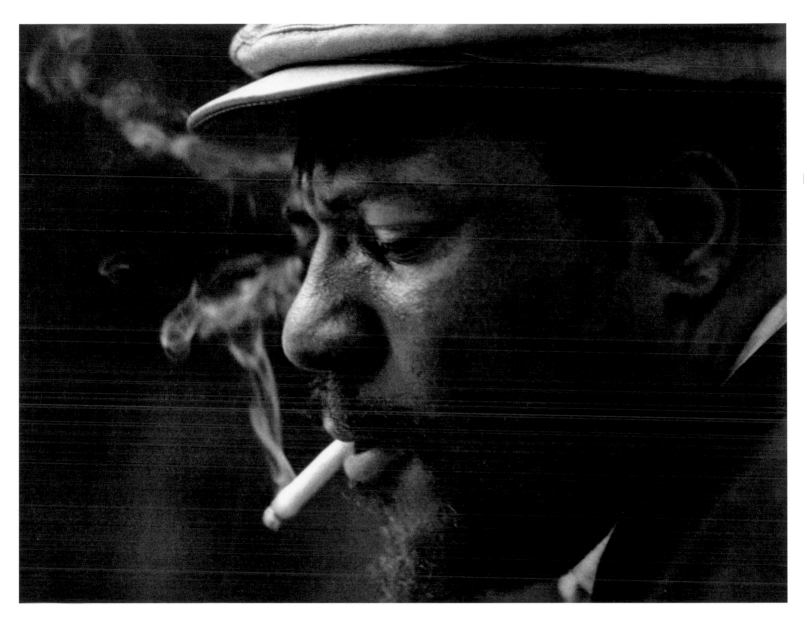

Thelonious Monk

"The first time I was at the loft was actually towards evening. It was a hole in the wall. I went in, saw the stairs, and all the photos lining the stairs all the way up. Really dark, no lights. And I thought, *This can't be the place.* But anyway, I kept going up. The photos were thick along the wall. You actually had to ease past them all the way up to the top floor. The landing [on Smith's floor] was just stacked with photos."
—**DEANNE SIBLEY,** wife of bass player Dave Sibley, who lived in the loft during the summer of 1961. Deanne came down from Boston to visit Dave often that summer.

"In those days you had to go down to the corner of Sixth Avenue and Twenty-eighth Street, where there was a phone booth, and call to the loft, and someone would open the window and throw a key out down to the sidewalk, and that was the way to get in and go upstairs and play."
—**FRANK AMOSS,** drummer who lived in the loft in 1961

"There was a metal door with glass that had crossed wire in it, I believe. There was a buzzer system. And the steps were metal, I believe, and they were very steep. It was poorly lit and because this was a loft building with extra-high ceilings it seemed like each flight had an extra two or three steps."
—**ROBERTA ARNOLD,** artist manager

July 27, 1963

Smith recorded writer Katherine Anne Porter on WNYC's radio program *Spoken Word* talking about her acclaimed 1962 novel *Ship of Fools*, which took twenty years to finish:

"What I meant to say was already in my mind and it never changed. Just the size of it changed! It just kept growing."

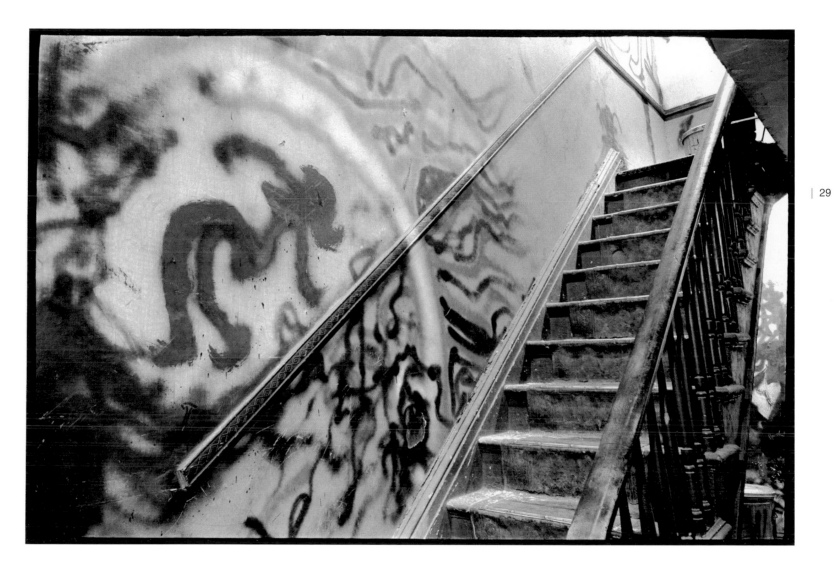

Stairs at 821, wall painted by Gene Smith.
Photo by David Vestal, 1965. (Artist Bill Heine
contributed to the graffiti on the wall.)

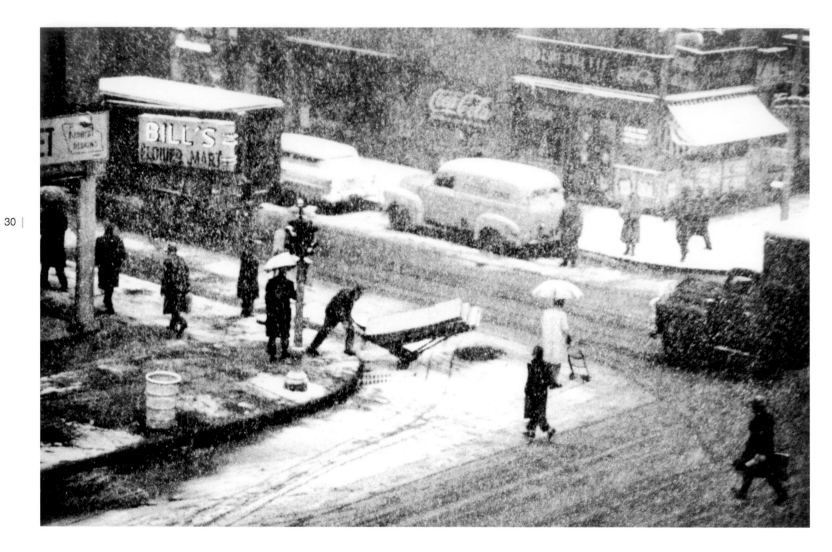

"Rhythm of a Corner"

October 23, 1962

Dizzy Gillespie and Charles Mingus were playing opposite each other at Birdland. Zoot Sims and Al Cohn were opposite Art Farmer at the Half Note. Ted Curson was at the Village Vanguard, and Marian McPartland was at the Hickory House. Twenty-one-year-old Bob Dylan was singing "A Hard Rain's A-Gonna Fall," "Blowin' in the Wind," and "No More Auction Block" at the Gaslight Café on MacDougal Street and Third Street in the Village, around the corner from the Fat Black Pussycat lounge, where loft musicians such as Sonny Clark and Lin Halliday played regularly.

Edward Steichen had installed a show of Farm Security Administration photographs by Walker Evans, Dorothea Lange, and Ben Shahn at the Museum of Modern Art, and the Metropolitan Opera was staging *Aida* (with Leontyne Price), *Madama Butterfly*, and *Cavalleria Rusticana*. On October 27 at Madison Square Garden, only seven blocks from 821 Sixth Avenue, there was a middleweight fight between Florentino "the Ox" Fernández and former prison inmate Rubin "Hurricane" Carter, and on the same day Sidney Lumet's movie adaptation of O'Neill's *Long Day's Journey into Night*, with Katharine Hepburn, Jason Robards, and Dean Stockwell, opened in cinema houses around the city.

But everything was overshadowed by the Cuban Missile Crisis. The threat of nuclear holocaust paralyzed the country. People were digging backyard bomb shelters and stockpiling canned food. Gene Smith and his girlfriend, Carole Thomas, had recently returned to 821 Sixth Avenue from a year in Japan, during which Smith photographed the Hitachi company village. His loft had been robbed by junkies in their absence. But he had enough equipment to keep his tapes rolling throughout the month.

WBAI radio, eleven p.m. news and commentary by Edward P. Morgan:

President Kennedy tonight signed the momentous proclamation ordering a selective blockade of Cuba. The document is the bluntest challenge to Soviet imperialism since at least the Korean War, possibly the strongest U.S. challenge ever made to the Communist hierarchy. At present, more than twenty-five Communist-bloc ships are reported steaming toward Cuba; if any ship refuses to halt and be searched, U.S. warships are instructed to sink it.

The White House said it had received thousands of telegrams running 12-to-1 in favor of the blockade. It is doubtful, however, that the public has immediately grasped the full implications of the blockade, which, whether or not legal scholars consider it an act of war, does require enormous military support.

Smith pans the radio dial looking for something else, finally settling on a woman singing. It is *Salome*, the 1896 opera by Richard Strauss, based on a play by Oscar Wilde. After a few minutes, Smith turns the radio dial again, across several stations, settling on WNYC and another news report on Cuba, this time from a local New York perspective:

Governor Rockefeller ordered a crash program to put the state in a maximum posture of readiness. Mayor Wagner summoned his top commissioners and other high-ranking political leaders to consider civil defense requirements in the city. Rockefeller ordered a speedup in the stockpiling of food, water, and medicine for the state's grammar school children, announced plans to recruit a state militia in the event the National Guard is called into federal service, and called on local school districts for immediate action on fallout-shelter programs.

Bassist Jimmy Stevenson had moved to New York with his wife, Sandy, in 1961, not long before Smith and Thomas went to Japan for a year. Stevenson remembers the fear of that time as an experience in which he and Smith bonded.

"Sandy was back in Detroit visiting her mother, and this crisis came down and I went downstairs to see Gene and I said, 'We're liable to be toast here anytime.' And Gene says, 'Yeah, I know. Well, come on in,' you know, 'we can talk.'

"Gene was playing the Miles Davis and Gil Evans record *Sketches of Spain*, and he was furious. He said, 'You know, the music they're playing . . . it's just warmed-over Rodrigo.' I said, 'But it is Miles Davis and it is Gil Evans and those guys are awesome.' He laughed and said, 'Yeah, well, you ought to hear some real music,' and he put on a recording of Louis Armstrong from the 1920s.

"It seemed like an easing of the tension. We continued to talk and listen to the news reports. At the time, you'd only get five-minute news reports on the hour."

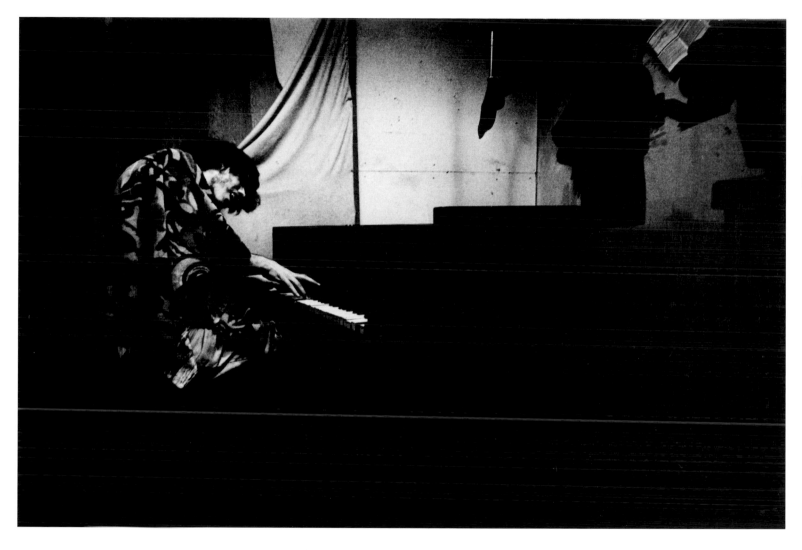

Jimmy Stevenson, a bass player professionally,
who, like many jazz musicians, was known to be
proficient on the piano

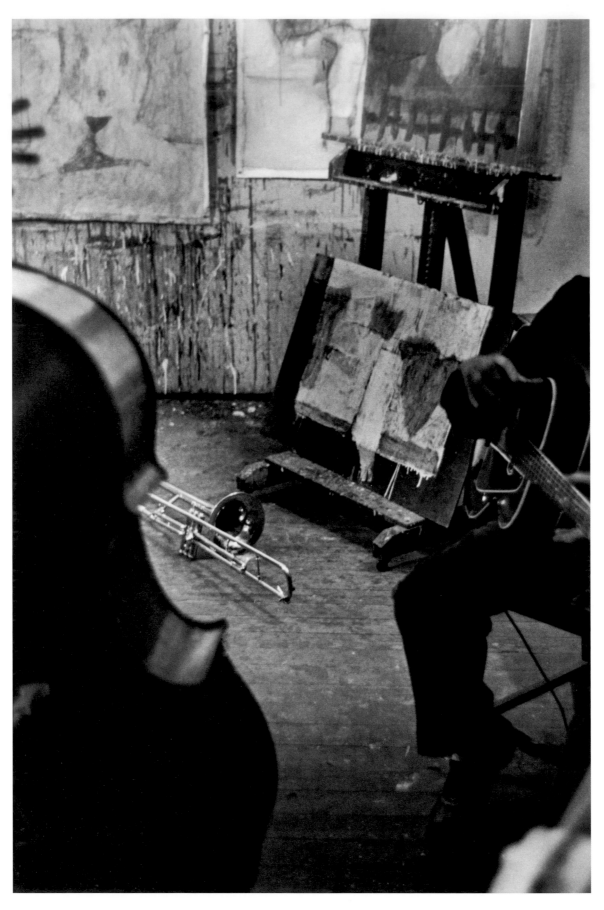

David X. Young's canvases;
Jimmy Raney, guitar

Sometime in 1959

In an otherwise random loft conversation that Smith recorded with painter David X. Young and two unidentified women, Smith describes a favorite garden he encountered near the France-Spain border, along the Atlantic coast, while en route from Paris to Deleitosa, where he created his famous "Spanish Village" photo-essay for *Life* magazine. Gardens intrigued Smith throughout his life—his most famous photograph is called "The Walk to Paradise Garden," named for music by Frederick Delius. The photo depicts his toddler children, Pat and Marissa, walking through dark brush toward a cradle of sunlight. In ancient mythology gardens were places of tranquillity, often for deformed, handicapped people. Was it a coincidence that Smith left his home in peaceful Croton-on-Hudson, in a period of his life he called "the worst," and moved into Manhattan's wholesale flower district? Probably so, but the metaphor of his moving back into the heart of the metropolis and finding a home among flowers befits the contradictions that riddled him.

YOUNG: Gene, you got a garden?

SMITH: Mine's not a complicated garden. And it isn't my garden, for one thing. My garden would be much messier and more . . . and more sensual. . . . I couldn't have a real garden, could I?

YOUNG: I don't know, well, you know, whatever garden hits ya, you know.

SMITH: Oh, well this is the most remarkable garden in my life. I was walking down the streets of this very tiny French town, and I was deeply, deeply, deeply troubled, and I looked at all the . . . because I'd been looking at all the closed walls of the town, and all of the people were behind it. And I was just on my way into Spain, and my problem was, How do I penetrate these walls? How will I ever know these people in here when I cannot understand, that I don't know, I'm a stranger here. I will be a stranger to them. How, how may I find my way in, and it seemed impossible. It seemed completely impossible. And we went down on across the town and came out—I was walking with the lovely Nina[*]—and we came out of the area of the houses and plain, not plain, but the simple walled-in houses, and we came into the garden. It was a garden of love that I . . . as I had never seen a garden of love. I think it was probably a public park. But I'm sure that the man who took care of it did it only with love and for love, and it had a tremendous love that was labored and that there are many more fantastic parks in the world, I've been in them, and they have been labored and labored and labored. At busy infantines with respect, and sometimes people are involved in what they're doing. But here was this creation that apparently, probably one man, and it was very beautiful, and in this place I felt the greatest peace I've ever felt and I felt much more able, restored to my ability to reach through those walls. I remember not so much a color but a rhythm. I remember the colors as vivid and working together as a lovely rhythm. I remember a tremendous neatness about it, but not a fussiness. And I have cherished this product for this garden ever since that day, and I am a man immediately bored by talk. And I don't know whether Nina also cherishes as I do, because I don't know whether she could see what I could see as I stood there, but it was lovely.

[*]Nina Peinado, daughter of artist Joaquin Peinado, who was Smith's assistant for "Spanish Village: It Lives in Ancient Poverty and Faith," *Life*, April 9, 1951.

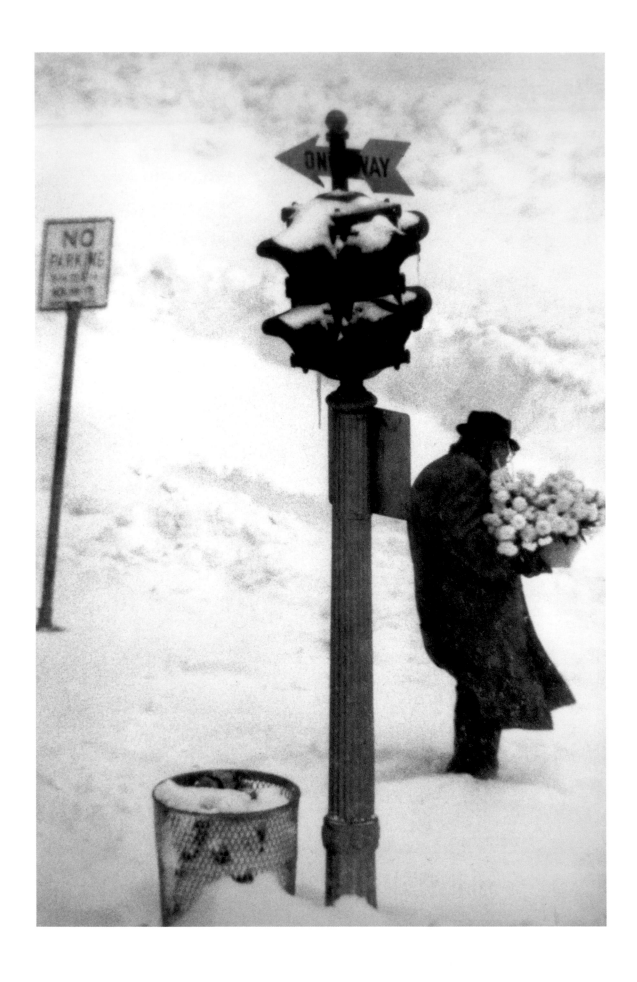

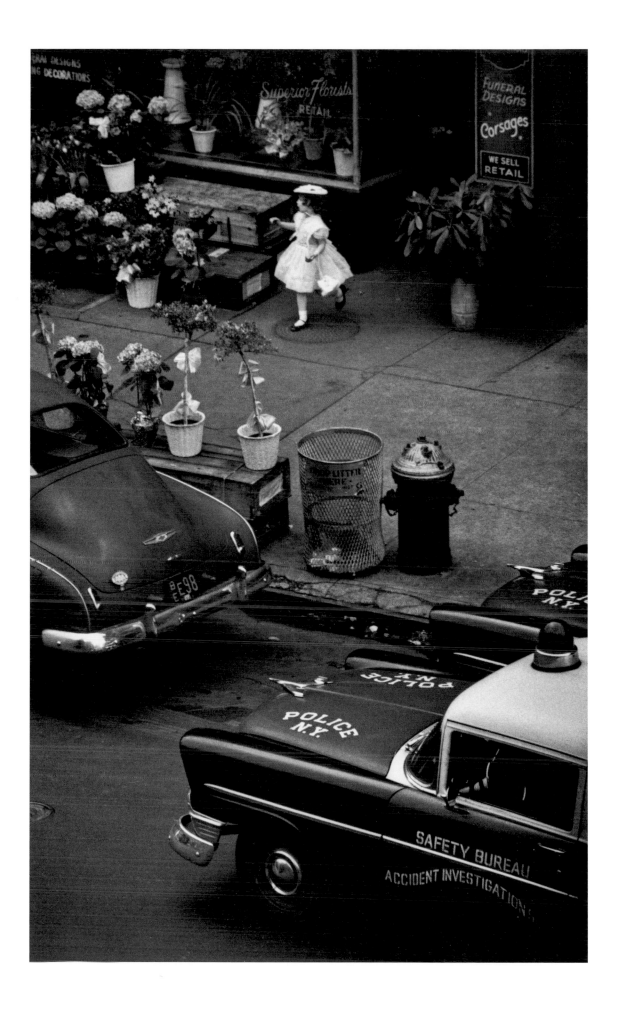

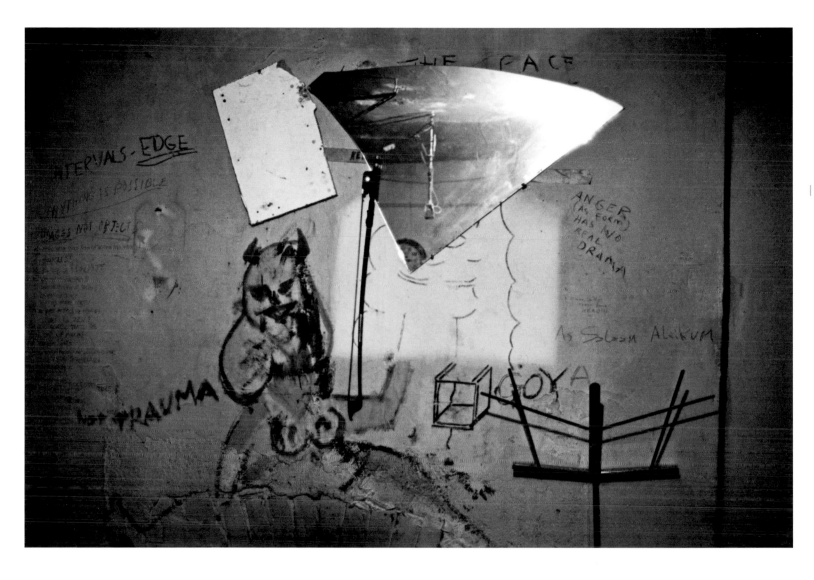

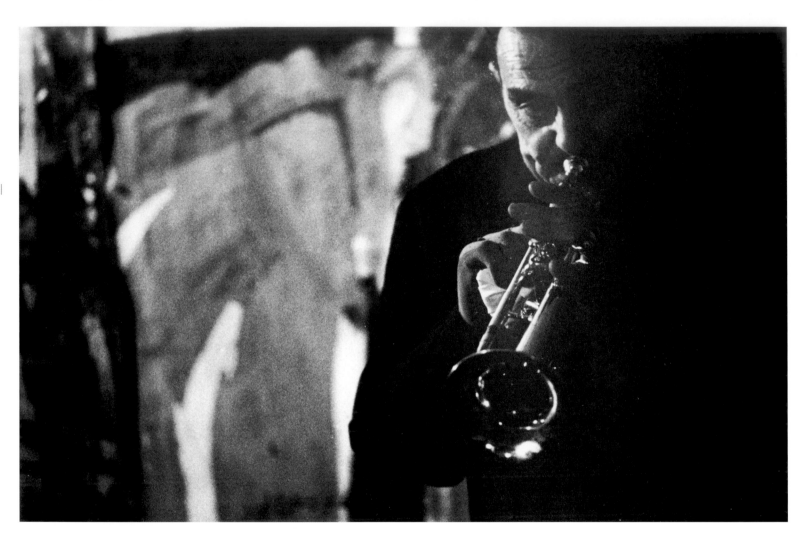

Wingy Manone

Opposite: Zoot Sims

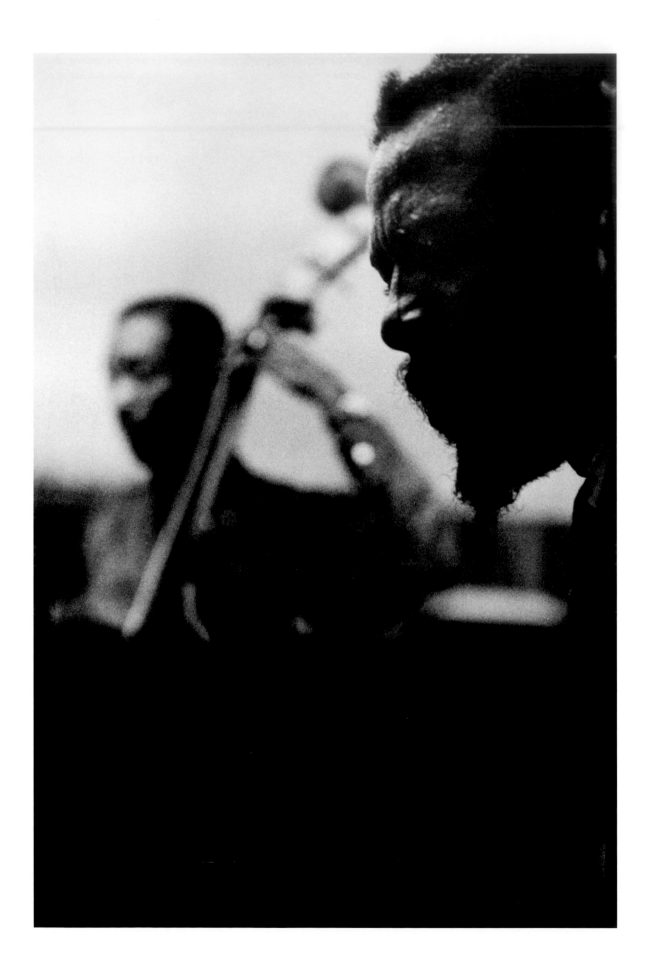

October 5, 1960

The afternoon weather in New York City was fair—a high of sixty-five degrees with variable cloudiness. The forty-one-year-old Smith worked in his darkroom with his transistor radio tuned to the broadcast of Game 1 of the 1960 World Series, between the Pittsburgh Pirates and the New York Yankees, from Forbes Field in Pittsburgh. The announcers for NBC radio were Jack Quinlan and Chuck Thompson.

Smith decided to load a seven-inch reel into his tape machine and record the last few innings of the game. Maybe it was because the underdog Pirates, playing in their first World Series since 1927, took a promising 6–2 lead. Maybe he thought fondly of his days wandering the soot-stained streets of Pittsburgh—the few years a lifetime ago—when he said his photography was "red hot, or something," when his Pittsburgh dreams were growing and hopeful, before his desire turned to fever, before he left his family in Croton-on-Hudson and moved into 821 Sixth Avenue, and before he pinned his Pittsburgh opus all over the walls and stairwells of the dilapidated loft, fluid and unpublishable.

In the eighth inning the great relief pitcher Elroy Face, age thirty-two, came in from the Pirate bullpen to close out the Yankees. Jack Quinlan casually told the radio audience that in the off-season Face worked as a carpenter in Pittsburgh. He said, "If you want to get corny you can say that he's nailed down many victories this year for these Bucs." With two runners on base, Face struck out Mickey Mantle on a forkball that "fell off the table," according to Thompson, and got Yogi Berra to pop out harmlessly to right field.

The broadcast is filled with short advertisements for automobiles and related products, motor oil and wiper blades.

Value and choice from GM. For '61 it's the hot newcomer from Pontiac, the Pontiac Tempest, America's first front-engine, rear-transmission car. Priced with the compacts, Tempest gives you a winning 120 horsepower from just 4 gas-saving cylinders. See Pontiac's new 1961 Tempest at your quality Pontiac dealer.

The game ends, and the recording on this reel skips to a month later, around eleven a.m. on Wednesday, November 9, when Smith catches William Faulkner reading from his 1932 novel *Light in August* on WNYC's radio program *Spoken Word*. Faulkner had long been a hero of Smith's—the writer's 1950 Nobel Prize acceptance speech clipped and pinned to his loft bulletin board. In this story Joe Christmas is on the run after allegedly killing his lover. Faulkner reads:

Then, sitting there, the sun warming him slowly, he goes to sleep without knowing it, because the next thing of which he is conscious is a terrific clatter of jangling and rattling wood and metal and trotting hooves. He opens his eyes in time to see the wagon whirl slewing around the curve beyond and so out of sight, its occupants looking back at him over their shoulders, the whiphand of the driver rising and falling. 'They recognized me too,' he thinks. 'Them, and that white woman. And the negroes where I ate that day. Any of them could have captured me, if that's what they want. Since that's what they all want: for me to be captured. But they all run first. They all want me to be captured, and then when I come up ready to say Here I am Yes I would say Here I am I am tired I am tired

Sam Jones, Thelonious Monk. The interplay of musicians influenced Smith's imagery throughout his career and, perhaps, his tapes, where surprising juxtapositions are found.

of running of having to carry my life like it was a basket of eggs they all run away. Like there is a rule to catch me by, and to capture me that way would not be like the rule says.'

The reading ends. Smith turns the radio dial, briefly settling on an Italian opera and then the noon news on WCBS. Twenty-nine-year-old Bill Beutel, a future television anchor, reports on the results of the previous day's presidential election.

A high Vatican spokesman has hailed Senator Kennedy's election as a demonstration of the high degree of religious tolerance and freedom in this country. Said the spokesman, "What is important is not so much that a president of the United States is a Catholic, but that a Catholic could become president of the United States."

Smith's parents were devout Catholics, and after his father committed suicide, Smith was raised, bittersweetly, by his pious, domineering mother.

Back to the news in just a moment. Beutel reads a promotion:

Every woman knows value when she sees it, and that's why you'll want to be sure you look for Marcal paper napkins on your grocer's shelf or at your favorite supermarket.

Beutel continues reading the news briefs:

Elsewhere in Western Europe, newspaper reaction on the Kennedy election is generally favorable, but with a note of caution. Editorials and political figures alike are predicting definite changes in United States foreign policy, but they describe Kennedy as a bright and refreshing new leader of the Western world. As for the Communists, their radio transmitters are calling the vote a crushing defeat for the Eisenhower administration. The official Soviet news agency, TASS, said Kennedy won because Americans were seriously alarmed by the present administration's policies. More news in just a minute.

The reel ends quietly and abruptly; it will be stored away in its box for almost half a century before anyone hears it. It is unclear why there is a monthlong interval between the recordings on this reel. During that month Smith made many more recordings on other reels. Among them are jam sessions with obscure musicians such as Race Newton, Gary Hawkins, Joe Lopes, Manny Duran, Tom Golden, and others. He also taped some UFO stories off the Long John Nebel program. It would be cumbersome to pause a reel-to-reel recording and insert a new tape, because each end of the plastic tape would be wound around a different reel. Smith was known to do that, though, taking a tape off his recorder while attached to two reels and setting it aside in order to load a fresh new reel.

"Gene used to, when he was working in the loft darkroom sometimes, put a red filter on the screen of his TV set so he could watch some of the games, some of the football or baseball games. And some people are just horrified at this. It sounds a lot better, more romantic or something, if he was just listening to music, which he also did for sure. But, you know, when you're living, you do normal stuff. Gene loved sports."
—CAROLE THOMAS

Shana Smith, daughter of W. Eugene Smith

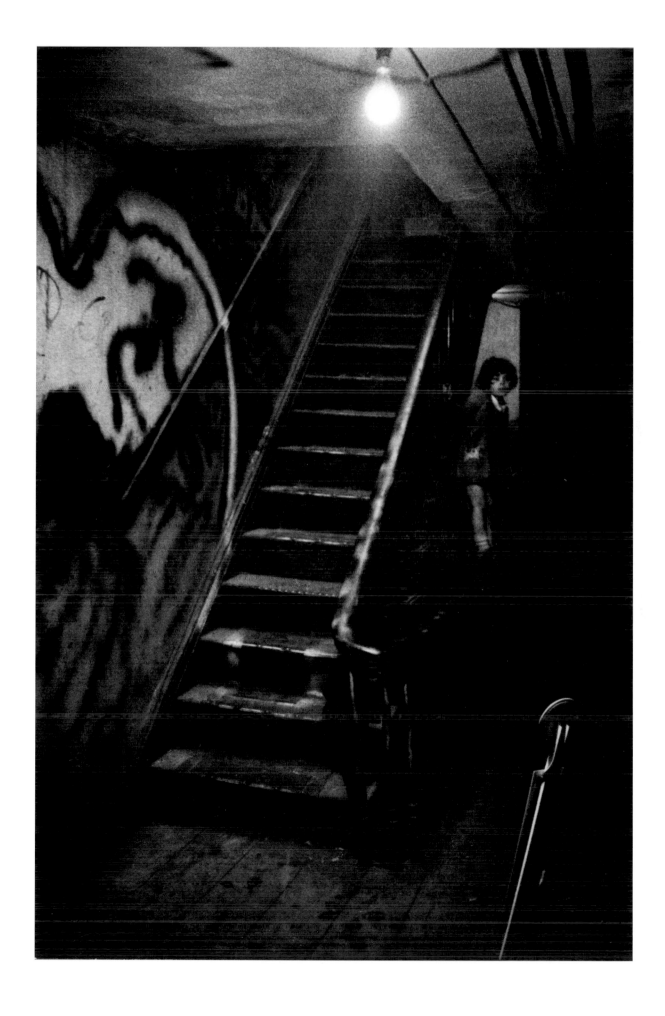

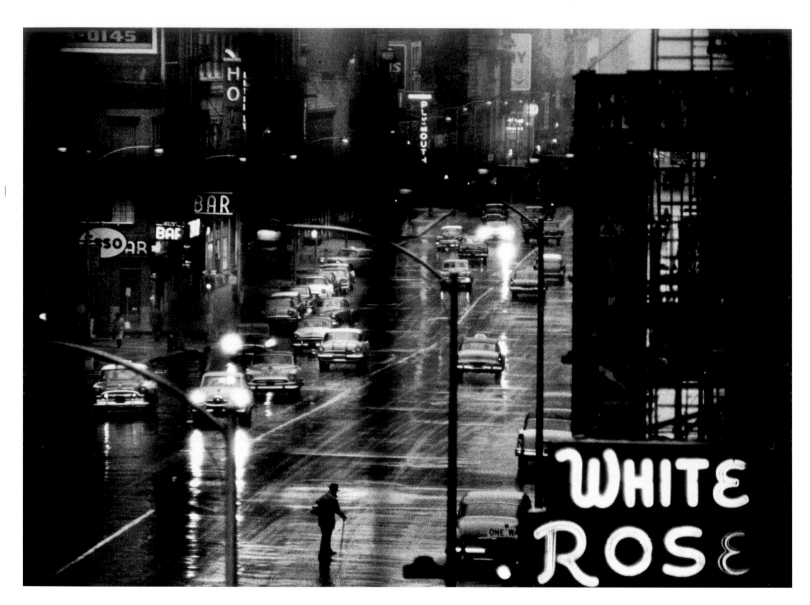

"One time my brother and sister-in-law came to visit me in New York, and I can remember taking them up the stairways, and they were really aghast at where I was taking them, where I was living, and going up those . . . It wasn't rickety, but it was well worn, and no one painted the walls or did any maintenance. It was just like a funky, functional stairway to the top."
—FRANK AMOSS

December 1960

It is a typical late hour at 821 Sixth Avenue, with Smith's tape machine rolling. Somebody says something about two o'clock in the morning.

A neighborhood beat cop enters the sidewalk door, walks upstairs. He isn't familiar with Smith or the building like some other cops documented on Smith's tapes. He's inspecting the building, looking for evidence that it is illegally being used as a residence. The neighborhood is zoned commercial.

COP: Where's the lock for this?

SMITH: It's right here. Come on, Pending [Smith's cat]. There's my compass.

Smith riffles through a ring of keys to open the door.

SMITH: First, you see my name up there on the door? It says "No Anticipation Allowed."

COP: Who's upstairs, anyone?

SMITH: A drummer by the name of Gary Hawkins; um, there's also a man by the name of Hall Overton next door who is a piano teacher. I think he was working late and he may still be there if you'd like his identification.

Smith is showing him he has keys for all the locks.

COP: Ah, is this your studio?

SMITH: It's where I work on layouts. As a matter of fact, actually, I've taken several pictures, in fact many pictures, out the window, several of which appeared in *Life* a year or two ago. One was a picture of one of your coworkers coming out of the flower shop in uniform, which I refused to publish because I asked someone on the beat at the time . . . that's my daughter.

COP: You work late, don't you?

Footsteps in the hallway, on the stairs.

COP: What are the tapes for?

SMITH: The tapes actually are all from jam sessions around here. Musicians here and upstairs. One reason why there are people here so late is because they all can play here and have a jam session. Here's another one of my daughter . . .

COP: Very nice. How many kids do you got?

SMITH: Four.

Lots more footsteps in the hallway, on the stairs.

COP: What's this? You paint? Oh, for touching up, huh? There's some painting to it, huh?

SMITH: Hi, Gary.

GARY HAWKINS: Hi, Gene.

SMITH (*to the cop*): This is my upstairs neighbor. Tell him we all work all night around here.

HAWKINS: Yeaaah.

COP: Why you got the tape recorder going for?

SMITH: Among other things I'm doing a book on the building, which is taken inside and outside.

COP: What you got this thing running for?

SMITH (*laughs*): Well, because my cat was chasing a mouse [*laughs*], and I was recording my cat chasing a mouse [*laughs again*].

HAWKINS (*laughs*): What happened?

SMITH: The goddamned mouse got away [*laughs*]. And so has Pending, as a matter of fact.

. . .

COP: Hey, Christ, how much electrical stuff you got here? Jesus, look at all this. What, are they all speakers? One, two, three, four, five. Holy Jesus.

SMITH: There are two more over there.

COP: Jesus Christ.

SMITH: As a matter of fact, Gary, he says he's never had a complaint on you characters upstairs.

COP: What do you play?

HAWKINS: Drums. We haven't been playing much lately. We have to play with the windows shut, naturally, but in the summertime they'd be open.

COP: I was wondering if you had any beer left.

SMITH: As a matter of fact, I think this . . .

COP (*pointing at a photograph*): Oh, Christ, that's some shot. These are all very nice shots.

SMITH: As a matter of fact, this one, the day I was taking that . . . it's an abandoned coal mine near Pittsburgh. It took me back to the war. I had my car parked down there, and suddenly bullets started cracking around my ears. I was laughing like hell, but I was also scared as hell, too, because there were a couple of kid hunters around there and they were firing in my direction, and for the first time since the war I had to go running down into the brush with bullets cracking in my ears.

COP: What the hell you got in here, film of everything?

SMITH: There's twenty-six years of work here.

COP: Be careful of fire around here.

SMITH: Scares the hell out of me as a matter of fact. Every time I take a walk up the block I keep my fingers crossed that the building's still there.

SMITH (*to Hawkins*): You have any more of that beer you can lend him?

HAWKINS: I've got a can of beer if you'd like; I should have offered.

SMITH: You have a beer on duty?

COP: Aren't you going to turn off that tape recorder? You're only wasting it.

SMITH: I'm sorry; hit that center button.

COP: No, I won't touch it.

February 24, 1960.
Tandberg recorder. Opera *Peter Grimes* by Benjamin Britten. *Monaural of Ronnie [Free]—then stereo of Ronnie and Fred [Greenwell] using Norelco mike.*

Christmas/New Year's 1959–60.
Music, mood (crowd, etc), sounds, recording, balance, in all ways one of very best (in good feeling). Freddie Redd and Friends. Male blues singer. Among the tunes played is "(Back Home Again in) Indiana," published in 1917 by Ballard MacDonald and James Hanley.

Top-left box

BRAND FIVE
magnetic
recording
tape

Top-right box

PLAY ON 4 TRACK
MACHINE

FEB 24/80

RECORDING LOG

STUDIO_____ ENGINEER_____

MASTER INDEX NO._____ FILE SUBJECT_____

FOOTAGE	TRACK NO.	SPEED	SUBJECT TITLE	TIME	DATE RECORDED
			2ND BAR 4		
			PETER GRIMES		
		2ND	SIDE		
			THEN STATIC		
			THEN MONOLOG		NO
			OF RONNIE		
			THEN STEREO OF		
			RONNIE AND FRED		
			USING NORELCO		
			MIKE		

ADDITIONAL PLAYBACK INFORMATION:

SOME GOOD NOT MUCH PACKER

Bottom-left box

1ST Side Stereo (2 TRACK ONE WAY)
4
2ND " Sounds like a big VERY GOOD
celebration XXXXX
XX XXXX

Ballad

MANTECA — TRUMPET ? SEE OTHER OF SAME SESSION
Indiana — Tenor ?

BEGINS WITH BANJO SOLO (GOOD)
(WITH GOOD CROWD REACTION)

ALSO THERE IS A MALE BLUES
SINGER (E)THER CHRISTMAS '59
OR NEW YEARS, 60'

MUSIC, MOOD (CROWD, ETC) SOUNDS
RECORDING, BALANCE, IN ALL
WAYS ONE OF VERY BEST (IN GOOD FEELING)

FREDDIE REDD
& FRIENDS

Bottom-right box

GUARANTEED SPLICE-FREE

Grand
Central "professional"

HIGH FIDELITY

recording
tape

exclusively at
Grand Central Radio, Inc.
124 E. 44 Street at Lexington Ave., New York 17

LEADING DISTRIBUTOR OF HIGH FIDELITY COMPONENTS

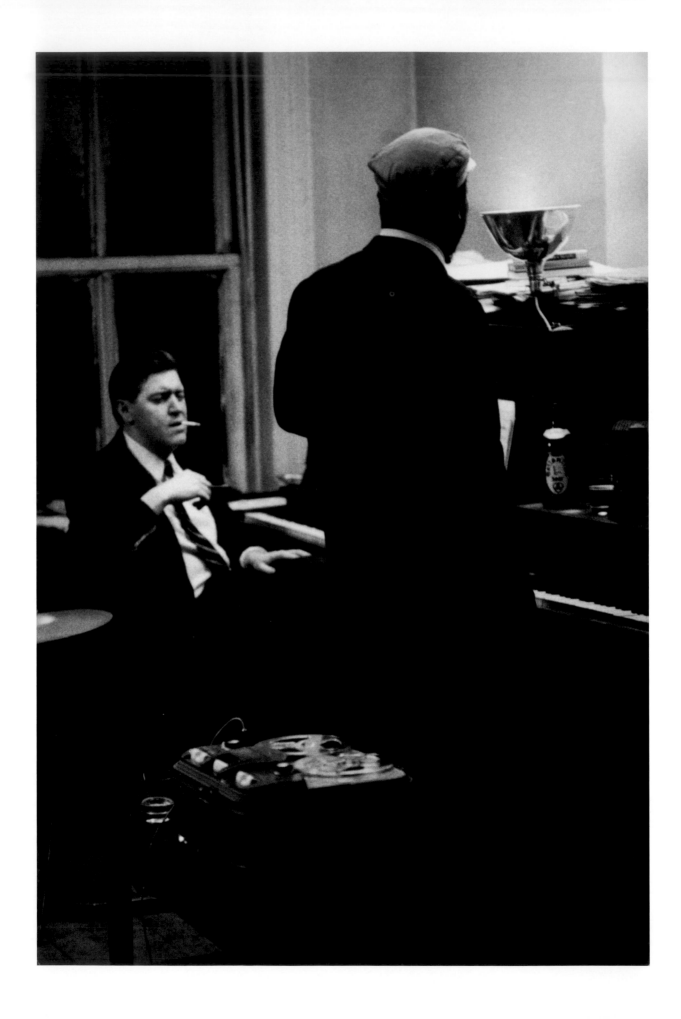

Thelonious Monk and Hall Overton

Musician Dick Cary, who lived at 821 Sixth Avenue from 1954 to early 1960, kept a diary for most of his life. In concise entries he accounted for his jazz gigs and pretty much everything else—musical compositions, women, drinking, hangovers, problems with plumbing and electrical work, and personality conflicts with other musicians. It is a remarkable document of ordinary details in the life of a terrific, undersung jazz professional at midcentury.

On April 21, 1955, Cary wrote, "Thelonious Monk and gang upstairs." Upstairs was Hall Overton's loft space. Cary had the third floor, Overton the back half of the fourth. This is the earliest record of Monk and Overton working together. They were preparing for an event at the 92nd Street Y on April 23, billed as a "Modern Jazz Festival," headlined by the First Jazz Sextet, which featured Charles Mingus, Kenny Clarke, Art Farmer, Eddie Bert, Teo Macero, and Hall Overton, with "Special Guest: Thelonious Monk." This was the "gang upstairs." If Smith had been living there then we might have a tape of that evening, but he didn't move in until 1957.

Smith did, however, thoroughly document the preparations by Monk and Overton for historic concerts by Monk's big bands at Town Hall in 1959, Lincoln Center in 1963, and Carnegie Hall in 1964. Smith's tapes reveal a unique relationship between the two musicians and an extraordinary level of craft, discipline, and practice—traits that are generally more often attributed to classical music than improvised jazz—required to perform those concerts.

"I think it was Hall who called me [to join Monk's Town Hall band]," said French horn player Robert Northern. "Monk spoke very little. He would've never picked up the phone and called me. Overton called me and said that we were preparing for a performance. I asked him a little bit about the music. He said, 'Well, we're gonna transcribe Monk's piano music into a large ensemble.' Nobody had ever done that before. I knew it was going to be really interesting and a challenge. I knew I was going to be playing with some of the musicians I had always admired. So I didn't hesitate. The only thing that I did hesitate about was that rehearsals started at three a.m. That was the only time that everybody could make it. It was after the clubs had closed. Everybody [in the band] was playing some nightclub somewhere, you know,

Hall Overton, Thelonious Monk, W. Eugene Smith's tape recorder. Suits and ties, in the middle of the night, in a dilapidated loft building in the center of Manhattan.

Birdland or the Royal Roost or something. So, between two and three, people began to congregate in Hall Overton's loft. And by three-thirty or four we were well under way. And we were there until seven or eight in the morning rehearsing. I don't think it would have been the same had it been somebody less than Monk. This was an occasion nobody would want to miss. I was teaching in the South Bronx, and I had to be at school by nine a.m."

"Monk trusted Hall because Hall knew exactly what to do. He knew what to leave out and what to put in. And you got to know that with Monk. I mean, you can't just—you know, it's not vanilla. In other words, it ain't like usual. It's got to be what Monk did. And the band, that tentet, was like a piano. You had to write it like a piano. So you'd be playing all kind of parts. They intertwine and go up and down. Each instrument was like a key on the piano. Monk must have been pleased with Town Hall or else he wouldn't have wanted to work with Hall again on Lincoln Center and Carnegie Hall."
—trombone player **EDDIE BERT**, who was a member of all three of Monk's big bands that rehearsed in the loft

"Hall would be playing piano for the rehearsal, and Monk would be in the other room dancing around in the way he did," said Bert. "Hall would ask him,

'When are you going to play?' Monk would say, 'When the tempo gets right.'"

"I remember sitting there, listening to the three of them talk [Monk, Overton, Smith], and I had no idea what they were talking about. I don't know if *they* knew what they were talking about to each other. They knew what each other was saying. But it was three monumental, marvelous minds, just expressing themselves, and whether somebody understood or not was beside the point."
—**BOB DE CELLE**, Overton's longtime music copyist, who became an archivist for the New York Philharmonic

In a remarkable 1963 appearance with Overton at the New School in New York, Overton asked Monk to demonstrate his technique of "bending" or "curving" notes on the piano, the most rigidly tempered of instruments. Monk drawled notes like a human voice and blended them (playing notes C and C-sharp at the same time, for example) to create his own dialect. Overton told the audience, "That can't be done on piano, but you just heard it." He then explained that Monk achieved it by adjusting his finger pressure on the keys, the way baseball pitchers do to the ball to make its path bend, curve, or dip in flight. It is doubtful that Monk would have made this public appearance with many—or any—people other than Overton.

January 1959.
Preliminary searchings & rehearsals by Thelonious Monk and Hall Overton in preparation for Monk's Town Hall concert on February 28, 1959

105

MORE OF THELONIOUS AND HALL
(SOME OF HALL PLAYING FRAGMENTS)
START OF 3 OF HALLS "REELS" TAKEN FROM A 3¾ TAPE)
STILL PRELIMINARY SEARCHINGS)
& REHEARSALS

#2

28

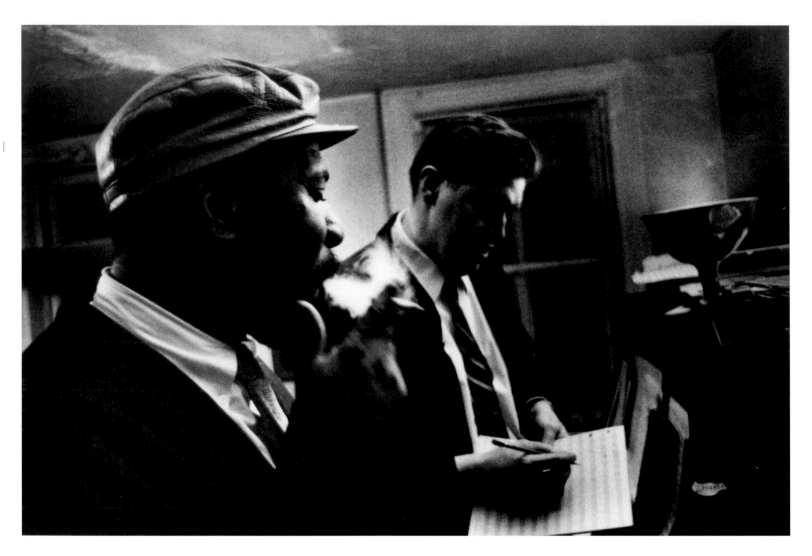

Thelonious Monk, Hall Overton

January 1959

Monk and Overton prepare for Monk's historic big-band concert at Town Hall on February 28, 1959. (It was recorded for an album still in print in 2009.) Before bringing the entire band into the loft for rehearsals, Monk and Overton met many times to discuss and arrange the tunes one by one, a private process recorded by Smith.

THELONIOUS MONK: Those three arrangements are crazy. I like 'em.

HALL OVERTON: Yeah, I do too.

MONK: I like 'em.

Monk continues walking around the room, his heavy boots thudding gracefully at one-second intervals on the creaking planks that date to the building's construction in 1853, when Monk's grandfather Hinton Monk was an infant living in slavery in Newton Grove, North Carolina, about five hundred miles away.

MONK: We got enough to start a rehearsal, three arrangements, you know?

OVERTON: Sure.

MONK: If they [the band] did one arrangement a day, that would be a motherfucker.

OVERTON: Boy, I tell you, they're going to sweat their balls off on that, uh, "[Little] Rootie Tootie." It's gonna be a hard one for them, to get that clean, all that phrasing clean . . .

MONK: [We] make them work on *that* all day, you know . . . one song, you know. [It] don't make no sense working on a *gang* of songs if you don't play nothin' right.

OVERTON: You're lucky if you get it in one day . . .

MONK: I've seen cats where they bring the whole book down—like they run the book down—like they playing on the job, and they still don't know shit. Nobody still can play nothing, you know? We can take one arrangement and run that down, and learn that, you know?

OVERTON: Sure.

MONK: One a day.

MONK: We should let everybody take that "Little Rootie Tootie," let them take their time and get it. Ya know?

OVERTON: Sure.

MONK (*in jest, making fun of "sight-reading," playing notated music at first sight*): Nobody would have to be showing how fast they can read. No sight-reading or something, you know. Just take one bar, and work on it.

OVERTON: Like sight-reading Stravinsky.

MONK (*sarcastically*): A sight-reading contest; we'll have a sight-reading contest.

OVERTON: It's going to be hard, man.

MONK: It's generally good to tell cats that, ya know. And they really figure it out. You know, clashing notes, some times reading something they can't read perhaps, or understand how it sounds or goes or nothing. Let 'em listen to the record, you know? You do that by letting them listen to the record.

There is a pause of a minute or two as Monk continues pacing around the room, his footsteps a rhythmic pattern underneath the fragmented conversation.

MONK: That's three arrangements. You know, all of them are crazy, all of them are cool, you know, so far. They sound all right to me; they sound all right to you? Huh?

OVERTON: Pardon me?

MONK: All three of them sound all right, like they are.

OVERTON: Crazy, yeah. It's very clear to me, yeah. Friday the thirteenth. "Monk's Mood." "Crepuscule with Nellie." "Thelonious."

MONK: "Crepuscule with Nellie," all we need are about two choruses on that. We end up everything with that or something, end the set with that. You know, there ain't too much you can do with that, you know; it's just, you know, it's just the melody and the sound, you know, a couple of choruses.

OVERTON: Yeah, well, how do you want to do that, Monk?

MONK: I'll play the first chorus. Let the band come in and play the second chorus and finish that. And then we get up, you know, and get our bread and quit [*laughter*].

"I mean, when you're in the center of an experience, it's feeding you, in a sense, you know, mentally and emotionally, and that [loft] music did. It seemed like something natural. It was, you know, like having trees outside your window. It had that element to it, too. I used to be able to . . . after we got the top floor, I could soak in my bathtub and listen to Thelonious Monk [on the fourth floor below] for hours. There were some holes around the pipes, so the music came up real loud and clear. And I knew that was wonderful, you know, but I was experiencing it. I wasn't saying, 'Oh, one day this will be a great moment in history.' I mean that never . . . I didn't think in those terms. It didn't seem historic, because it was normal at the time."

—CAROLE THOMAS

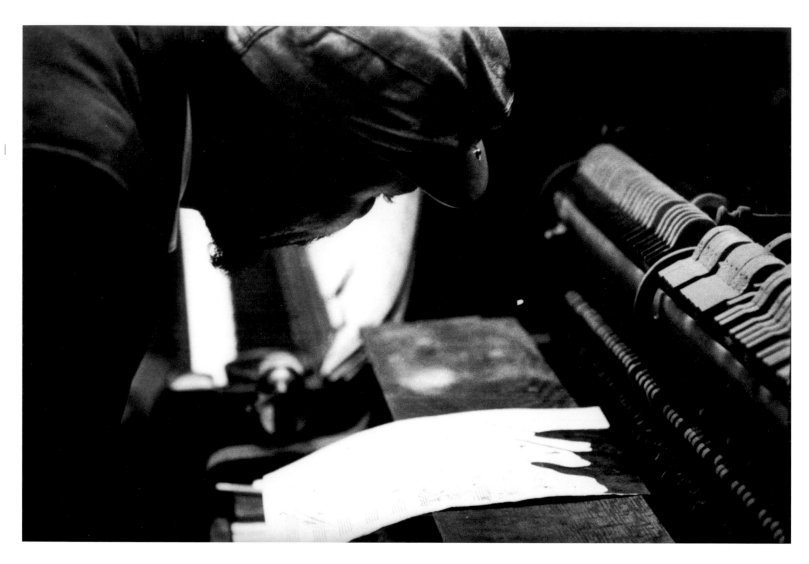

Above: Thelonious Monk

Opposite: Thelonious Monk, Hall Overton

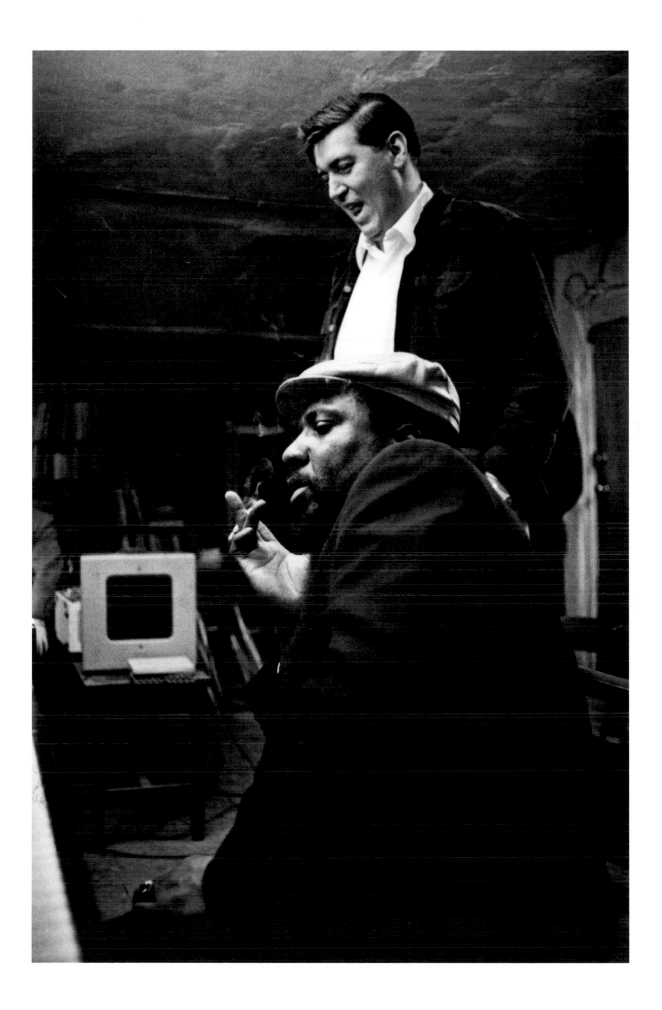

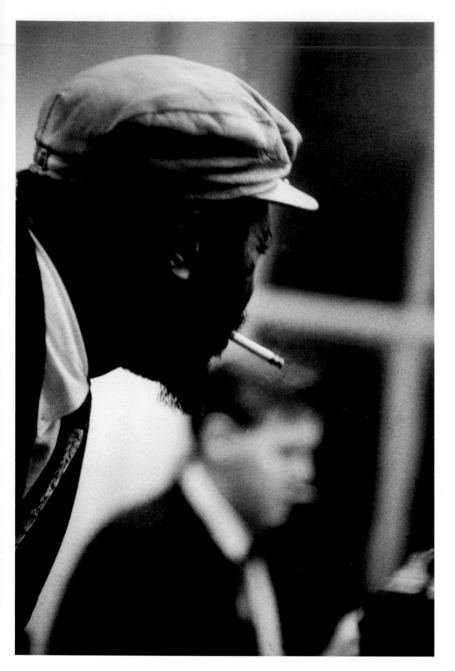

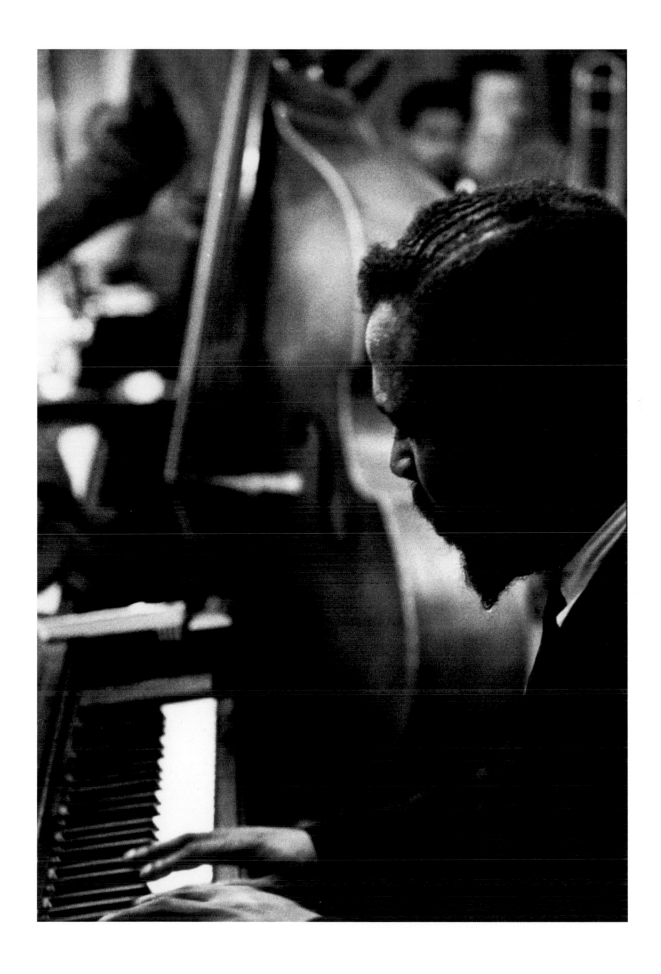

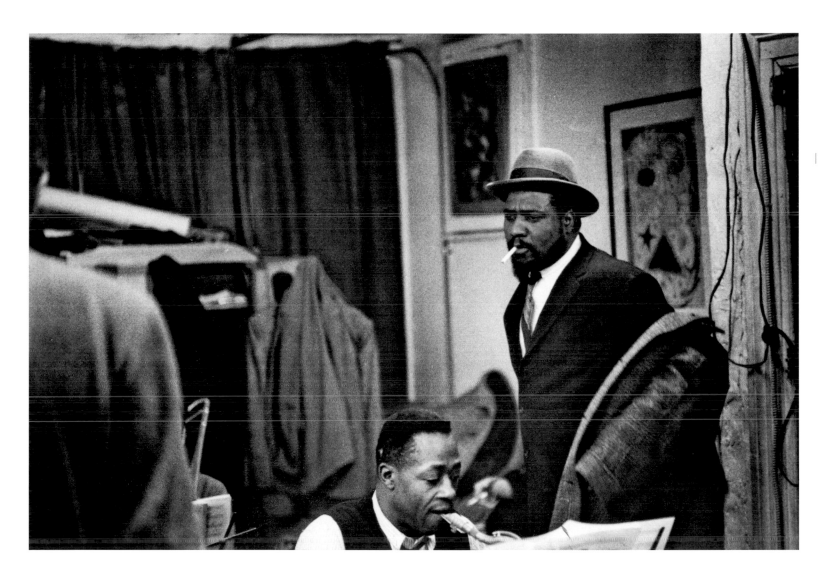

Charlie Rouse, Thelonious Monk

Opposite: January 26, 1959. *Monk rehearsal at
Hall's, mostly playing.* Rehearsal of full Monk band
two days before the Town Hall concert.

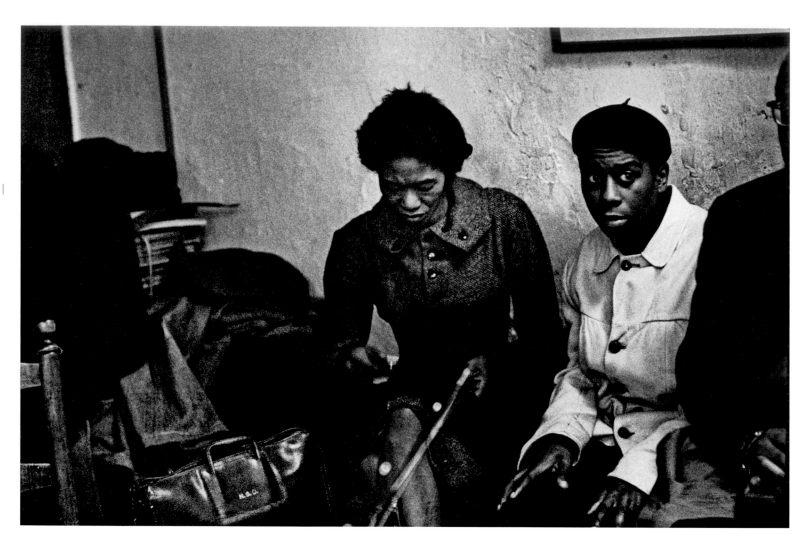

Nellie Monk, unidentified man
Opposite: Thelonious Monk and Town Hall band in
rehearsal. Smith's grease pencil mark indicates
where he will crop the picture.

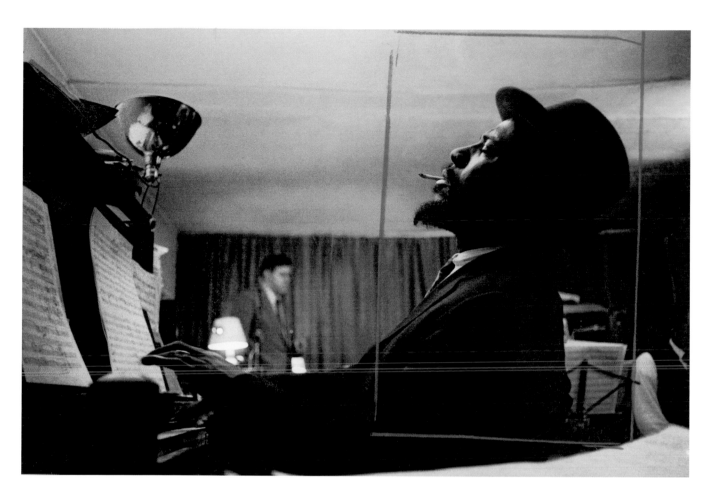

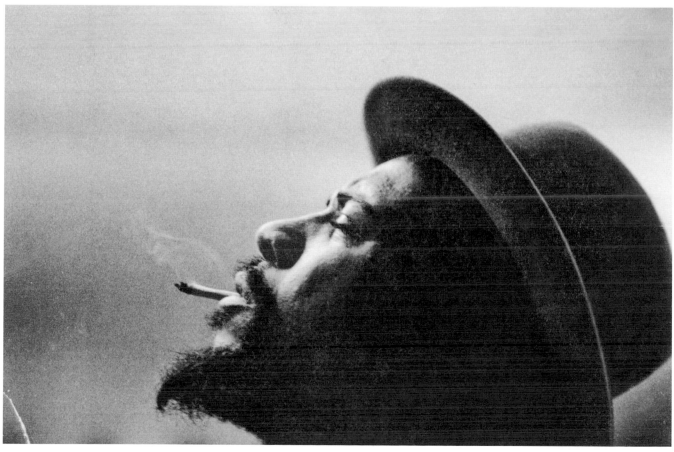

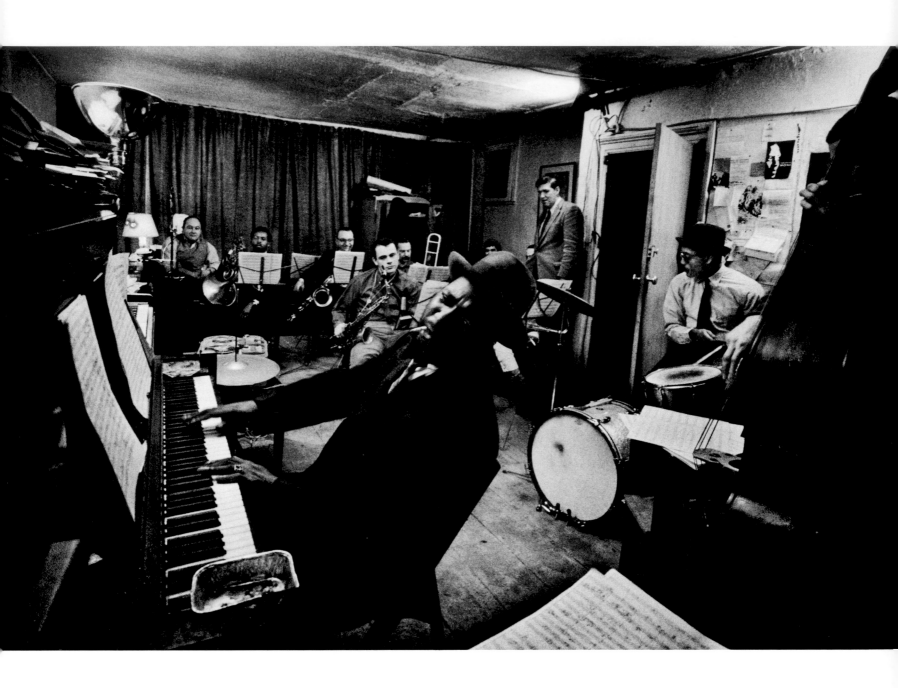

Thelonious Monk and Town Hall band in rehearsal. Monk's dedication, diligence, and sense of humor are profoundly documented on Smith's tapes and in his photographs. If you had to pick one jazz musician for a behind-the-scenes glimpse like this, it would be Monk.

Summer 1963

Smith and drummer Tommy Wayburn are discussing topics ranging from Wayburn's translations of Russian technical journals to the saxophone playing of Lee Konitz to the importance of Smith's loft recordings, the latter of which leads them to a discussion of obscure loft saxophonist Freddy Greenwell:

WAYBURN: Freddy is really something, man.

SMITH: One of Freddy's best nights is the night he was squeaking like mad. He couldn't stop the squeaks. But, really great. Hall [Overton] on piano and two guys from Ornette's band. What're their names?

WAYBURN: Rhythm players?

SMITH: No, no, horns.

WAYBURN: Don Cherry.

SMITH: Yeah, Don Cherry, yeah, yeah, yeah. And I forget who the hell else was on drums, some guy I don't know. He was good. Hall liked him very much.

WAYBURN: Ed Blackwell or Billy Higgins?

SMITH: I can't seem to think of the name.

WAYBURN: And you got these recorded? I mean, that's a treasure, you know.

SMITH: Well, yeah, Hall's been having some of his sessions every Saturday night. Hall had, well, last Saturday, he had Sonny Rollins, Thelonious Monk . . .

WAYBURN: Here?

SMITH: Well, yeah, he'd have them up here, and Zoot [Sims] and Al Cohn, too. But I'm sorry I didn't get that photographically and on tape. But I didn't have a chance.

WAYBURN: Those guys will be recorded for posterity. There's no problem. It's not as though they're going to be lost.

SMITH: Yeah, but see, no, I've never heard Zoot play like he plays when he gets so loaded that he can't sit up straight but he's still fully playing. And he's very introspective, very beautiful playing, and I never heard him play like that before.

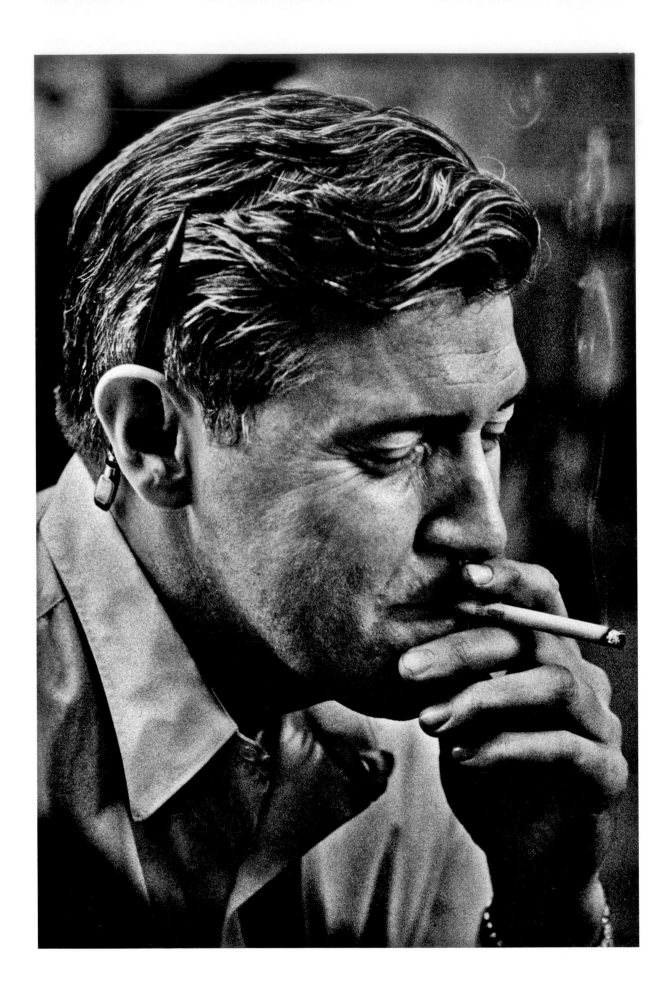

March 3, 1961

Smith on Hall Overton, in the company of Bill Pierce and an unidentified man:

SMITH: We'll import him for a jazz session downstairs.

PIERCE: You should be here when he's here; it's quite something . . .

UNIDENTIFIED MAN: They don't play it over there like they do it here.

PIERCE: Well, they don't play it here like they play it here. You know, very relaxed.

SMITH: Relaxed, but some of the best jam sessions, and they're not happening very often. Next door at Hall's, when he has sessions: One, he has very top musicians. Two, he's one of the most learned of all connected with jazz and music. He teaches at Juilliard. He's a magnificent jazz pianist. And among other things, he hooks the other characters into the line of completing something, which for most of 'em . . . they kind of fade away.

And you know, he has a beautiful . . . he has a way of controlling musicians to make them work right. If the drummer is lagging, he has a way of forcing him around with his playing, somewhat decently, and few people play as well as when Hall is driving them on. Which is very impressive.

MAN: Who is Hall?

SMITH: He guided the orchestration for Monk, for instance. He also does operas and symphony work, and in other words, he's extremely talented, mainly as a teacher, now. But I've never heard one of these jazz musicians that wouldn't pass his door at all without stopping. And that's very true, whether it's been Zoot [Sims] or [Gerry] Mulligan or anyone else, it's always "Gee, I've gotta study with that guy someday." It's always so amazing because his piano playing is almost too polite and quiet in a way. But he has a tremendous way of urging other musicians on.

The composer Steve Reich visited 821 Sixth Avenue once a week for two years, beginning in June 1957. After Reich graduated from Cornell University at age twenty, his primary teacher there, William Austin, sent him to New York to seek out Hall Overton. Overton taught formally at Juilliard, but jazz was still considered unworthy music there at the time, so he did his most innovative teaching in the loft. Reich's influences—John Coltrane, Kenny Clarke, Stravinsky, and Bartók, among others—were embraced by Overton. Later, after Reich enrolled at Juilliard himself, he brought over a string quartet to practice his nascent music in the loft, and Gene Smith taped some of those sessions.

REICH: The milieu around Overton was very lively. Thelonious Monk was there; Jimmy Raney and Jim Hall, the two jazz guitarists; Mal Waldron, the piano player. All these people were coming in and out of the studio and you'd see them. Downstairs from Overton, there was the famous American photographer W. Eugene Smith . . . he was absolutely insane, fantastic; his entire studio, every wall, was photographs. Into the photographs were stuck more photographs. He wanted to hear my little string quartet pieces. . . . I was thrilled to play these, not for another student-composer, but for a real artist [like Smith].*

REICH: Eugene Smith did not come across as your normal human being [*chuckle*]. . . . I just remember the one overpowering image, which is that I walked into this room, and this room was wall to wall, with four walls, of photographs—or, you know, every available—obviously there was a door. But outside of that it just seemed to be all photographs. But it wasn't just that: every photograph—there were like all these photographs that were attached to the wall, and then into those photographs were stuck other photographs that were kinda like leaning because they weren't carefully [attached], and behind them were others, sort of stuck, so the whole room was like [*laughing*] leaning, and about to fall and engulf you. He was a very intense vibe.*

REICH: So the ambience around Overton was very positive. . . . I remember seeing him [later] and it was as if his shoulders had begun to sag—the weight of the academy was on his shoulders, and he died shortly thereafter. He was a heavy smoker and a bit of a drinker. A wonderful man, and a very gifted teacher.†

REICH: I think Hall stood alone in being somebody who was a [classical] composer and a professional jazz musician and someone who really had a place in the jazz community. I think he was totally unique . . . which means it was kind of a lonely position to be in.‡

As a composer Overton's intended magnum opus was an opera, *Huckleberry Finn*, which was conducted by his acclaimed student Dennis Russell Davies at Juilliard in 1971. The midwestern river story and its racial implications appealed deeply to Overton, who grew up in southwestern Michigan's rural apple-farming region. In 2003 Robert O'Meally, the Zora Neale Hurston Professor of Literature at Columbia University, published a new introduction to Twain's novel in which he made an extensive case for it being a "blues novel." He described the blues as an expression "of romantic longing and, in a larger frame, of desire for connectedness and completion, for spiritual as well as physical communication and love in a world of fracture and disarray. As an improvised form, the blues admits life's dire discouragements and limits to the point of death, but nonetheless celebrates human continuity." In November 1972 Overton died of cirrhosis at age fifty-two. Two months before his death he and the bassist Eddie Gomez had a three-week engagement at Bradley's, the Greenwich Village piano bar. Composer Francis Thorne remembers attending the gigs and having his first opportunity to meet Thelonious Monk, who was increasingly reclusive in those days but was there to support his friend.

*From Steve Reich, *Writings on Music, 1965–2000* (New York: Oxford University Press, 2002).

*From a personal interview with Reich by Sam Stephenson and Sara Fishko, December 6, 2007, Pound Ridge, New York.
†From *Writings on Music*.
‡Stephenson and Fishko interview.

The rental arrangements at 821 Sixth Avenue were always in flux. The owner of the building was the Esformes family, who had a check-cashing business in the neighborhood. But the tenants were transient, and sometimes Overton paid for the entire fourth floor and Smith paid Overton for his half. Other times Smith made direct payments to Esformes.

"Hall got pissed off because Gene Smith owed him a couple of months' rent. And Hall said, 'I'm going to fix him,' and he knocked at the door and he banged at the door. And Gene didn't answer, so he figured he was out. Then, Hall got out a hammer and he hammered and nailed the door shut. But Gene was in there. And you could hear Gene wailing, 'Let me out of here!' Oh, man, there were some wild things happening in that place."
—BOB DE CELLE

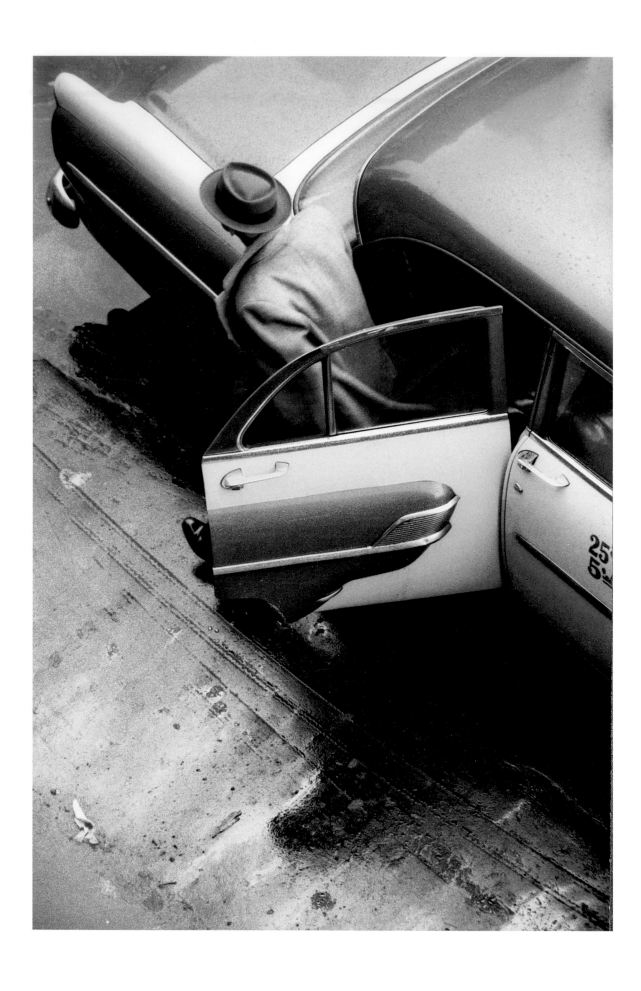

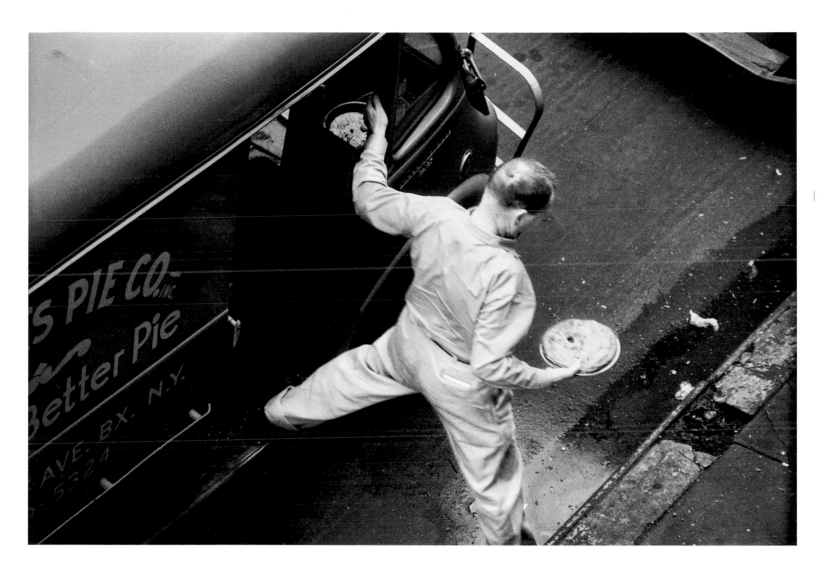

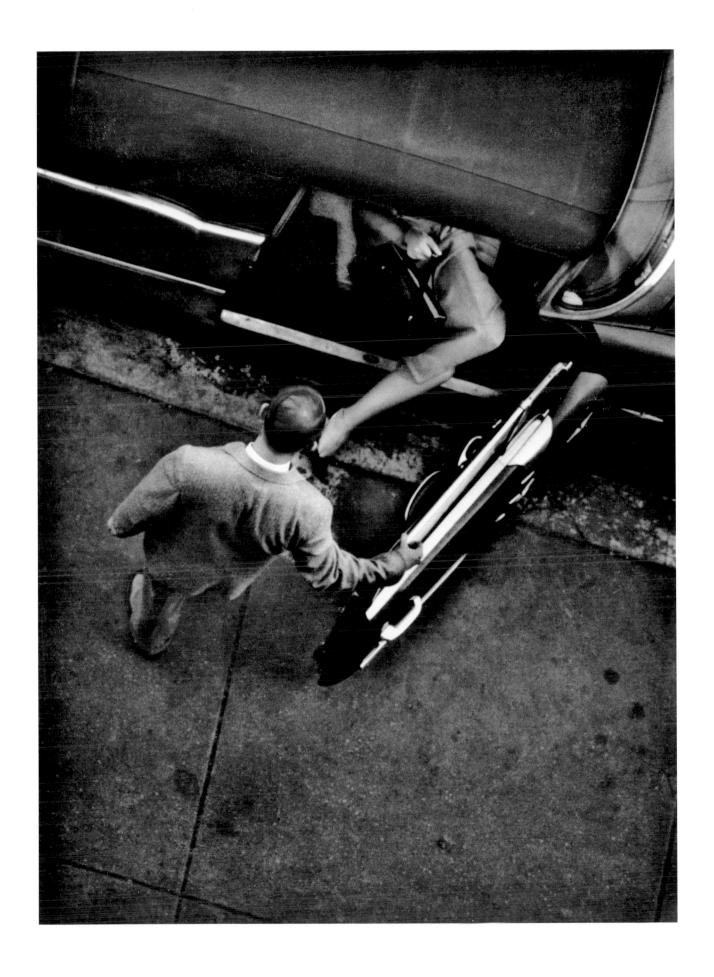

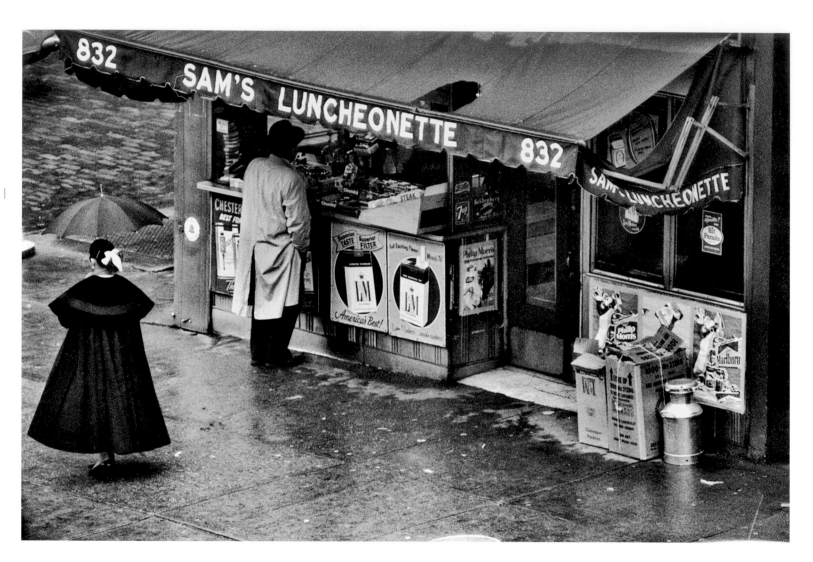

Jazz musicians spend a lot of time waiting. Waiting to get called for gigs, then waiting for the gigs; waiting for a pianist or drummer to show up; waiting for a turn to solo; waiting to get paid by a club or label owner. Bassist Bill Crow said, "There was a lot of idle time in the afternoons. We learned which museums and galleries were free, and we'd go look at art in the afternoons, when we weren't practicing."

The drug users also spent time waiting for a fix. In 1959 Jack Gelber's play *The Connection* dramatized this particular brand of waiting, at the Living Theatre on Fourteenth Street and Sixth Avenue, just fourteen blocks from 821 Sixth Avenue. The "connection" was a dealer named Cowboy, and jazz musicians—

Freddie Redd and Jackie McLean, among others—were languishing in the theater space, playing tunes to pass time and escape boredom. The loft could have served as the play's stage set, and Gelber sought to achieve a realism that broke down the boundaries between the stage and an audience in a manner not unlike Smith's fly-on-the-wall loft recordings. Loft musicians Ronnie Free and Frank Hewitt were stand-ins for *The Connection*, and Redd remembers the opening-night party for the play's cast and crew being held at 821.

In December 1959, Smith recorded Symphony Sid's radio show on WEVD, and he caught this mention of *The Connection:*

Ladies and gentlemen, have you seen *The Connection*? This is a play written by Jack Gelber. And a play with jazz featuring the Freddie Redd Quartet with Jackie McLean on alto. It's called "a play with jazz," the *Village Voice* explains, because there's a quartet onstage which provides lots of good jazz and lots of good acting. Of course, there are fourteen other people in the play. And this is the first production of any sort, not just theater, in which modern jazz is used dynamically to enhance dramatic action rather than merely decorate or sabotage it, with music written by Freddie Redd. The *Villager* says, "It's jazz of an exceptionally superior sort, almost alone worth the price of admission." And all the musicians are making their acting debuts. *The Connection* is now playing at the Living Theatre, Fourteenth Street and Sixth Avenue. And you can call for a ticket reservation at Chelsea 3-4569. Weekdays, *The Connection* starts at eight-thirty. Saturday shows are at seven and ten-thirty. And there's a Sunday show at eight-thirty p.m. The *New York Post* said, "Fascinating, a real gone slice of life that you won't find unless you know the right path."

The Living Theatre revived *The Connection* in 2009.

Over 20 top Critics say 'BRILLIANT'

THE CONNECTION (X)

Story JACK GELBER

Direction SHIRLEY CLARKE

MEN HELD CAPTIVE BY THE POWER OF DRUGS

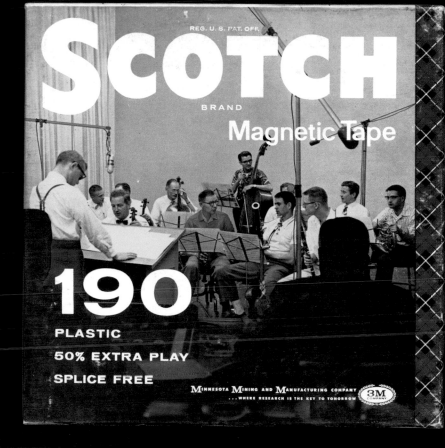

SCOTCH

BRAND

Magnetic Tape

REG. U. S. PAT. OFF.

190

PLASTIC

50% EXTRA PLAY

SPLICE FREE

MINNESOTA MINING AND MANUFACTURING COMPANY
...WHERE RESEARCH IS THE KEY TO TOMORROW

3M COMPANY

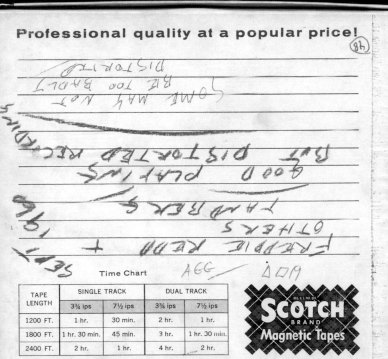

Professional quality at a popular price!

(48)

SOME MAY NOT
BE TOO BADLY
DISTORTED

GOOD PLAYING
BUT DISTORTED RECORDING

FREDDIE REDD +
OTHERS
TANDBERG

SEPT '60 AEG / 190

Time Chart

TAPE LENGTH	SINGLE TRACK		DUAL TRACK	
	3¾ ips	7½ ips	3¾ ips	7½ ips
1200 FT.	1 hr.	30 min.	2 hr.	1 hr.
1800 FT.	1 hr. 30 min.	45 min.	3 hr.	1 hr. 30 min.
2400 FT.	2 hr.	1 hr.	4 hr.	2 hr.

SCOTCH
BRAND
Magnetic Tapes
REG. U.S. PAT. OFF.

notice: Buyers shall determine that contents are proper kind for intended use. If defective in the manufacture, labeling, or packaging, contents will be replaced. There are no other warranties, expressed or implied.

Patented under one or more U. S. Patents: 2654681, 2694656, 2711901.

THE TERM "SCOTCH" AND THE PLAID DESIGN ARE REGISTERED TRADEMARKS FOR MAGNETIC TAPE MADE IN U. S. A. BY MINNESOTA MINING AND MANUFACTURING COMPANY.

September 1960.

Freddie Redd & others [recorded with a] Tandberg.
Good playing but distorted recording. Musicians on
this reel other than Redd are Gil Coggins, Ronnie
Free, Dudley Watson, and Zoot Sims.

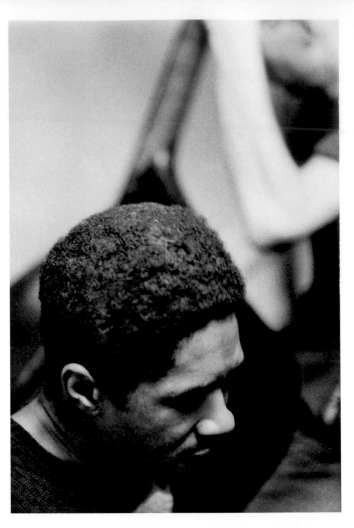

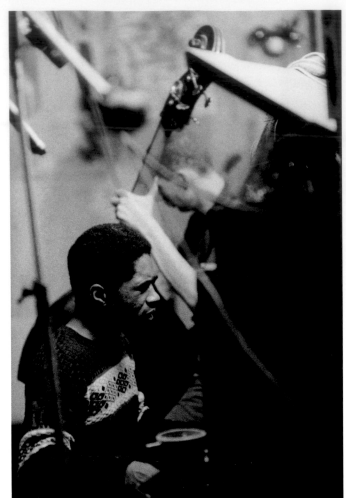

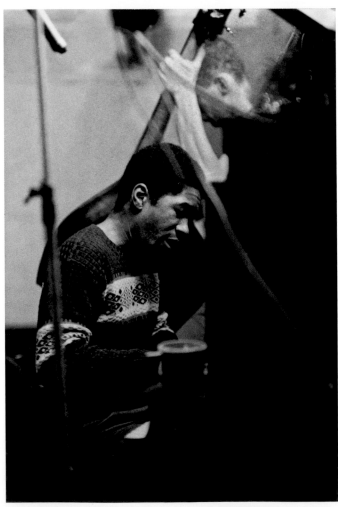

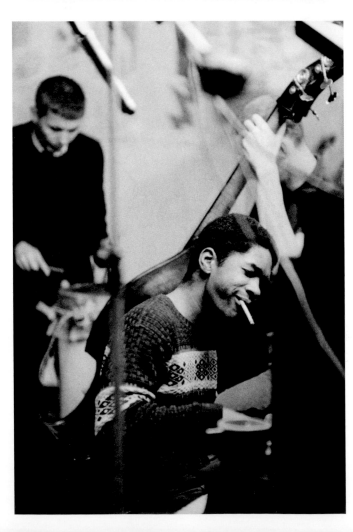

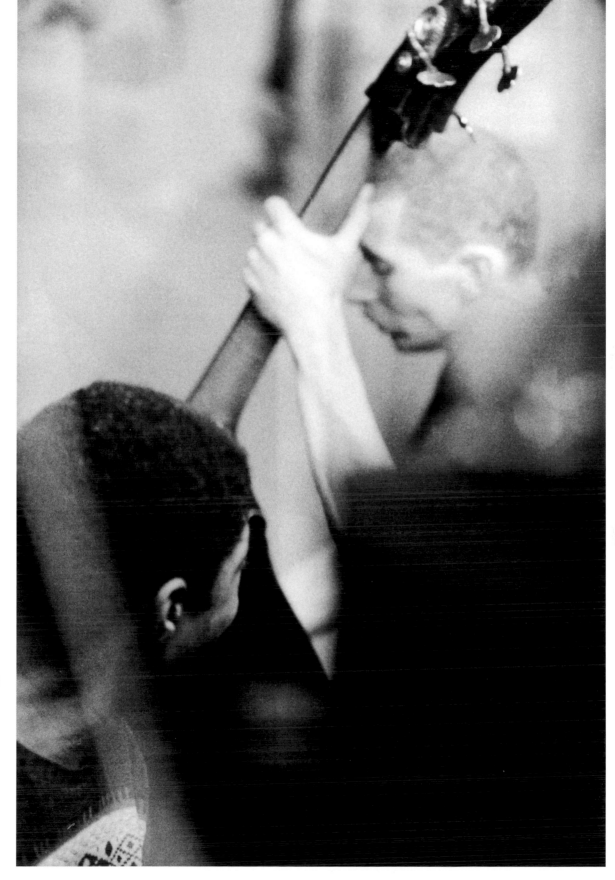

Ronnie Free (drums), Freddie Redd (piano), Bill Takas (bass). Takas lived on Bleeker Street in the West Village. He kept a Porsche automobile engine in his apartment for four decades, taking it apart and putting it back together over and over.

MARCH 3, 1961

RECORDING LOG

STUDIO_____ ENGINEER_____

MASTER INDEX NO._____ FILE SUBJECT_____

FOOTAGE	TRACK NO.	SPEED	SUBJECT TITLE	TIME	DATE RECORDED
TAPE (WITH)	(MOTTA)	LOW,	A DAY OF SPOT RECORDING		
			CAMERA 3 (ABOUT AFRICA, AND) THEN ORAL ROBERTS		
SOME WITH PIERCE,	CAROLE,		TO ED. G. ROBINSON IN A SEA MOVIE TO		
			TALKS OF JUVENILE DELINQUENCY, TO		
			OMNIBUS — 3 OR 4 PARTS OF PLAYS		
			INCLUDING — SHOTARD, TO IONESCO,		

ADDITIONAL PLAYBACK INFORMATION: TO BECKETS
KRAPS LAST TAPE
TO THE SANDBOX,
PERHAPS BEGAN OR ALL OF
SHIRLEY TEMPLE PROGRAM — THE MERMAID.

March 3, 1961.
A day of spot recording. Television programs
including televangelist Oral Roberts and a perfor-
mance of Samuel Beckett's *Krapp's Last Tape,*
among others.

March 3, 1961

Personal, portable recording equipment was a postwar invention, and a cultural fad. Full-page advertisements for this equipment were common in men's magazines such as *Playboy* and *Esquire*, and in general-interest magazines such as *Life* and *The New Yorker*. Smith had various recorders made by Ampex, Wollensak, Norelco, Uher, Hitachi, and Sony, a few donated by his friend and occasional darkroom assistant Will Faller.

The writer Samuel Beckett foresaw the implications of casually recorded time with his shattering 1957 play, *Krapp's Last Tape*, which concerned a sixty-nine-year-old man listening to tapes of himself—extemporaneous, private monologues—that he had recorded thirty years earlier. This play made explicit Beckett's lifelong literary enterprise, which endeavored to penetrate and expose, in his words, "that double-headed monster of damnation and salvation—Time—and its necessary corollary, Memory." Smith, who was fixated on theater, once proposed a photo-story on Beckett to *Life*.

On this reel, Smith describes some of his new recording equipment in the loft, in the company of his longtime friend photographer Bill Pierce and an unidentified man. On this same reel there is a recording of a performance of *Krapp's Last Tape* and of the televangelist Oral Roberts.

SMITH: You can hook onto this contraption out here, and then you set the thing so that when there's five seconds of silence the machine stops, and as soon as your voice picks up, the machine starts again. Which is very good, say, if you're trying to dictate a book or your voice and, you know, it's fifteen minutes between thoughts. Which was one of the reasons I never used tape in trying to dictate articles, because [of] such long breaches between thoughts.

UNIDENTIFIED MAN: That's a very clever idea. How quickly does it come in when you start speaking again?

SMITH: Before . . . well, actually it's hard. You're hard put to realize that you have had part of a word clipped, because it's really on the first syllable.

MAN: Is that so?

SMITH: You can adjust it so it's a half second or so before it stops, or otherwise I adjust it to five seconds for, you know, dramatic silences. But, unfortunately, or as far as I've been able to work it out, which was only an attempt to use it yesterday, is the fact that I'd like to, you know, say, have a mike hanging here and so it would be activated by, say, anyone in the room.

BILL PIERCE: You mean, you're Gene Smith, the photographer?

SMITH: No, I'm the recording engineer.

March 5, 1961

Two days later, on the same reel, Smith taped sounds from the show *Omnibus*, hosted by William Saroyan, on NBC television, Channel 4 in New York. This episode, titled "Fierce, Funny, and Far Out," features four segments of theater, from Beckett's *Krapp's Last Tape*, Eugène Ionesco's *The Killer*, Edward Albee's *The Sandbox*, and Saroyan's own *The Time of Your Life*.

Krapp, at age sixty-nine, near the end of the play:

Just been listening to that stupid bastard I took myself for thirty years ago, hard to believe I was ever as bad as that. Thank god that's all done with anyway. [Pause.] *The eyes she had!* [Broods, realizes he is recording silence, switches off, broods. Finally.] *Everything there, everything, all the—* [Realizes this is not being recorded, switches on.] *Everything there, everything on this old muckball, all the light and dark and famine and feasting of* [hesitates] *the ages!*

Krapp's voice continues for a couple more minutes, until he puts another old tape into his machine and begins listening to himself again:

I lay down across her with my face in her breasts and my hand on her. We lay there without moving. But under us, gently, up and down, and from side to side.

Past midnight. Never knew such silence. The earth might be uninhabited.

Pause.

Here I end this reel. Box [pause] *three, spool* [pause] *five. Perhaps my best years are gone. When there was a chance of happiness. But I wouldn't want them back. Not with the fire in me now. No, I wouldn't want them back.*

Krapp motionless staring before him. The tape runs on in silence.

Smith changes the channel to WOR-TV, Channel 9, catching Oral Roberts in a faith-healing ceremony:

Now, as always, I invite the members of our television audience to come forward and use my hand as their point of contact, to lay their hand upon my hand as I pray for healing. So, I invite you to come up now, just place your hand there upon my hand upon your television screen. Make a move toward God. Let this be a point of contact. God's able to heal you. Let's let our faith go as we pray. Are you ready?

December 1960

Television-show host Ed Sullivan makes an appearance on the Long John Nebel show on WOR radio. Smith's girlfriend and loftmate, Carole Thomas, said that Smith often taped Nebel's show, which aired from midnight to six a.m., for both entertainment and documentary purposes. In doing so, Smith captured a unique glimpse of the wee hours in postwar urban America—roughly the same hours that jazz musicians were heading home after gigs, or heading over to 821 Sixth Avenue to see if anything was happening. Often the topic of Nebel's show turned to UFOs and alien abductions.

LONG JOHN NEBEL: I want to ask you another question. This is probably something you'd never expect to be asked here, but have you any opinions on flying saucers?

ED SULLIVAN: On flying saucers?

NEBEL: Yeah.

SULLIVAN: I'm for them [*laughter*].

NEBEL: I think we should be fair, because Ed is not staying up all night listening to the Long John show. We have discussed the possibility of flying saucers with many people . . .

SULLIVAN: You say "possibility"; I was a little stronger than that.

NEBEL: And we've even had people on here that claim that they've gone to other planets, so it's sort of a stock question.

SULLIVAN: I know, I know all about that, but when we were—it reminds me—when we were in Russia doing our show in August, the embassy people there told us—the American embassy people—told us that there wasn't a single American tourist—now there

were twelve thousand at the time in Moscow—so there wasn't a single American tourist who didn't feel that from the time he disembarked or deplaned . . . at the airport that he wasn't being followed, or he or she were not being followed by secret police. And day after day they had just one man there who said, "No, it's because of your American clothes, the women's shoes, the silk stockings; they follow you because they are entranced by seeing this new wardrobe." I think it's about seeing something the same way—one night I thought I saw one, and then discovered I had my glasses on wrong [*laughter*].

NEBEL: So I was seeing with the one hole of my glass . . .

September 1960

Fidel Castro in a speech to the U.N. General Assembly, which Smith taped off the radio:

Much has been said of the universal desire for peace, which is the desire of all peoples and, therefore, the desire of our people too, but the peace which the world wishes to preserve is the peace that we Cubans have been missing for quite some time. The dangers that other peoples of the world can regard as more or less remote are dangers and preoccupations that for us are very close. It has not been easy to come to this Assembly to state the problems of Cuba. It has not been easy for us to come here.

If a being from another planet were to come to this Assembly, one who had read neither the *Communist Manifesto* of Karl Marx nor the cables of the United Press or the Associated Press or other monopolist publications, if he were to ask how the world had been divided, and he saw on a map that the wealth of the world was divided among the monopolies of four or five countries, he would say, without further consideration: "The wealth of this world has been badly distributed, the world is being exploited."

There is no use in going all over the question again. This is the substance of the matter, the substance of peace and war, the substance of the armaments race. Wars, since the beginning of mankind, have occurred for one fundamental reason: the desire of some to despoil others of their wealth.

January 8, 1960

Gene Smith and Carole Thomas are watching television, New York's Channel 2. The 1942 movie *Mrs. Miniver*, directed by William Wyler and with Greer Garson in the title role, is playing while Smith's tape recorder rolls. From another microphone onto the same reel of tape, drummer Tommy Wayburn is recorded noodling on the piano and muttering inaudible comments to himself.

Smith turns up the microphone for the following soliloquy from the movie. The scene is set in 1939 and the speech is made by a pastor at a bombed-out church in England.

The homes of many of us have been destroyed, and the lives of young and old have been taken. There is scarcely a household that hasn't been struck to the heart. And why? Surely you must have asked yourself this question. Why in all conscience should these be the ones to suffer? Children, old people, a young girl at the height of her loveliness. Why these? Are these our soldiers? Are these our fighters? Why should they be sacrificed? I shall tell you why. Because this is not only a war of soldiers in uniform. It is a war of the people, of all the people, and it must be fought not only on the battlefield, but in the cities and in the villages, in the factories and on the farms, in the home and in the heart of every man, woman, and child who loves freedom! Well, we have buried our dead, but we shall not forget them. Instead they will inspire us with an unbreakable determination to free ourselves and those who come after us from the tyranny and terror that threaten to strike us down. This is the people's war! It is our war! We are the fighters! Fight it, then! Fight it with all that is in us, and may God defend the right.

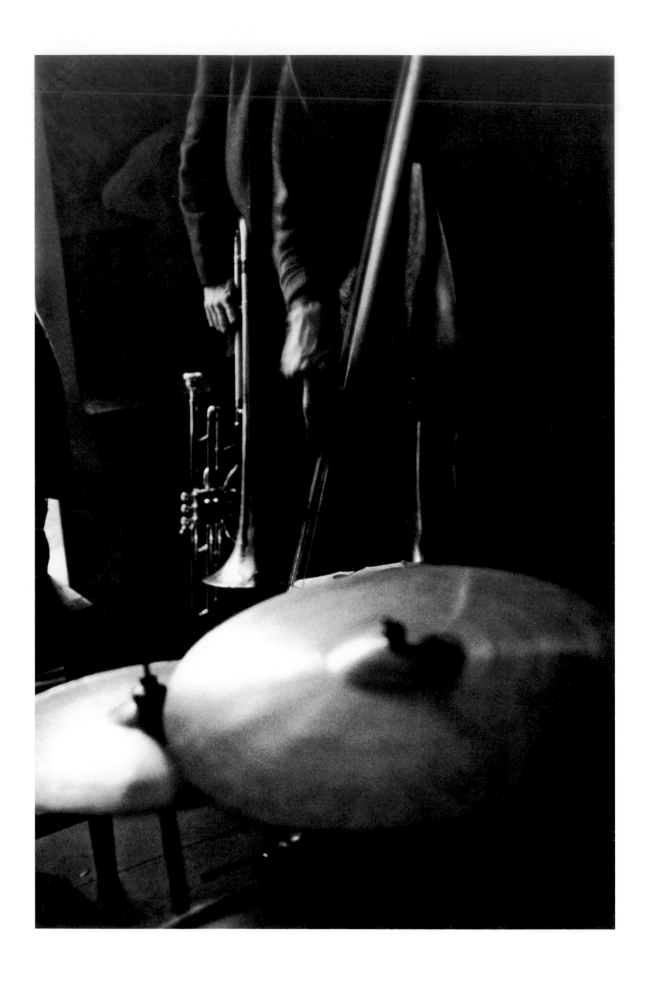

Lee Raney

November 1964

Former *New York Times* and *Time* magazine photo editor John Durniak, former *Popular Photography* editor Charles Reynolds, photographer David Vestal, and Smith are appearing on the WOR radio program hosted by James "the Amazing" Randi. Either the show was aired on tape delay or Smith had someone in the loft record the program live for him.

RANDI (*to Smith*)*:* There's another facet of your experience I didn't know about you, was music.

DURNIAK: Gene has also said this onstage, sometimes very poorly. He's not a very good speaker . . .

SMITH: Only when I get angry. Or too much Scotch. I mean, enough Scotch.

DURNIAK: He edits as music is written. He thinks of it as beats and moods and counterpoints and points as he can listen to a story. I'd like to hear one of his editing sessions sometime.

SMITH: But that's only as an underlying message of editing. But that helps me in keeping, sustaining mood, rhythm, and meaning. It helps me with the structure.

DURNIAK: If you follow this out logically, then Leonard Bernstein should be a good guy to work with you.

SMITH: Not at all, not at all. It has to be the music I hear, not music that is already composed and played. It is a feeling. This is no set piece of music I am punctuating. This is a rhythm and a feeling, a dramatic device that is helpful in doing an essay or laying out an exhibit or so.

DURNIAK: Do you hear this music when you're shooting the story?

SMITH: No, I hear other music [then].

REYNOLDS: Only you can hear it, right?

SMITH: And there's a certain singing going on inside while I'm working. And certain photographers apparently go into a subject and photograph and then do not know . . . get so emotionally involved in it . . . that they do not know what they have until they return to the darkroom. Now, I think I can get as emotionally involved in a situation as they can. But, I am almost aware of the final print when I am in the middle of a situation like that. And I certainly am aware of many facets. I will fool myself in, say, a slight degree . . . but basically the rhythm and the meaning of the picture is rather clear to me at that moment. . . .

But understand one thing about the music: that there is no evidence of it in a final layout or in a final exhibit. This is simply a device that helps me in my bringing it together with meaning. It may be felt . . . as paced relationships or of the graphic image when it is on the wall. It doesn't mean at all that I have laid this out according to a symphony, although it is the feeling of the contrast and meaning of the symphony that has helped me to do this layout.

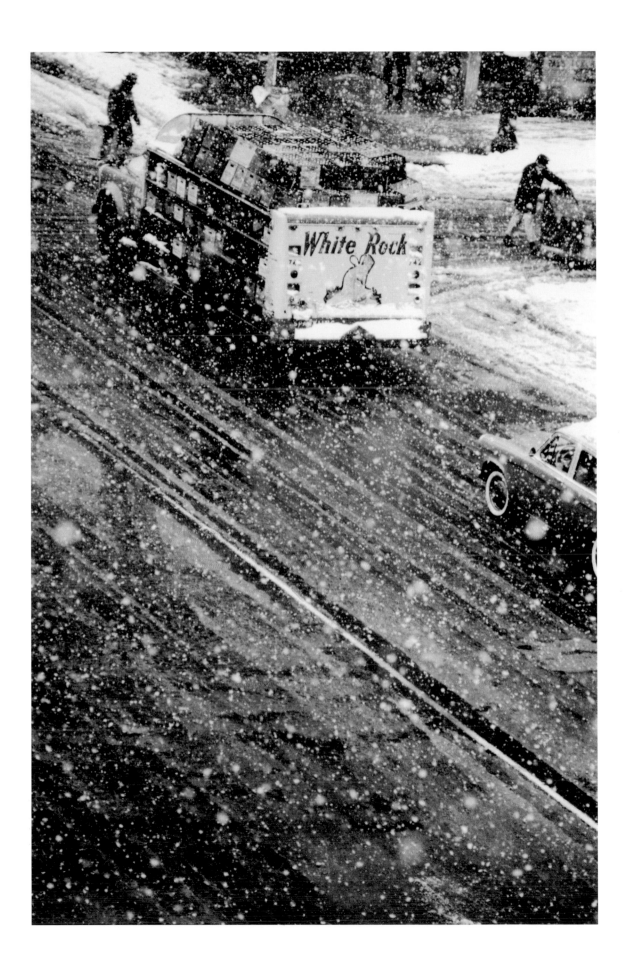

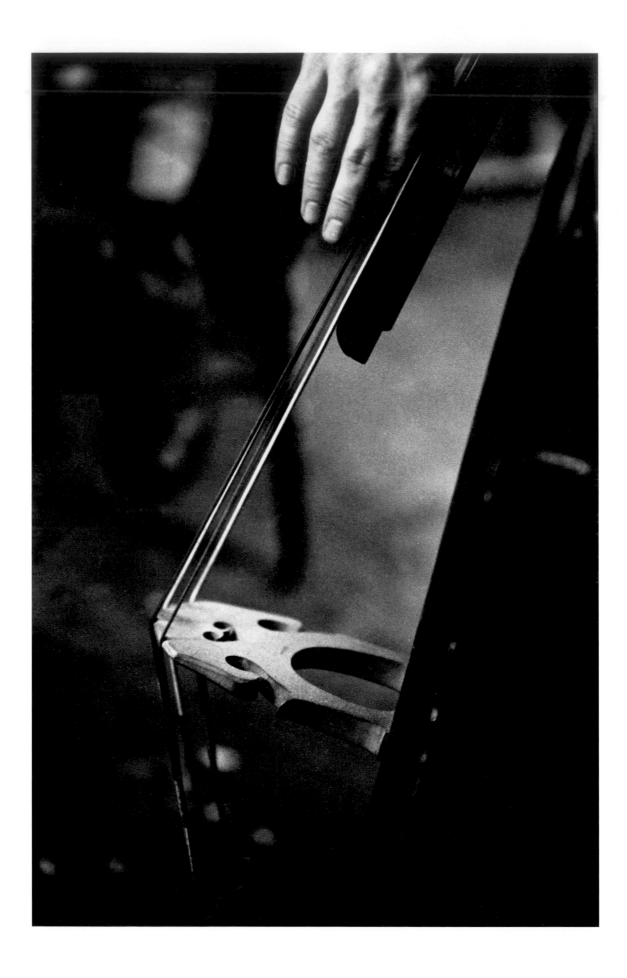

July 1963

Smith, Carole Thomas, and photo editor Charles Reynolds were in the loft preparing a mail-order course in photography.

REYNOLDS: I'll tell you some of the things we've been involved in this chapter. We've had a rather extensive discussion of the differences between the way the eye sees and the way the camera sees, which I think is something a lot of people are not aware of, and it is something to establish early in the game. We have the discussion of seeing in a frame and what's important is what can be seen within that frame visually.

SMITH: Yeah, but you've got to establish a philosophic outlook before you go into that. You've got to strike at the very beginning and it's got to be their challenge to grow, their challenge to see. We have no formulas. We can help give them questions to help them walk, but that is all.

I've learned more about photography from music and literature than I have from anything else . . . as far as the idealistic stimulation for seeing.

REYNOLDS: Could you write up a little paragraph on this? You've written this somewhere surely?

SMITH: Oh, I've mumbled it many times.

REYNOLDS: Of course, just to say this is one thing, but in some way if you could give an indication of *how* these things had stimulated you, rather than just saying they did, I think it would be even stronger.

SMITH: You can't outline it. You can't build a fancy framework. Like Paula [a student of Smith's], who keeps plugging me, angry, becoming now really bitter to me because I can't give her that secret. But she is sure I'm keeping one little thing from her somehow. That [Eugene] O'Neill quote is the best one for that. I can't remember it well enough to quote it. I'm just going to call him up for it one of these days.

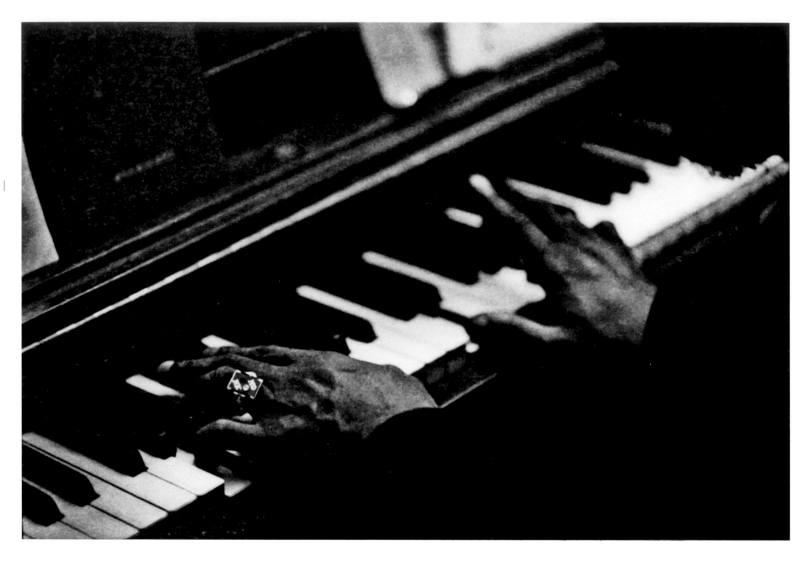

Thelonious Monk. Most music (except voice) is made with the hands, and Smith was drawn to this quality, finding it comparable to handcraft in photography, especially his intricate darkroom work.

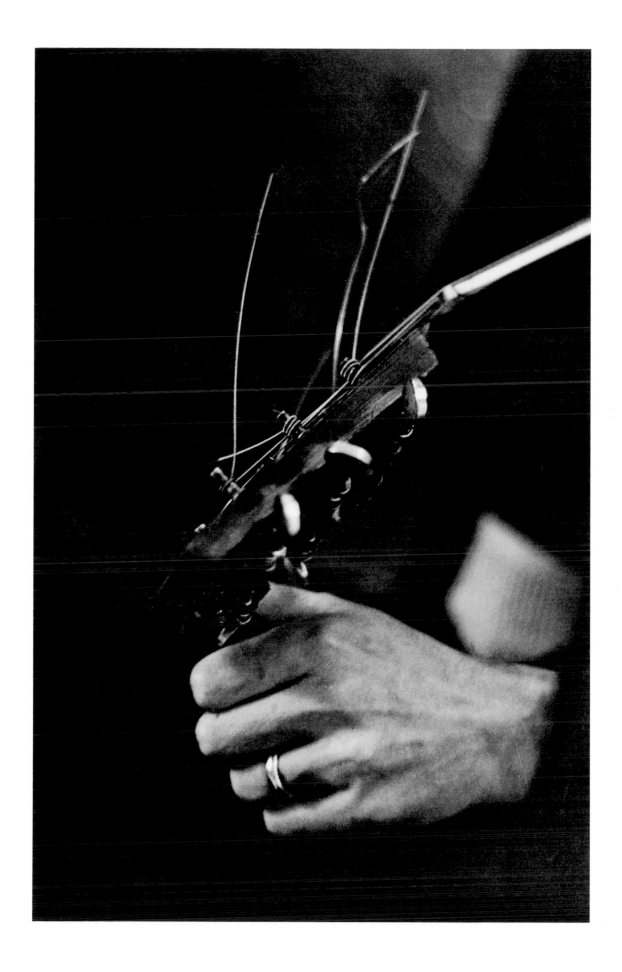

Jim Hall

Bob Brookmeyer

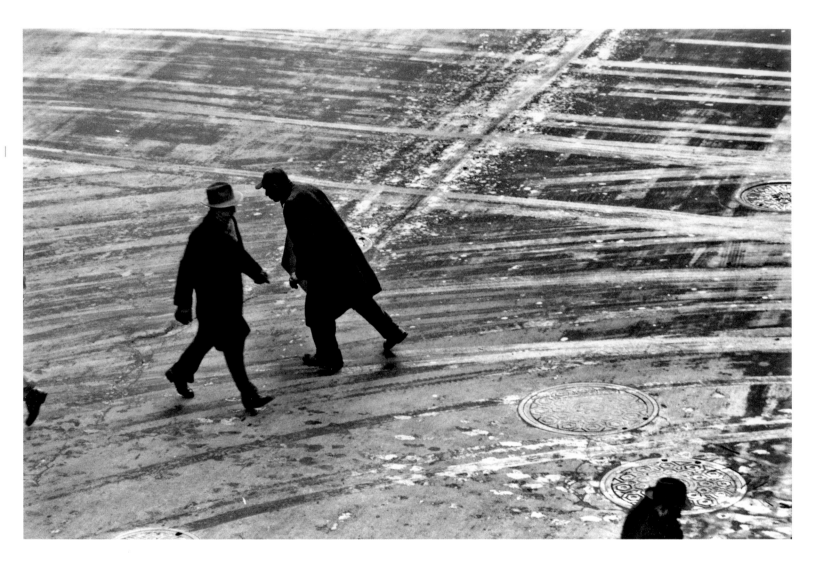

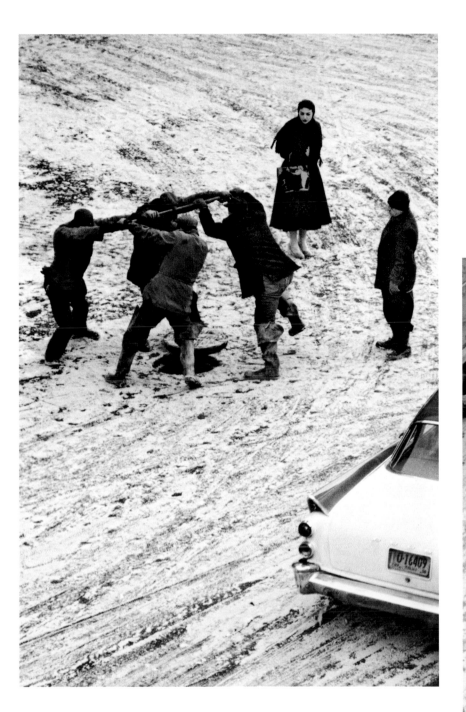

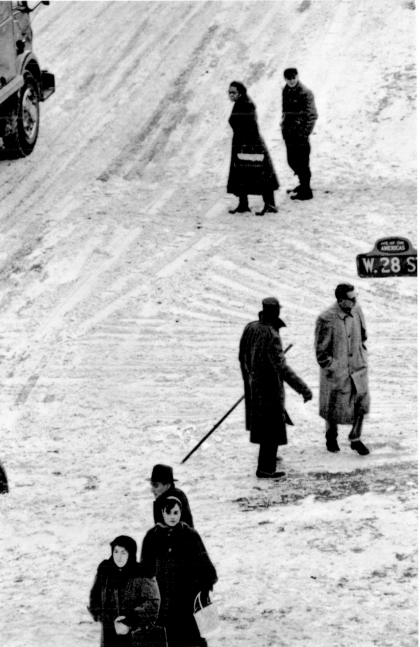

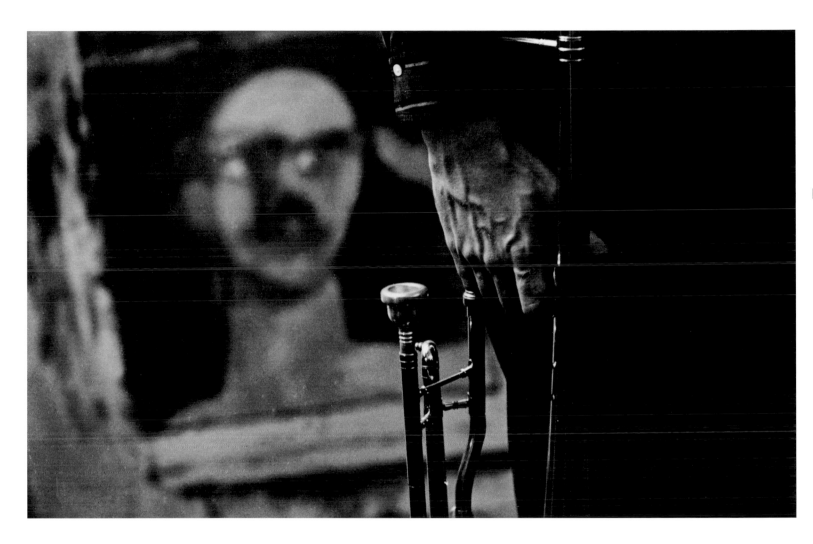

Opposite: Bob Brookmeyer, Smith's reflection.
Throughout his career Smith shot an unusually
large number of vertical photographs with his
35mm camera, perhaps influenced by his back-
ground publishing in magazines with a vertical
orientation.

Arthur Taylor, drummer. The drawback of being a
drummer or pianist at a jam session is potentially
having to wait your turn at the chair, whereas
horn players can blow one after the other.

Anatomy of a Jam Session

Those jam sessions may have been more fun to play than they are to listen to.
—STEVE SWALLOW, 2008

This sounds like one of those planned sessions; one of those sessions that was organized. Somebody would call around and try to get certain musicians to be there.
—HENRY GRIMES, in my rental car riding around downtown Los Angeles, 2003

January 4, 1964

Multi-reed player Roland Kirk, saxophonist Jay Cameron, drummer Edgar Bateman, and bassist Jimmy Stevenson are on the fifth floor of 821 Sixth Avenue:

"I called Chick Corea."

"Who was that tenor player?"

"Paul Plummer?"

"How does he play?"

"Good."

"I just talked to Don Cherry. He said he's coming."

"Maybe he's wrong. It's four o'clock in the morning."

"I'm sure he'll be here."

"I know a piano player who I bet would like to play, Bob James, you know, Bobby James from Detroit?"

"Yeah, he's a good player."

"You got his number? Call him, man."

"This is the place that was upstairs, right? I remember those stairs. Hmmm, this is very emotional for me to hear. Ahhhh, listen to Zoot. That melody . . . nobody plays melody like Zoot anymore. You know, I once tried to hire Zoot for my quartet and he was away. He was on the road. I always regretted that didn't work out."
—drummer **ROY HAYNES,** in Durham, North Carolina, 2005, listening to himself playing the tune "Indian Summer" in the loft in 1960 with Zoot Sims on saxophone, Dave McKenna on piano, and Eddie De Haas on bass

"I think Roy and I were at the Five Spot that night. I think we went to this loft after playing at the Five Spot."
—EDDIE DE HAAS, in Chicago, 2005. De Haas and Haynes had been playing in pianist Randy Weston's trio at the Five Spot.

"It was freewheeling, I mean the music was freewheeling. But there was a social undercurrent, like a sense that this was an audition. I felt that it was more of an audition, and it was a very hard place. I

didn't feel any love or softness there. I felt that in the music there was the love of the music, and the love among musicians, but you really had to be a pretty extraordinary player to get to play the second tune."

—ROBERTA ARNOLD, artist manager

"The standard American songbook was a key ingredient of the sessions. You had to have a common repertoire. If you didn't know tunes like 'I Got Rhythm' and 'Indiana' you couldn't make it in those sessions. But in the 1960s the 'everybody is creative' hippie movement really changed things. Nobody had the common repertoire anymore. Nobody knew the standards."

—bass player **BILL TAKAS**, 1998, in the Bleecker Street apartment where he'd lived since the 1950s. He died a few months later.

"Over time we got so jaded with the session scene. We were sick of every tune. Freddy and I would sit around and try to think of tunes we weren't sick of."

—RONNIE FREE, 2003. He lived at 821 Sixth Avenue and participated in countless jam sessions with saxophonist and part-time loft resident Freddy Greenwell from 1958 to 1960.

August 13, 1963

Trumpeter Don Cherry, multi-instrumentalist Eddie Listengart, bassist and sometime piano player Vinnie Ruggiero, unknown drummer who probably is Earl McKinney, and bassist Jimmy Stevenson, on the fifth floor of the loft:

LISTENGART: Are you using the same chord this many times leading into the third? Is that right?

CHERRY: Yeah, you just augment it, 'til you can play open, so you can play all the open things, like you dig it, it's like a cycle. [*Cherry demos on piano.*]

UNKNOWN: Let's just play, man, fuck it.

STEVENSON: "Softly, as in a Morning Sunrise."

UNKNOWN: Let's play some blues so Vinnie can play piano.

"You know, I hear on one of these sessions Zoot is playing and for some reason he stops for a number of bars, and the trumpet player Don Ellis starts to play. And Zoot says something like, 'Wait a minute. I'm not finished.' And he comes back and plays some more. That kind of thing wouldn't happen in a club."

—alto saxophonist **LEE KONITZ**, 2002

"This sounds like a drummer who wasn't sure of himself. This sounds like a drummer who is trying to figure out what to play."

—BEN RILEY, 2006, hearing himself playing in the loft in 1964 with Thelonious Monk's band

"I just went to the front of the line and said, 'I'm here. Can I sit in?' I thought I was as good as anybody in the room, and I kind of projected that. People were taken off balance, but I knew what I was doing."

—JANE GETZ (no relation to Stan Getz), 2009, a piano prodigy who was fifteen years old and five-foot-two, under one hundred pounds, when she found her way to 821 Sixth Avenue in late 1963 after dropping out of high school in Texas

"There was one night when I believe Monk and Pee Wee Russell first played together. Monk was playing with a group, and Pee Wee was sitting quietly in the back of the room. After a while Pee Wee suddenly got up and started playing his clarinet. It surprised everybody. It was like somebody had thrown a javelin across the room."

—saxophonist **LEROY "SAM" PARKINS**, 1999

Christmas Eve, 1959

Zoot Sims, pianist Mose Allison, saxophonist Pepper Adams, bassist Bill Crow, and others in the loft:

"Come on, Mose, one more tune, just one more."

"I have to make it home. It's Christmas Eve."

"It's actually Christmas Day now."

"We won't have a piano player if you leave."

"One more, come on, just one more."

June 3, 1960

Smith recorded actress Claire Bloom reading from Joseph Bédier's novel *The Romance of Tristan and Iseult* on WNYC's radio program *Spoken Word* at eleven o'clock in the morning. This passage corresponds with comments in 2008 by Smith's son, Pat: "The loft became my father's world. I'm not sure if he was king of that world, or just a citizen."

In her British brogue, Bloom reads:

On the appointed day he waited alone in his chamber and sadly mused: "Where shall I find a king's daughter so fair and yet so distant that I may feign to wish her my wife?"

Just then by his window that looked upon the sea two building swallows came in quarreling together. Then, startled, they flew out, but had let fall from their beaks a woman's hair, long and fine, shining like a beam of light.

King Mark took it, and called his barons and Tristan and said: "To please you, lords, I will take a wife; but you must seek her whom I have chosen."

Tristan, when he looked on the hair of gold, remembered Iseult the Fair and smiled and said this:

"King Mark . . . I will go seek the lady with the hair of gold. The search is perilous and it will be more difficult for me to return from her land than from the isle where I slew the Morholt; nevertheless, my uncle, I would once more put my body and my life into peril for you; and that your barons may know I love you loyally, I take this oath, to die on the adventure or to bring back to this castle of Tintagel the Queen with that fair hair."

What Happened to Ronnie Free?

"I was thrilled to have Ronnie working with me in my trio at the Hickory House in 1959 or 1960," says the pianist and radio-show host Marian McPartland, who studied with Hall Overton at 821 Sixth Avenue. "He was considered the great young hope among drummers on the scene, a really wonderful player. He had a different style, more swinging, very subtle. Free is a good name for him. He didn't play bombastic solos like many drummers did. Ronnie was one of the best I ever saw. Then one night he just disappeared. We had a gig and he didn't show up. Nobody saw him after that. Thirty or thirty-five years later, in the early 1990s, I was walking down the street in Columbia, South Carolina, and I couldn't believe my eyes, but Ronnie Free was walking right toward me, looking exactly the same. My first words to him were, 'What happened to you that night you didn't show up for the gig?' "

The short answer is that earlier that day Free was committed to the psychiatric ward at Bellevue Hospital by police. They found him wandering through the streets erratically, virtually daring cars to run him over.

The longer answer could be a movie or novel. He got out of Bellevue in mid-1960, took a train back to his hometown of Charleston, South Carolina, kicked a dangerous drug habit, and never returned to New York. He had somebody ship his drums to him from 821 Sixth Avenue, where he'd lived in Eugene Smith's fourth-floor loft space for two years. He pawned his drums and didn't play music for more than twenty years. He ended up in San Diego driving a cab for a decade. "It's astonishing that he could just stop playing like that," said the late bassist Sonny Dallas. "I mean, we are talking about a phenomenal musician here." But he saved his life.

Today, Free is seventy-three years old and lives in Hot Springs, Virginia. For fourteen years he has been playing waltzes and slow dance numbers at The Homestead, a resort founded in 1766 around seven natural springs deep in the Allegheny Mountains near the West Virginia border. It is a comfortable gig in a beautiful setting—the house musicians live in quarters provided by the resort—but it is a long way from the hot New York scene of the late 1950s, where Free was sought after by many prime bandleaders. Yet, Free is content. He has no regrets, no bitterness. He rarely mentions his former reputation, and many of

Ronnie Free (drums), Zoot Sims (sax)

his current friends are unaware that Free's drumming is credited with driving some of the greatest sessions at 821 Sixth Avenue. They don't even know he used to play in New York at all. Free doesn't own copies of the records on which he played. In his room the only clue to his jazz past is a small magazine picture of Miles Davis taped to his wall. Free seems genuinely surprised and embarrassed when told of the fond memories other musicians have of his playing fifty years ago. He says he is surprised they remember his name at all.

Despite a twenty-year age gap, Free and Eugene Smith were united by lamentable childhoods—Smith's father committed suicide; Free's father abused him physically and emotionally—and mutual desperation. Both dropped out of school as teens (Smith after his freshman year at Notre Dame, Free from high school) to be full-time professionals. Free was the drummer for a strip show in a traveling circus, the Royal American Shows, before finding his way to Staten Island and eventually to 821 Sixth Avenue. Smith and Free were both down and out when they met in the loft, battling severe substance addictions. Free gave Smith access to his drugstore connection, and Smith gave Free a place to stay. "Gene and I swapped goodies," Free says. "My favorite amphetamine was a little white pill called Desoxyn, which I shared with Gene. Gene gave me what he called 'psychic energizers' [given to Smith as antidepressants by the famous psychiatrist Nathan Kline]. In those days if I found a pill on the street I'd pop it in my mouth without even knowing what it was. At one point I was taking about a hundred amphetamines a day. I'm lucky to be alive. I was a neurotic, screwed-up mess. I was virtually homeless. The only things I owned were my drums and the clothes on my back. Gene was generous enough to let me stay. And he was in a similar situation as me, trying to get everything back in order."

The pianist Dave Frishberg found his way to 821 Sixth Avenue soon after moving to New York from Minneapolis, against the wishes of his parents, who wanted their son to be a doctor or a lawyer—to live the straight life. He credits playing with Free in the loft as helping affirm his decision to be a professional musician. "Ronnie had a certain raw, instinctive, profound musicianship that was overwhelming and inspiring," says Frishberg. "There was one night in particular when we played deep into the night. Ronnie and I achieved this remarkable rapport for several hours. It was one of the most nourishing musical experiences of my life. I went home feeling good about being a musician, glad to be playing with big leaguers."

On the afternoon of August 11, 1958, Ronnie Free received word that musicians were to congregate the next morning in front of a brownstone on 126th Street in Harlem for a historic group portrait. The photograph was to be published in an upcoming *Esquire* magazine issue devoted to jazz. On August 12 Free rolled out of bed—Smith's reclining chair—and headed up to 106th Street, where he met his friend and occasional bandmate pianist Mose Allison. The two men walked up to the designated address, but when they arrived the photographer Art Kane had already snapped the now famous shot of fifty-seven assembled musicians on the steps and sidewalk. The photograph included such icons as Thelonious Monk,

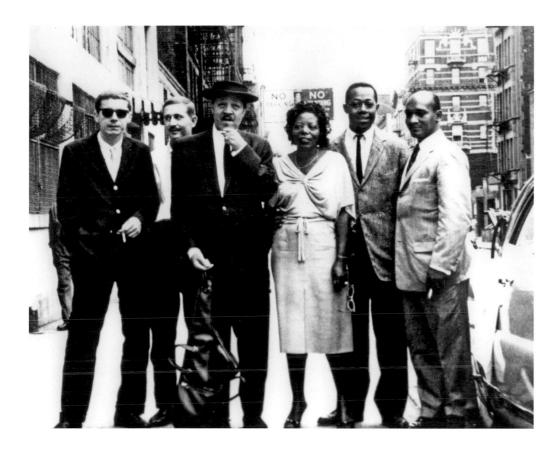

Ronnie Free, Mose Allison, Lester Young, Mary Lou Williams, Charlie Rouse, Oscar Pettiford. Photograph by Dizzy Gillespie. Courtesy of Dale Coleman.

Count Basie, Dizzy Gillespie, Coleman Hawkins, Pee Wee Russell, Charles Mingus, Gerry Mulligan, and Sonny Rollins. Filmmaker Jean Bach made an acclaimed documentary about the photograph in 1994, *A Great Day in Harlem*, and posters of the image sell around the world.

As the musicians dispersed on that "great day," Free and Allison mingled on the sidewalk. Dizzy Gillespie took their picture alongside Lester Young, Mary Lou Williams, Charlie Rouse, and Oscar Pettiford. For Allison, who in five decades has recorded a career that's made him a legend, Gillespie's obscure snapshot is a souvenir. For Free the picture is a tangible reminder that he was once a rising star in the jazz world.

But better evidence is found on Smith's tapes. Free's drum work in the loft is documented on more than one

hundred reels—at least two hundred hours of recordings—playing with the likes of Gerry Mulligan, Paul Bley, Freddie Redd, Gil Coggins, Sonny Clark, Warne Marsh, Henry Grimes, Zoot Sims, Eddie Costa, Hall Overton, Pepper Adams, and dozens more, including obscure figures such as Freddy Greenwell and Lin Halliday. Particularly memorable is one night in 1960 when Free shared the drum set with Roy Haynes.

"These your drums, Ronnie?" Haynes asked.

"Yeah, man. Here are some sticks."

March 24–25, 1960

Gene Smith is in the loft talking with saxophonist Zoot Sims, pianist Bill Potts, and drummer Ronnie Free, who has lived in the loft for roughly two years by this time. Potts is noodling around with notes on the piano keyboard.

SIMS: Do you dig these fucking wires and mikes, man?

POTTS: I like this. I like this pad, man. I want to get a pad like this.

SIMS: Yeah, well let's move in . . .

SMITH (*screaming in protest*): ARRRRRRGGHHHHHH!

FREE: I'll probably be moving out before long.

SIMS: You gonna be moving out? [*Then, to Smith:*] He's been with you all the time, man?

SMITH: Ever since I made the mistake of inviting him in for a couple of hours.

POTTS: Then he stayed for a few years, huh?

FREE: Shit, I ain't got no watch [*laughter*].

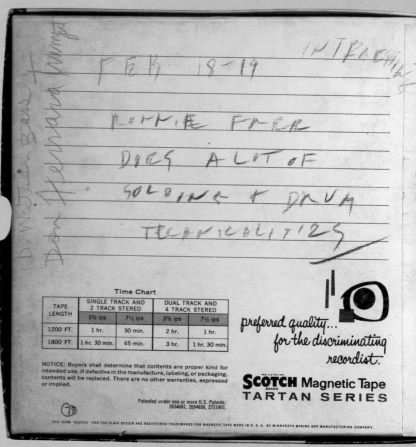

February 18–19, 1959.

Ronnie Free does a lot of soloing & drum

technicalities.

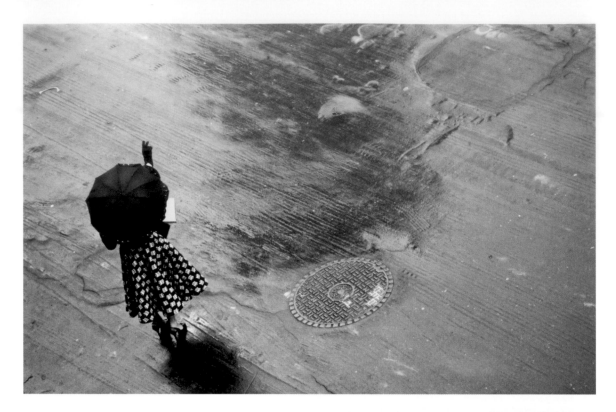

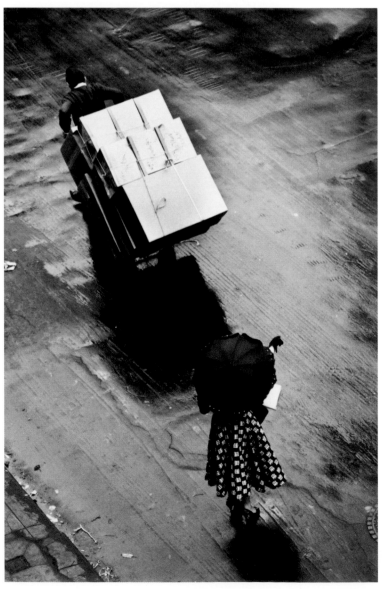

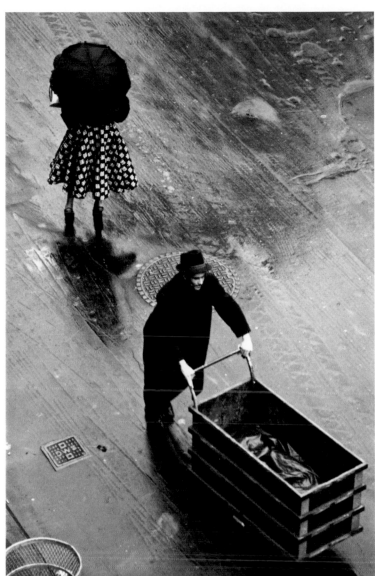

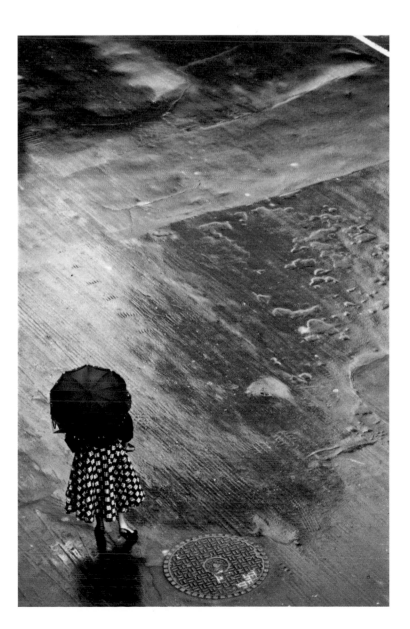

122

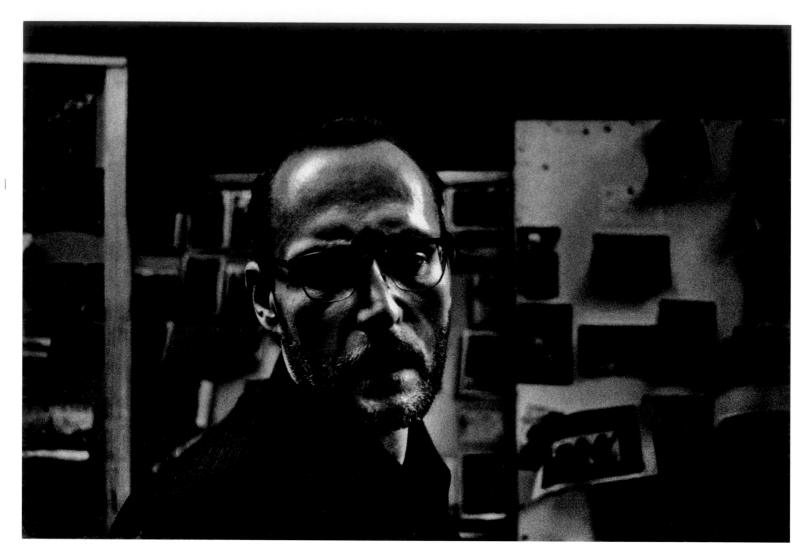

"They say all photographers are voyeurs. So part of it is to look; part of it is to eavesdrop. And I also think Gene had a sense of history. There's always a major project in the back of his mind."
—**HAROLD FEINSTEIN,** photographer and Smith's longtime friend and sometime assistant, 2005. Feinstein lived at 821 Sixth Avenue from 1954 to 1957, when Smith took his place on the fourth floor.

May 1961

Smith sent a telegram to Long John Nebel's late-night radio program. At approximately four-thirty a.m., he taped the program on which the telegram was read.

LONG JOHN NEBEL: I have a telegram here . . . from . . . This is a long one, too; in fact we're making bets on what it cost. And in starting to read the first paragraph I didn't know whether we would even get a chance to read it, a long one that's true, but then I wanted to find out who sent it, and this without a doubt was sent to us by one of the top photojournalists in the country. I know he listens from time to time, and he's Eugene Smith. He's without a doubt one of the finest photojournalists in the country. I have not even read the telegram, and naturally in order to do it justice I should read it through once or twice, and if I do that because of its length— would you please, Jim, thank you—I won't even have a chance to do it prior to getting off the air. Well all right, we'll take a chance on it, Anna.

ANNA *(Nebel's producer):* Well, I'll try it. [*Reading Smith's telegram.*] "First, believe my respect for medicine as one of the great professions. Secondly, let me harp on a point or two, and I hope Western Union does not transpose the word 'harp' in this particular sentence. It should easily be known that adequate medical facilities are not available to a great many persons in some parts of this country. Some of these areas I personally know from having walked and ridden and worked with and pitied those who are lucky enough to be visited in what was a maximum of even being noticed.

"I have also seen a baby brought to a medical center highly fevered and dehydrated and needing an immediate transfusion, for which the relatives"— I imagine there's a word left out there—"inadequate in blood, were told that they would have to find a way, forty miles out, to where they were acquainted, and forty miles back with a blood donor if one could be found. Also arose a resentment of me when I stepped from my role of photographic journalist to give the transfusions. A resentment in this particular instance because the child was Negro. However, this is not racial. For in a respected-name hospital in this our great-name city I too had to commit 'malpractice' and to 'coerce' the one overworked nurse. And when she tried to stiffen the rules, attempting surprise at my still being there when a doctor arrived at midnight to visit the patient I was interested in, I had to re-coerce—or more kindly and probably more accurately in the emergency of the circumstances—to convince the doctor it was acceptable for the nurse to allow me to stay and aid through the night with the patient, and so I stayed. My medical knowledge being based upon my journalistic experiences, a lifetime interest, and the fact of having been shot up during the war, I stayed giving glucose injections and blood transfusions as well as constantly checking such as the drainage tubes making certain they were not causing poisons to dam up in the critically ill patient. The nurse took a chance because she was desperate, without help. The doctor took a

chance because he knew something of my background and he knew as well as I that hospital ethics in such emergency would have listed the death of the patient under the heading of 'unforeseen complications.' Rather than face the scandal of what it was necessary for the three of us to connive in so that the patient might live. (I can almost feel the itch of some of my fellow journalists on certain publications.) It was gambling for the life of the patient with two or possibly three careers directly at stake and with the reputations of the hospital as well. Yet if man at times is not willing to gamble reputation and future that there may be life or if a good name must be maintained at the cost of lives, my conscience would be heavily burdened with conflict. Please, where the wrong is, I am not fully prepared to enter into, and I must make clear that I reluctantly would have understood if the doctor and nurse had insisted upon playing by the same rules, even if it had cost the life of this person close to me. It was a dilemma not of their making. I am simply concurring in my belief that much advance must be made within our medical system and with a slight carping at too early a dismissal of the vast need for conscientious general practitioners and that good medical aid is often more a theory than a fact.

"In fact, in those years since I was shot up, and since the doctors who originally worked on me have died, I have had a most difficult time trying to find medical treatment for conditions from the injuries which still plague me. And I have been fortunate

in personal advice as to who to go to from medical friends well thought of in high places. It is all difficult, and though I can wend my way with some understanding and appreciation of these difficulties, it must be terribly bewildering to the outsider. But I still give deepest honor to the profession of medicine and have sympathy with its problems as long as its practitioners refrain from cold-blooded arrogance. Arrogance is not a fault of your panel tonight, for their apparent sincerity comes over quite strongly. Warmest regards, and I hope this telegram is easier to read, W. Eugene Smith." Any comments?

DR. GUEST 1: Very, very fine. He describes a man in anguish at the time of his ordeal, obviously, and the need for warmth in the practice of medicine and for the need for more general practitioners as we mentioned earlier.

DR. GUEST 2: Oh, no one would deny this, indeed.

DR. GUEST 3: Also, it does mention one aspect that we haven't touched on. There are areas of the country where it is impossible for a doctor to be ethical in the highest possible standards, because if he is going to be ethical he has to sneak his way to do it. I mean, some sections of the South, and not only in the South, I mean a couple of other places as well as the South where if a doctor uses the best medical practice on some patients he will literally be run out of town. If he makes a transfusion, not just from a Negro, but from in some places a Mexican, or in certain sections a man who is Chinese, or things of that nature, he would be in trouble.

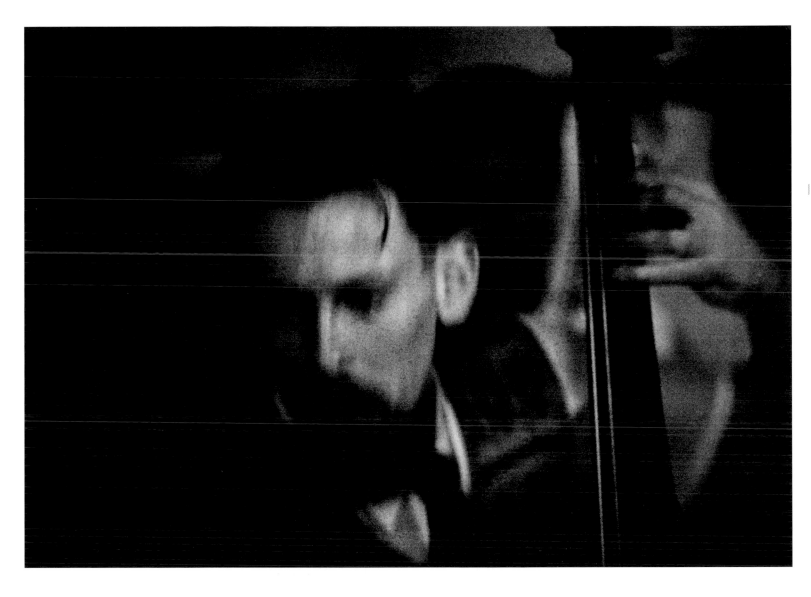

Peter Ind

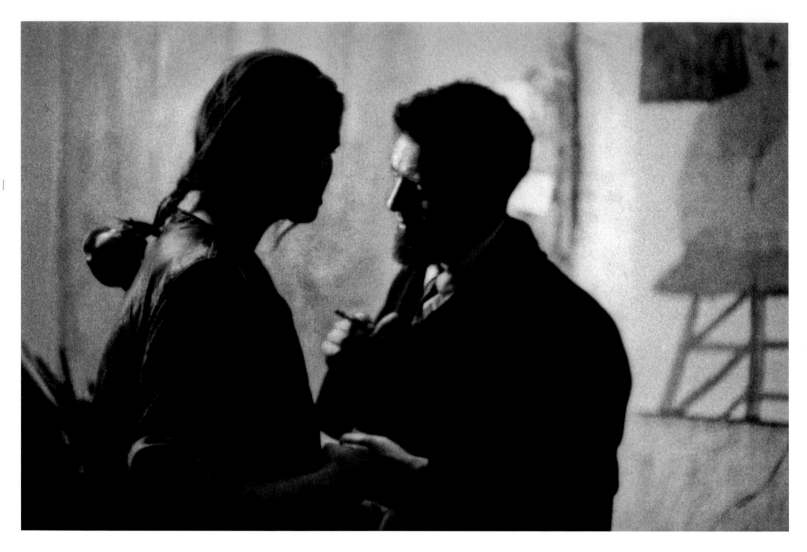

Gretchen Moynihan, Norman Mailer

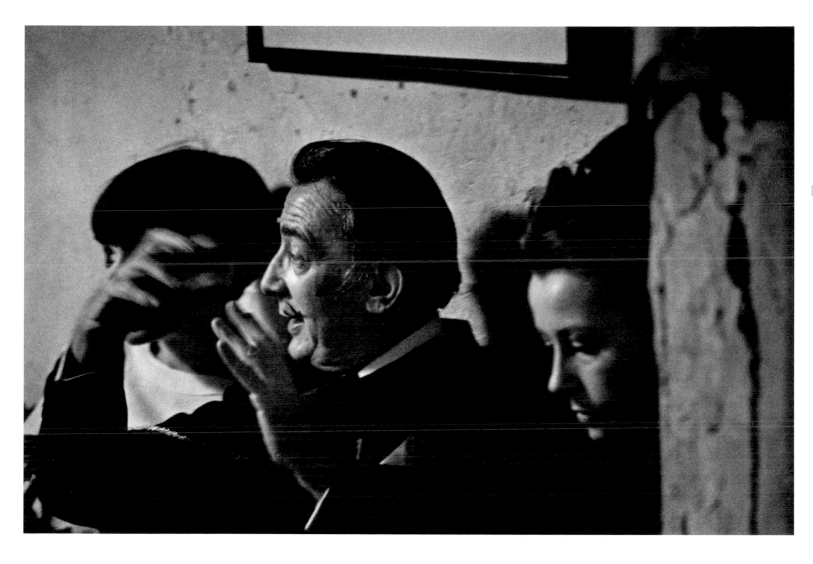

Salvador Dalí

Albert Ayler

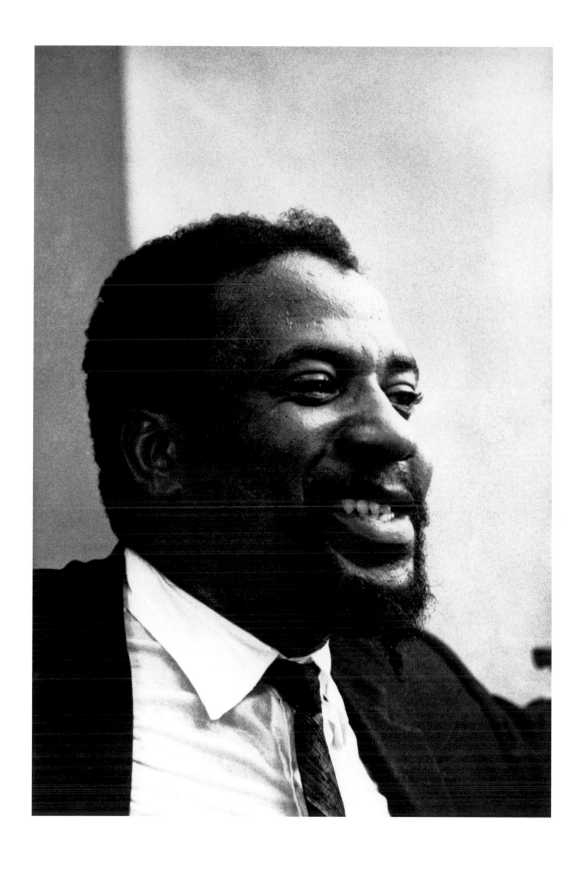

Thelonious Monk

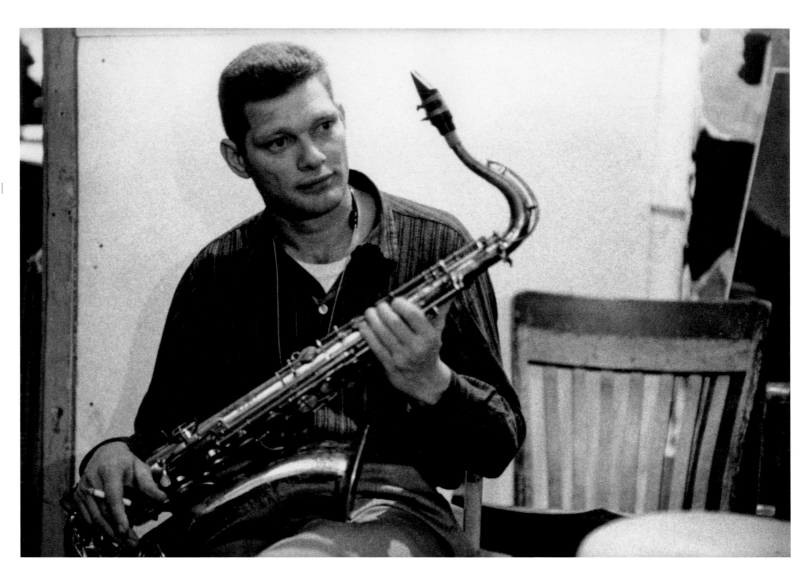

Zoot Sims

January 1964

Several unnamed musicians and a woman are taking peyote and smoking marijuana in the loft. Gene Smith walks in on them at the end.

The group is speaking of the 1963 Miles Davis album *Côte Blues*.

"Herbie [Hancock, pianist] sets the tempo there, whatever he does, then right from there it's outside and each soloist picks his own tempo."

"You mean everybody picked it at a different tempo?"

"Yeah, it's anybody's solo, what they want to do, really, is, like in 'Stella by Starlight,' George Coleman [saxophonist] plays it in one tempo and everybody else plays it in another on substitute changes."

Man whistles in awe. "Wow, they must be really exploring the possibilities."

"Oh, it's the freest thing I've heard."

. . .

The group is looking down from the window of the fifth floor of 821 Sixth Avenue.

"Do you know, hey, do you know what this reminds me of? As if I'm a doctor, or somebody, looking in a goldfish bowl, or something. Like we are all doctors here, and we're studying these people. Oh, they're like mice, or . . . they're just like us, bastards. They aren't as hip as us. Right now. They ain't got a chance. They stay fucked up on corned beef and shit. They don't know."

. . .

"Does anyone want coffee? I have some change, but I gotta keep subway fare."

"Hey, we gotta get some pot. I'm in love with everything right now. It's wonderful. It can't possibly be the drugs doing this. It's gotta be me. It's just knocking down barriers. I'll grow claws or something, man, if I have any more of that shit [peyote]. Just a little while ago I thought I had claws, like a fucking lobster, you know. All of a sudden T. S. Eliot I've been thinking about: 'I should have been a pair of ragged claws scuttling across the floors of silent seas.' "*

"What's that god-awful smell I smell here? Like something's burning."

"I know the smell, too."

"Goddamn! Like we're all gonna die."

"It smells like paint."

"Smitty."

"Smitty? What is Smitty doing? What the hell is Smitty doing?"

"It's got to be an electrical thing. We could be playing and this place could be burning and we wouldn't even know it. The building was burning for five hours and these idiots didn't know it. That's right, this building could be burning down right now."

"We've got to open a window."

"Hey, you wanna play a ballad?"

"We could analyze *The Waste Land*."*

"We're gonna get in trouble if we go out in the street like this."

"No, you look like something out of a 1940s movie."

"You look like Barbara Stanwyck or something."

. . .

"How old are you, Gene?"

"Forty-five."

"Yeah? You've got your shit together pretty good for a man forty-five years of age. This guy could almost pass for my father, but you'll never make it."

"Well, that's a relief."

*From Eliot's "The Love Song of J. Alfred Prufrock."

*The extended poem by T. S. Eliot.

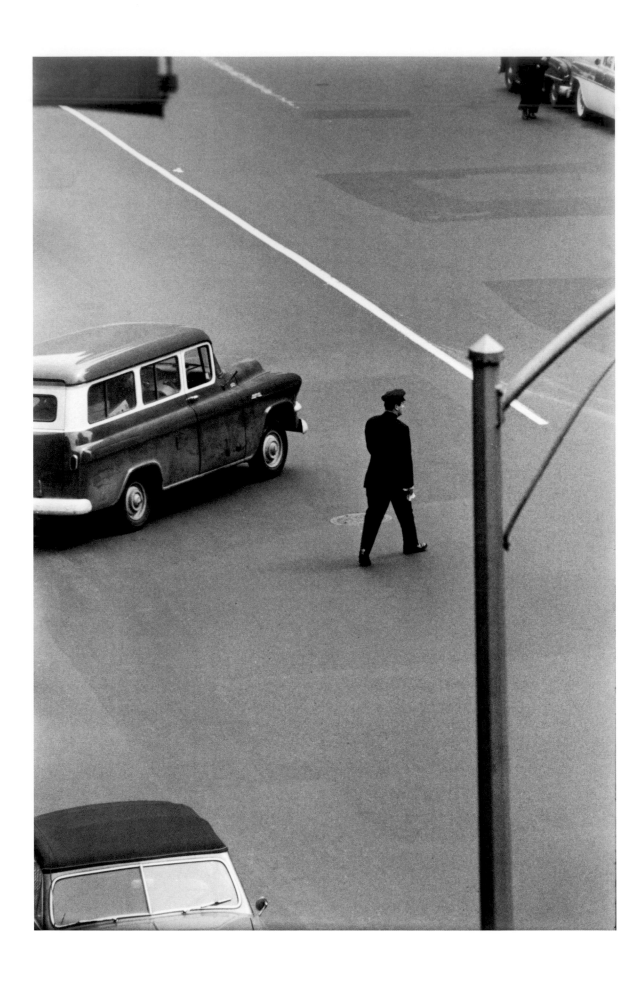

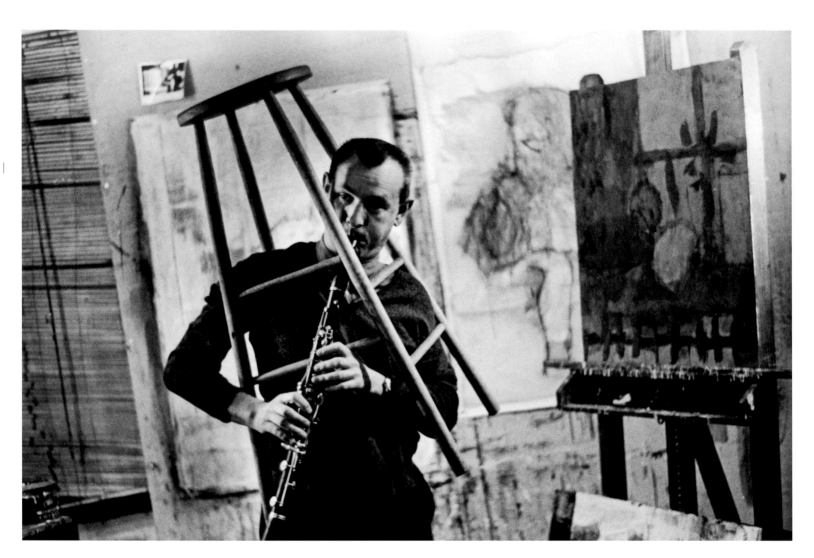

Jimmy Giuffre

Opposite: Harold Feinstein

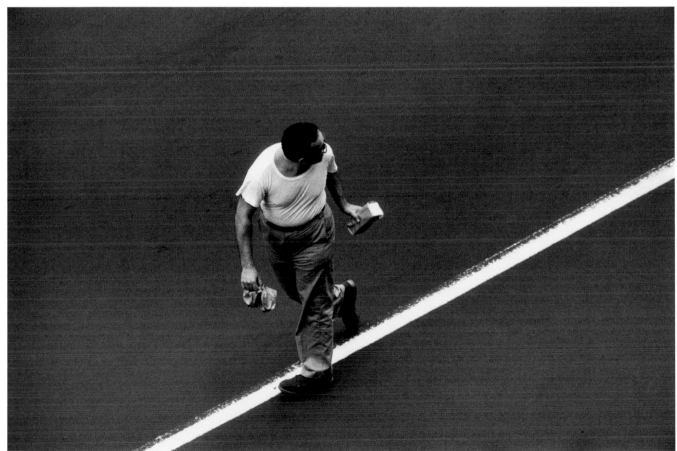

September 1964

Smith appearing on the WOR radio program hosted by James "the Amazing" Randi.

RANDI: What assignments based on what's going on today would you give Gene Smith? How would Gene Smith shoot "Justice in America" today? Something that broad; what would you do?

SMITH: Not in an eight-page story.

RANDI: Well, suppose you had the run of the book. What would you do with a topic like that? How would you shoot "Justice"?

SMITH: I wouldn't have any idea until I immersed myself into the subject with that kind of thinking started. In other words, no matter how much you kind of wade through it, live it . . . when you involve yourself in translating this somehow to others, you have to start seeing much more differently, much deeper. I couldn't possibly tell you how I would do it. Or, I couldn't tell you how I would do any other story at the moment, until I apply myself to it.

RANDI: We have a telegram that's just arrived, incidentally. Comes from New York, and it's, uh, who is Tabun Smith?

UNIDENTIFIED VOICE: That must be him. He's the only Smith here.

RANDI: T-A-B-U-N. Must be a cat.

SMITH: Let me see that. That's my cat.

RANDI: Would you read it, Gene?

[*Smith laughs.*]

RANDI: That's all it said?

[*Smith laughs.*]

RANDI: Well, let the folks at home in on this. Your cat's pretty clever, I'll tell you that. Would you read it?

SMITH: "Where are those dozens of telegrams I was supposed to send? Had difficulty dialing Western Union since you clipped my nails. Tabun Smith."

RANDI: It's a very intelligent cat. It's fantastic.

SMITH: No, but I told it to. No, Tabun applies, the name applies to you in this instance because "tabun" is Japanese for "perhaps."

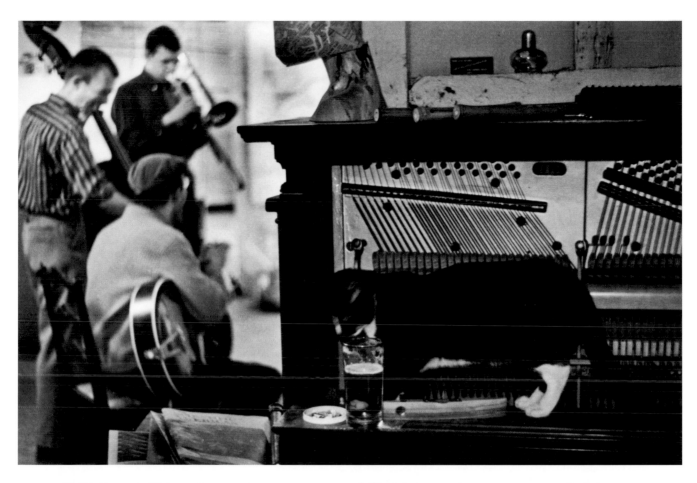

"As a musician there are some decades in which you can't help but become really good at what you do, and there are some decades that are a waste of your time. And it's not based on your talent; it's based on the calendar. And 1959 and this period, everything was so alive that just to be in New York City, it would be impossible not to absorb what was important in music. The jam sessions were an outlet so that you could lubricate your mind. It wasn't the place to revolutionize jazz. You surely couldn't have done it on an upright piano, you know. It was more or less unloading. So, Eugene was performing this incredible service of letting players meet each other, play with each other, socialize with each other. There was no professionalism involved."

—PAUL BLEY, pianist who played at the loft from 1955 to the early 1960s

"Gene Quill and I, we showed up down there in the afternoon, and, man, there were about thirty saxophone players. Everybody wanted to get a piece of Zoot, you know. So, Gene and I, we played six or seven hours, and the cats would be playing. Finally, we were exhausted; we went out, we went to the bar, had a few more drinks, and then went to bed, you know. And we went back over a day or two later. And we walked into the studio, and, man, there were saxophone players crashed out all over the fucking place! They were all wiped out, you know. And there's Zoot. He's behind a set of drums. He's playing the bass drum and a hi-hat and he's got his horn. There's nothing but bodies all around him, and he's still going! That was—the imagery is so vivid. You want a piece of Zoot? Lots of luck, man. That was one of the classic, classic sessions. Zoot wiped out every fucking saxophone player in New York!"

—PHIL WOODS, oral history interview about 821 Sixth Avenue

Circa 1960.

Hall O, Apt. session. Strong piano (2 players). The two piano players on this recording are Overton and Eddie Costa, sometimes playing at once on Overton's side-by-side upright pianos. Additional musicians are Zoot Sims, Jimmy Raney, Henry Grimes, and an unknown drummer.

RECORDING LOG

STUDIO Hall O, APT session ENGINEER

MASTER INDEX NO. 2 FILE SUBJECT

FOOTAGE	TRACK NO.	SPEED	SUBJECT TITLE	TIME	DATE RECORDED
			200T - GOOD BABY - 2 PIANOS		
			GUITAR JIMMY RAINEY (?) - DRUM		
			7 - MORE INFO INSIDE		
			DE BOX!		
			H. GRIMES ON SOME		
			VOTHERS ETC		
			HALL ETC		
			STROLL PIANO		
			(2 PLAYERS)		

ADDITIONAL PLAYBACK INFORMATION:

22

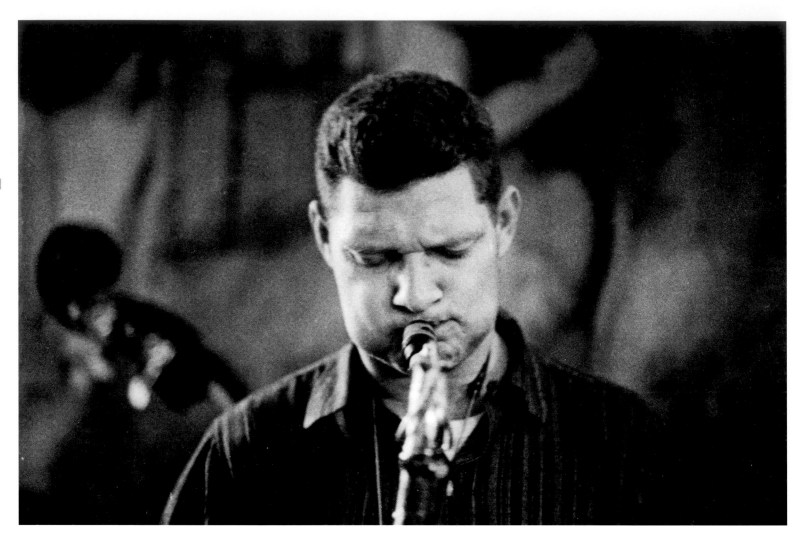

Zoot Sims

Opposite: Bill Takas

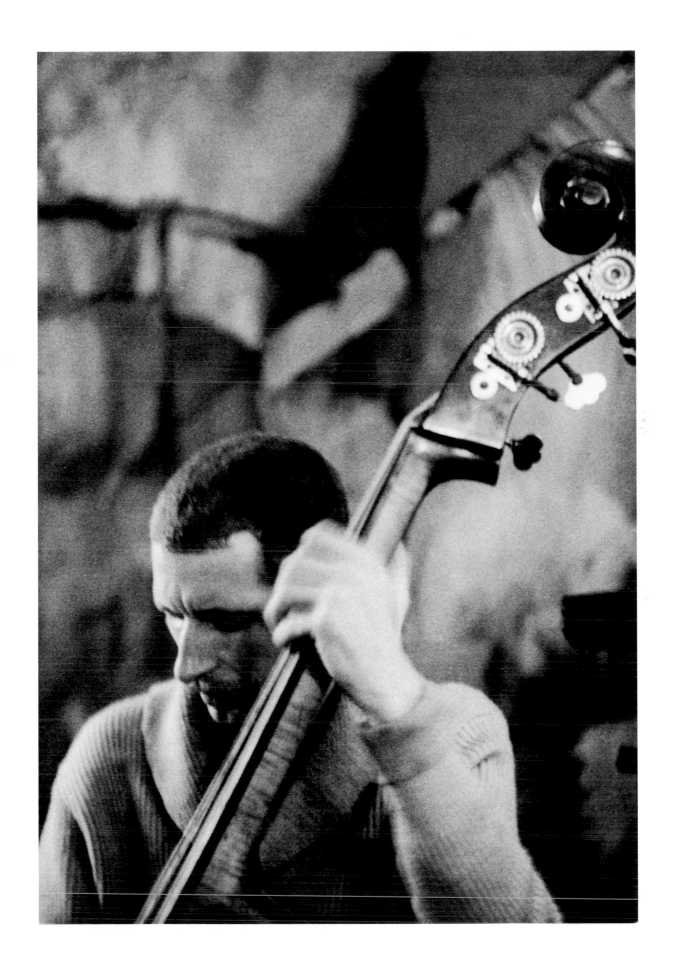

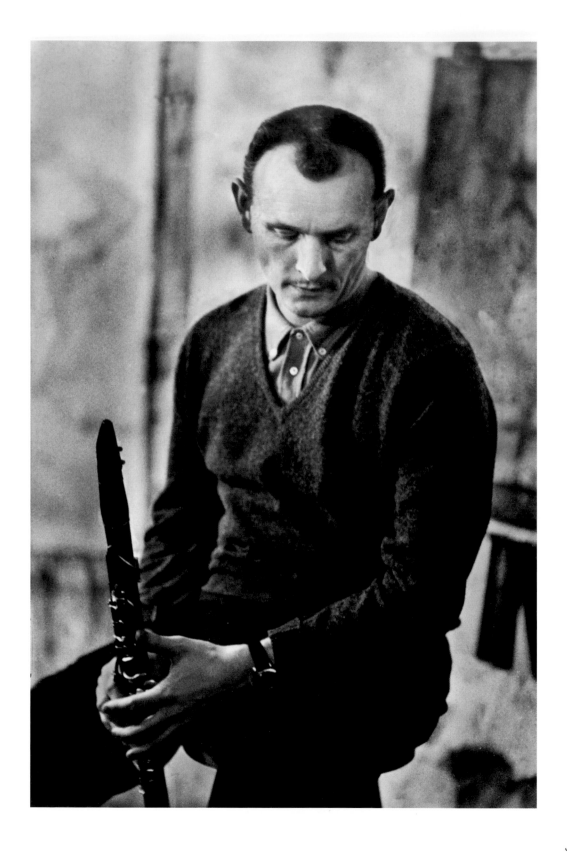

Jimmy Giuffre
Opposite: Herb Geller

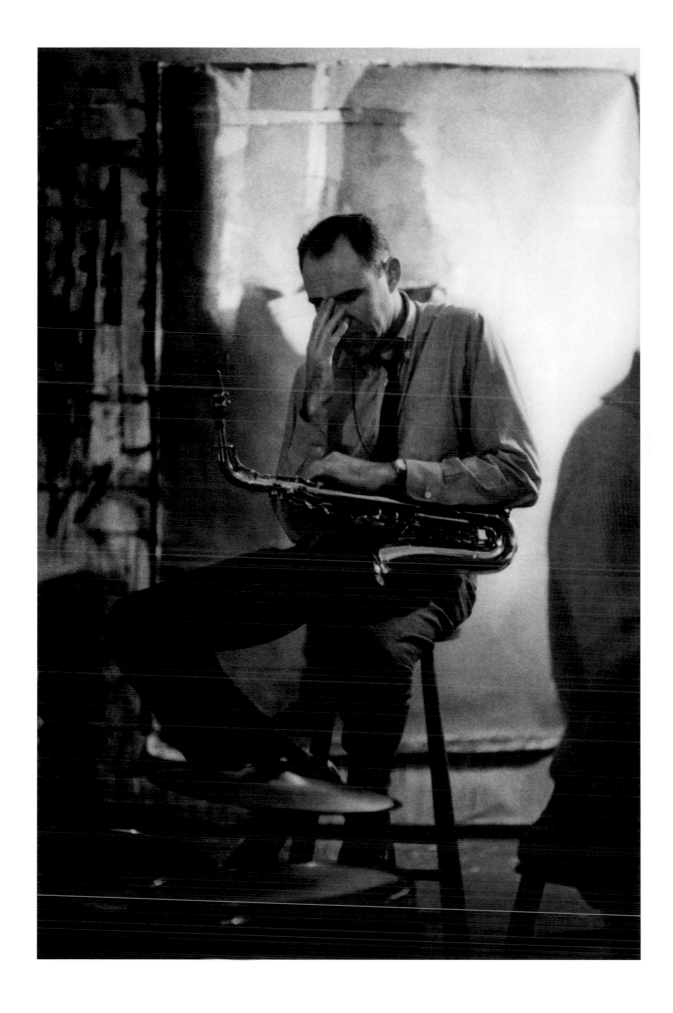

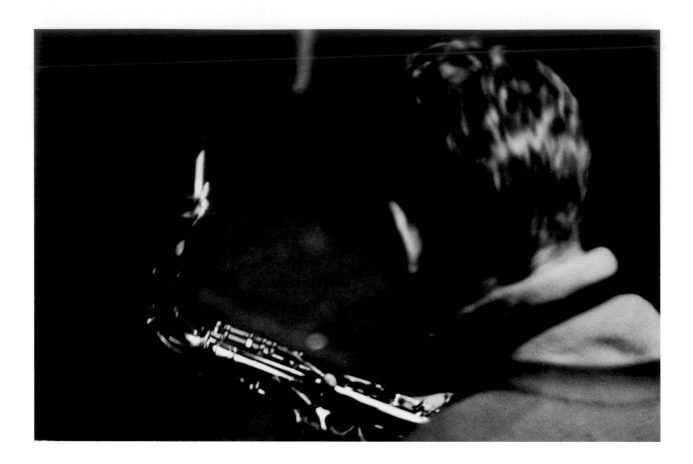

December 1964

Smith is in the darkroom working with photographers Larry Shustak and Ted Runge. He recorded almost nine hours of material on this day, with Long John Nebel and James "the Amazing" Randi programs taped off the radio, along with the darkroom discussion.

SMITH: If you can go into the darkroom to print and you can print, if you can come out and have one good picture printed, that's an evening. You've done something. You know, that's a lot: to actually come out and make one good print.

Unknown Date

Another telegram from Smith to Long John Nebel's late-night radio program, with an unidentified panel of guests on the program.

LONG JOHN NEBEL: We have a telegram here, and I think it's an important one. None of the people who are trained in psychology could possibly answer this. The question: "If I get all my sex at home, does this make me a home-o-sexual?" [*Much laughter.*]

PANELIST 1: Oh, that's wonderful; you know who it is?

PANELIST 2: Al Lottman?*

NEBEL: No, one of the greatest photographers we have, Eugene Smith. [*Pause, then laughter.*]

*Lottman was a regular panelist/guest on Nebel's program, frequently playing the role of the show's resident skeptic.

Lee Konitz

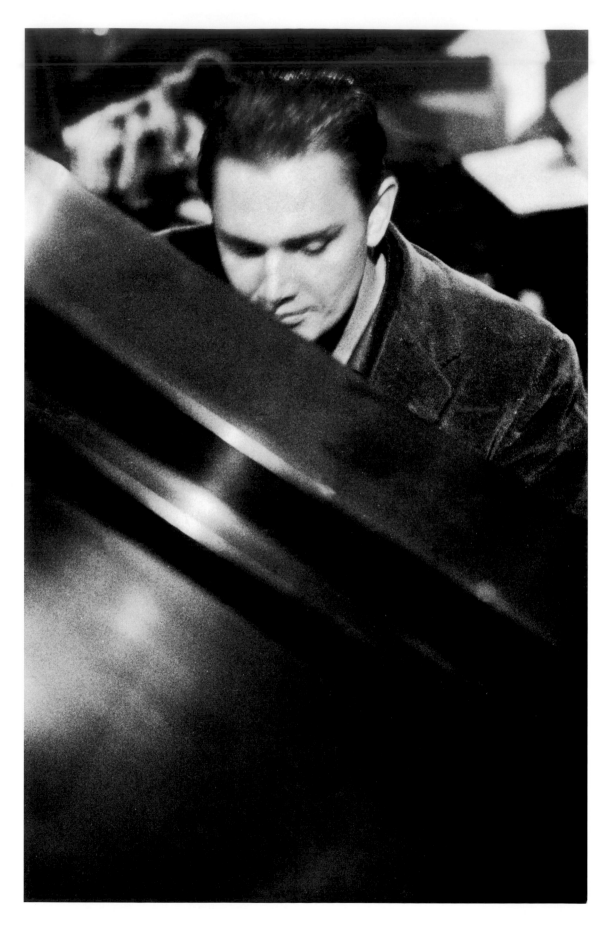

Dave McKenna

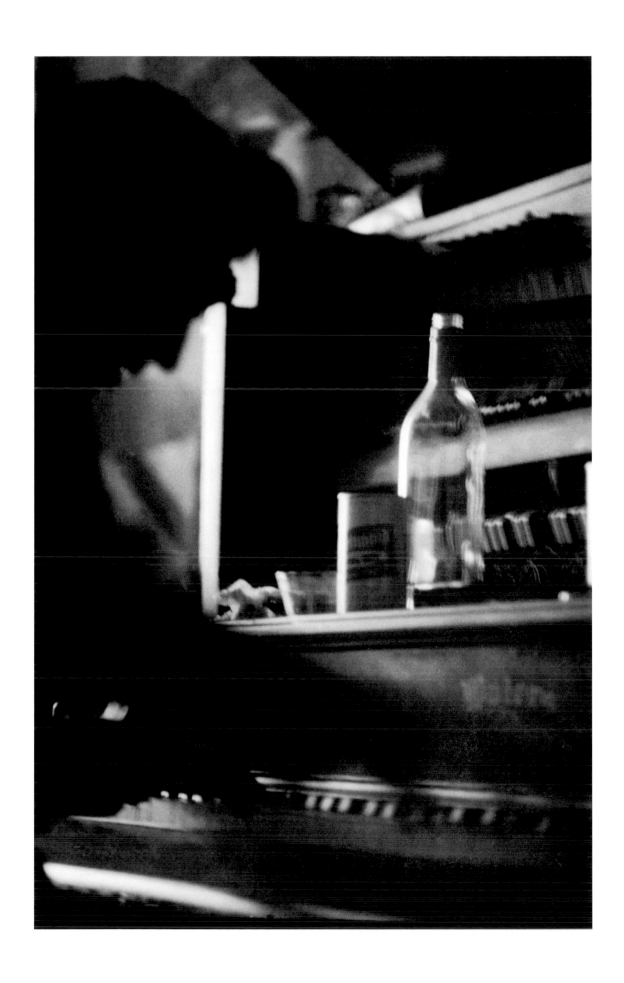

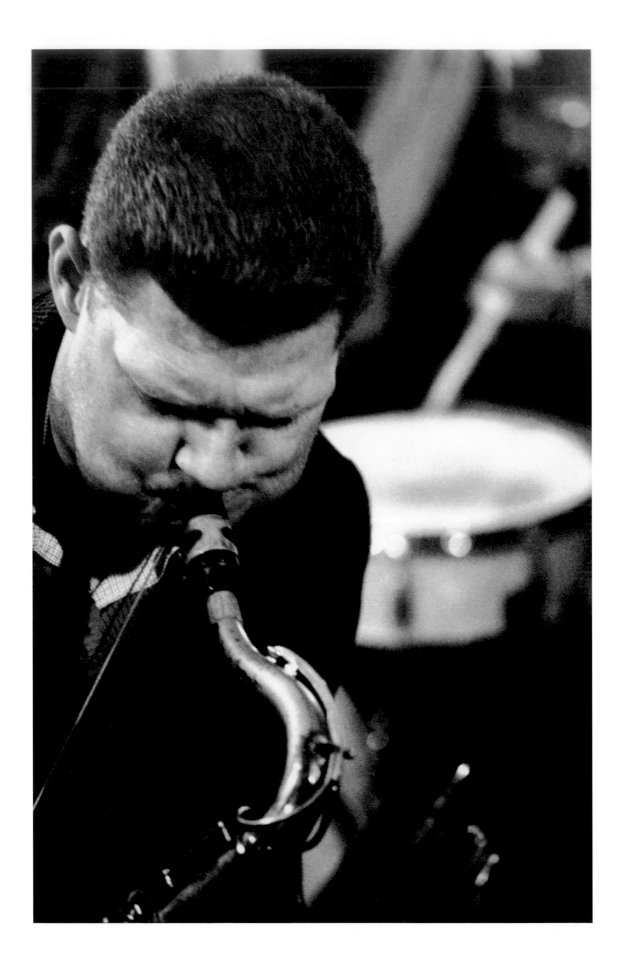

Zoot Sims

March 24–25, 1960

Gene Smith and saxophonist Zoot Sims discuss photography and the legendary camera repairman Marty Forscher, who was a close friend of Smith's. After serving in Edward Steichen's naval photography unit during World War II, Forscher opened his shop, Professional Camera Repair, in Manhattan. For forty years he fixed cameras for some of the most famous photographers in the world (and occasional jazz icons, too).

SIMS: Hey listen, Gene, I want to talk to you about something. You're a pretty fucking good photographer, you know? Right? You agree with me?

SMITH: Aww, shut the hell up.

SIMS: I want to show off a bit. I want to get into the art field, you know. They got a nonprofessional art exhibit. They had a painting exhibit—is that the right way to say it? Painting exhibit? A show? Now it's going to be a photographer, and I'm no professional, but I've got some color film and a couple black-and-whites that I want blown up maybe, you know, that I can get in the show. Not that big, just a couple. What's the best place to . . . ?

SMITH: Where to have prints made?

SIMS: But I want them blown up.

SMITH: There's one in Grand Central Palace . . . Forty . . . Forty-third and Lexington Avenue.

SIMS: Oh, I think that's where I had my camera repaired.

SMITH: Grand Central Palace; you probably had your camera repaired there . . . Marty.

SIMS: Yeah, Marty. Same guy . . .

UNKNOWN VOICE: Forscher?

SIMS: Yeah, I had my camera repaired there. Somebody recommended me to him. He was a photographer in the Pacific during the war.

SMITH: Not Marty.

UNKNOWN VOICE: That was Gene.

SMITH: He's very good. I met him for the first time out in the war. He came to our little island. I was desperately looking for someone to repair a camera. Here was this genius—

SIMS (*interrupting Smith*): That's what he did! Excuse me. He was working with the army for the camera supply. He repaired everything. That's what I'm trying to say, Gene; am I right now?

SMITH: That's right . . . there was this genius sitting there repairing cameras.

SIMS: A friend of mine recommended him to me. He takes the camera apart and spreads it all out, I mean like a thousand pieces all out, little screws and everything. Then he puts it all back together again, man! I mean, man, that's fantastic!

UNKNOWN VOICE: He knows it so well.

SIMS: Just like my horn. I've taken my horn apart, in my life, I would say fifteen times, which is enough. Forget once in a while, you know. That's a lot of shit on there. But just looking at that camera . . . how many times has he done that? Man . . . little teeny screws on there.

Sims changes the subject to a print made by Smith on the table nearby.

SIMS: How'd you do this, man? Can you explain that to me, how you did it?

SMITH: Yeah, you just pick out your finest solo and tell me how you did it.

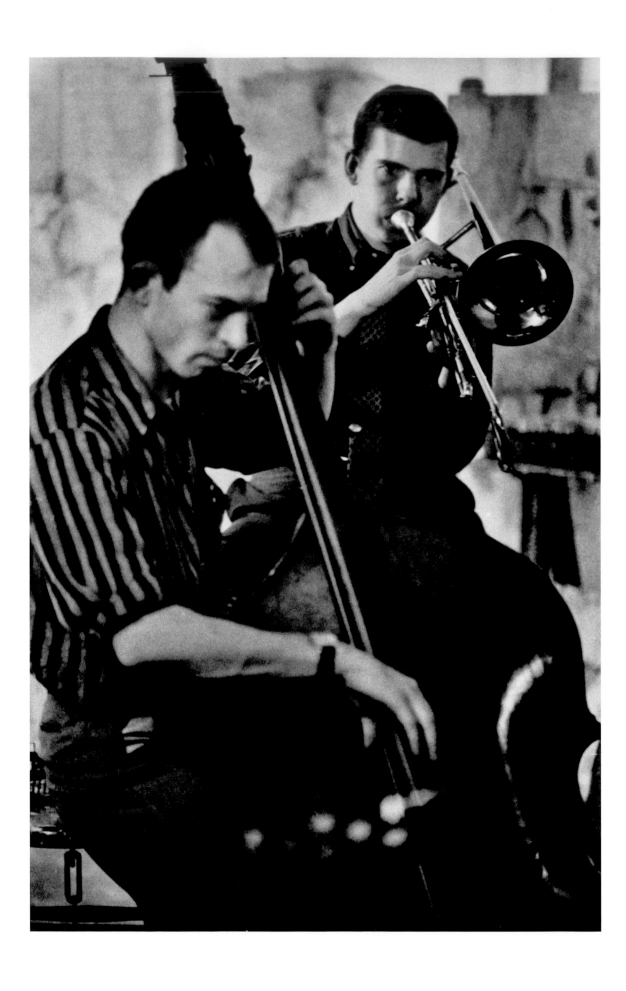

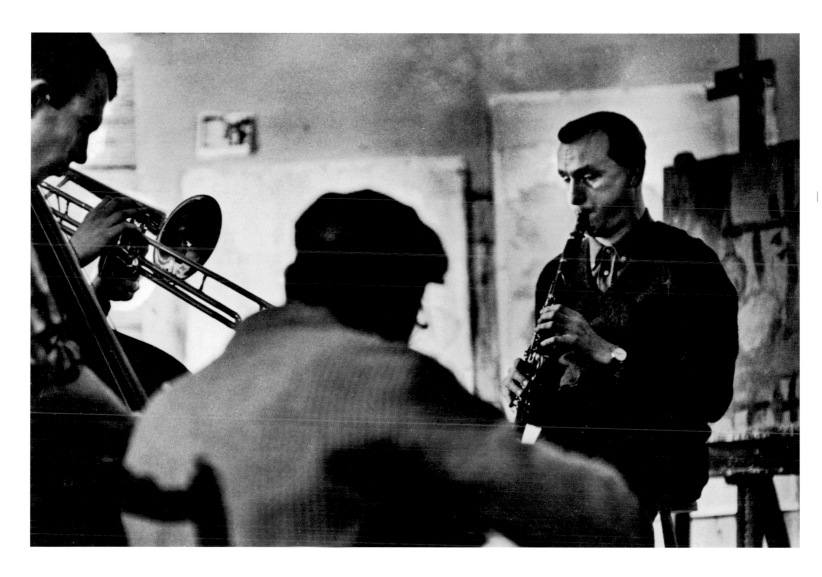

Bob Brookmeyer, Jim Hall, Jimmy Giuffre
Opposite: Bill Crow, Bob Brookmeyer

September 1961

Alice McLeod, a piano player from Detroit who later married legendary saxophonist John Coltrane, lived in a fifth-floor room at 821 Sixth Avenue next to her friend the saxophonist Joe Henderson. McLeod and Henderson knew Jimmy and Sandy Stevenson from their shared backgrounds in Detroit.

McLeod is heard on Smith's tape entering the sidewalk door to 821 Sixth Avenue and climbing the stairs, where she meets Gene Smith on the fourth floor.

McLEOD: I was coming this way tonight; I was coming from the store. And I saw this man coming down the street. I didn't pay any attention to him. Jimmy went to work and left the door unlocked. So I was coming from the store, and so I turned around and just like, he turned around . . . I didn't even look at him, but he passed me and . . . I don't . . .

SMITH: Like Carole [Thomas] was coming down; somebody passed and somebody said something. She hollered at me . . . and I came out.

McLEOD: These people see you like it just looks like you're going into a side place or something, you know, with all these stores and things, you know. But he had seen me coming from the corner, you know. And he walked past the building. And I walked; I was on my way up the stairs, and the . . . he's . . . you see this house . . . or something, so I turned around and he just stood there.

SMITH: If it ever happens and I'm here, just holler.

McLEOD: I will.

SMITH: I hope one day we can get a buzzer system down there. And also, when you go out you don't have to fool with a key; it locks automatically.*

*Circa 1965, radio talk-show host and friend of Smith's James "the Amazing" Randi installed a security system at 821 Sixth Avenue.

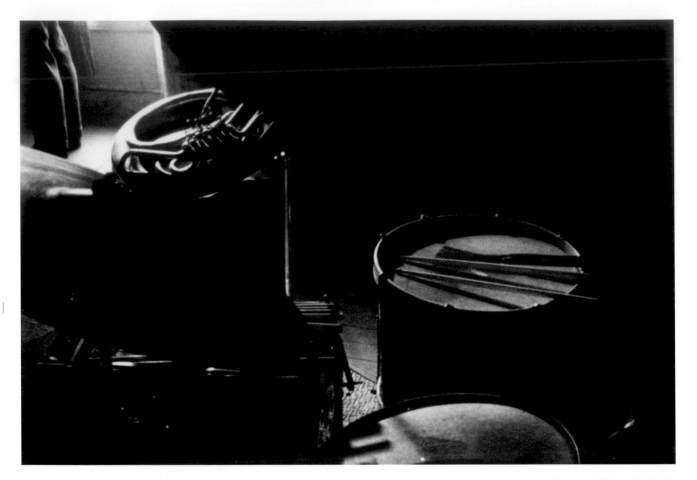

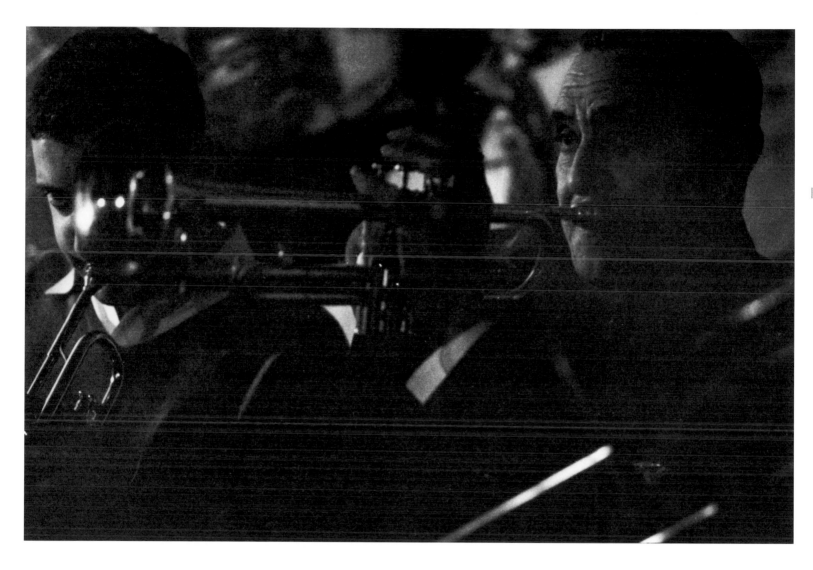

Wingy Manone

Opposite, bottom: Gus Johnson

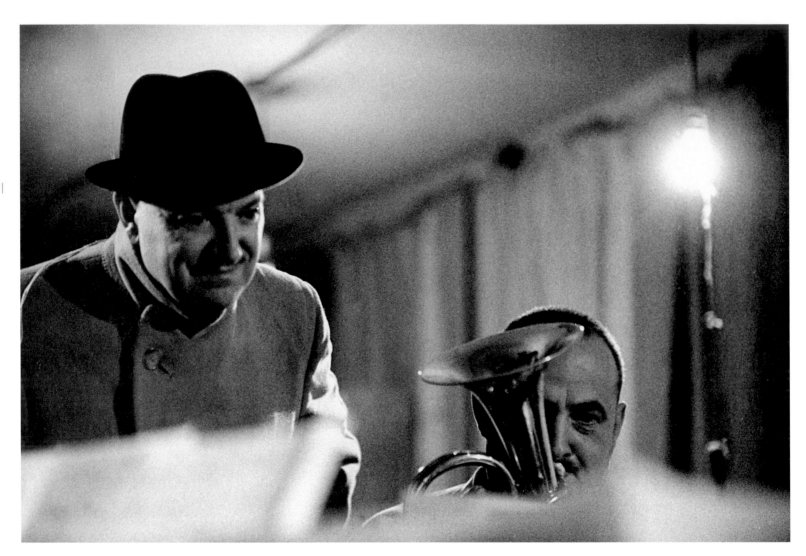

Bud Freeman, Dick Cory

Opposite: Robert Northern

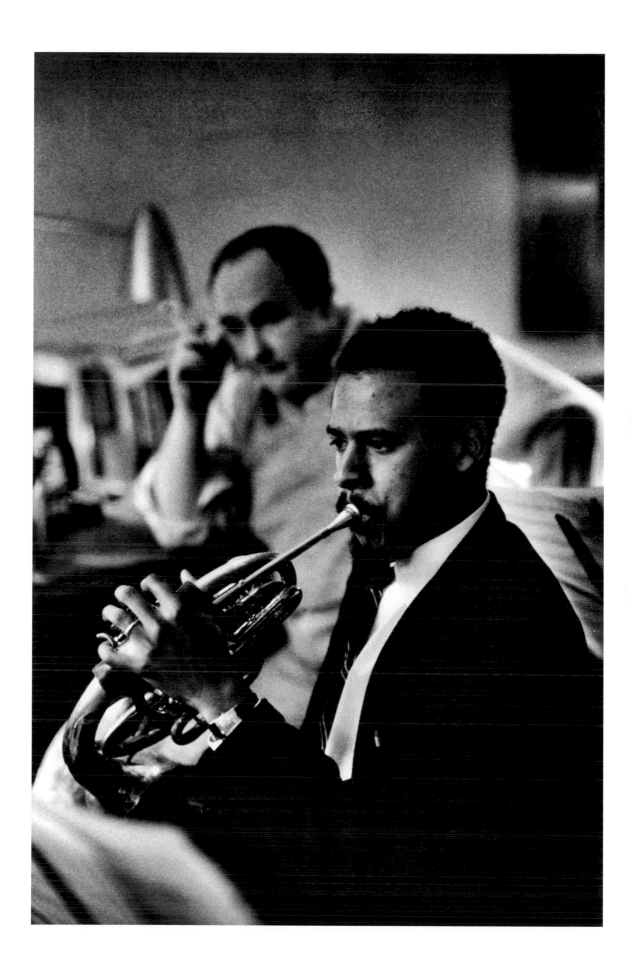

Chaos Manor*

Top row: September 1961.

Hard, grim. A dope tape, stereo.

Bottom row: September 1961.

1961 While packing for Japan. One of most important. At time Lyn and Gin were staggering in and out. Playing inside (one side) is Edna St. Vincent Millay recording. In hallway—grunts, groans. "They say it's so bad but it feels so good." I'm offered a hip shot. On other side is with someone upstairs talking about stealing (catching girl stealing clothes) & a mess of people. Etc.

Late September 1961

In the early hours of a morning in New York, the last week of September 1961, W. Eugene Smith packed for his first trip to Japan since he was carried off a battlefield on a stretcher in Okinawa during World War II.

He was forty-three years old and, as usual, broke. Whatever money he had was spent on cameras and film, darkroom supplies, recording equipment, vinyl records, books, alcohol, and amphetamines. According to surviving paperwork, he owed at least $555 (approximately $4,000 in 2009 money) to Walter's Electric, Sigma Electric Company, and Fono-Tape Service for blank reels of tape, which ran around two to four dollars apiece in 1961. He also kept a subscription to *Broadcast Engineering* magazine.

Smith's compulsions depleted him, but things were looking up at this time. He had a lucrative assignment from the electronics company Hitachi to photograph day-to-day life in and around the company village in Japan. His experience photographing combat during the war was the beginning of a lifelong obsession

*Chaos Manor was a name Smith often used for 821 Sixth Avenue.

with Japanese culture, and he was excited to return.

Around midnight Smith loaded a new seven-inch reel into his tape machine. With active microphones on the fourth and fifth floors he captured the goings-on until dawn, about seven hours of sound. A half century later, an anonymous night in New York City comes alive, if cryptically, the sounds transferred to a digital file from 1,800 feet of tape on Smith's original reel.

Temperatures that week in New York topped ninety degrees, and the baked concrete streets kept the nightly lows from going much below seventy. Windows were wide open at 821 Sixth Avenue, and the modest commercial neighborhood was typically desolate at night. On the twenty-fourth of that month there was a full moon.

Taxis rattled and honked down the avenue at a casual, nocturnal pace. The wholesale flower shops were shut down until dawn. Paper cups and sheets of trash tumbled down the sidewalks. Every fifteen or twenty minutes the Sixth Avenue bus rolled to a stop at the corner of Twenty-eighth Street, and then pulled away.

Smith's longtime girlfriend, Carole

Thomas, went to bed early to rest for their journey, which began the next day from Idlewild Aiport (now JFK). A pack rat, Smith worked all night and morning. He also prepared his loft for their absence, locking up belongings inside cabinets and trunks in an effort to limit open season on his things by thieves and heroin junkies while he was gone. The spring on Smith's screen door, which opened into the fourth-floor stairwell, occasionally stretched and creaked as the door opened and then slammed closed—a sound you'd expect from a farmhouse or a fishing bungalow—as he stacked his bags outside his door one at a time once packed.

Frank Amoss, a twenty-five-year-old drummer from Baltimore, was up and about. He dwelled in the front half of the fifth floor, his kit set up under the three open windows facing Sixth Avenue. He wandered around the loft while Smith was packing for Japan. Like so many of the musicians and artists who passed through 821 Sixth Avenue, Amoss was impressed and bemused by Smith. Every waiting room and coffee table in America displayed copies of *Life* at midcentury, yet Smith quit the magazine at the peak of his fame, gave up a high salary, and chose to live in the squalor of this building, impervious and friendly.

AMOSS: How long are you going to be gone?

SMITH: About three months or so.

AMOSS: Who is going to take care of your place?

SMITH: Will Forbes and Lou [Draper] will be having a hand in there.*

AMOSS: I got a letter from Gary [Hawkins]; I tell you? He's not coming back. I need money from Gary for the heat.* Gene, before you leave, you don't have a . . .

SMITH: A check will arrive on Monday or Tuesday, and we already have checks written. Hell, I practically have to walk to the airport tomorrow.

AMOSS: I'll drive you to the airport. What time does your flight leave?†

SMITH: I think somebody said we need to leave here around four p.m. But I haven't packed. I'll never make it.

AMOSS: Do you have anything to stay up on?

For the next ten minutes Smith discusses the pros and cons of various amphetamines—Desoxyn, Dexedrine, and Benzedrine. He flips through the pages of a pharmaceutical handbook. One of Smith's psychiatrists, Dr. Nathan Kline, pioneered experiments to fight depression with drugs, including early antidepressants called "psychic energizers," which Smith favored. He considered his stimulants just as carefully as he did his photographic chemicals, with which he was an idiosyncratic master.

Amoss expresses concern about the city government's crackdown on artists living illegally in nonresidential lofts, like he and the others at 821 Sixth Avenue. Smith's casual attitude reflects his normal pattern of avoiding practical matters.

Then, fifty-three minutes into this tape the sound of a man yelling shoots through the air, like a crow cackling for

*Forbes and Draper, two young photographers, were assistants of Smith's.

*Hawkins was a drummer from Boston who lived in the loft, sharing space with Amoss, before taking work playing music on cruise ships.
†Amoss had a 1960 Plymouth Fury that he parked on the street in the neighborhood.

attention. He is out on the sidewalk in front of 821 Sixth Avenue.

MAN'S VOICE (*yelling*): Hey! Where's Ronnie Cuber? Heeey! Where's Ronnie Cuber?

Ronnie Cuber is the nineteen-year-old saxophonist, a New York native who was a loft regular. Amoss leans out his fifth-floor window and responds.

AMOSS: Nothing's happening here tonight. It's too late. Nothing's happening.

He walks into the back of the fifth floor, where bass player Jimmy Stevenson and his wife, Sandy, are awake, their infant son, Jimmy Jr., asleep.*

Sixteen minutes pass, with only random loft and street noise, such as the Sixth Avenue bus, while Smith tinkers with equipment.

Suddenly, someone on the sidewalk outside 821 Sixth Avenue whistles a distinctive, piercing call from his lips. It isn't a casual whistle; it's an intricate call. Smith recognizes it immediately.

SMITH: Frank, there's a chuck-will's-widow out here.

AMOSS: Oh, somebody's out there?

There is the whistle call again. It is a near perfect mimic of the chuck-will's-widow, a nocturnal bird, kin to the whippoorwill, that inhabits the swamps of the South in the summer.

Smith grew up in Wichita, Kansas, and spent his youth in a house with no air-conditioning and with windows open, like everyone else in those days. From a young age he also wandered outdoors, photographing, learning the sounds of nature. According to the 1960 bulletin of

the Kansas Ornithological Society, the chuck-will's-widow occasionally migrates up the Arkansas River from the Mississippi Delta region to Wichita, the farthest-west known destination for that bird. Maybe that's how Smith knew it. Maybe he knew it from a record (he collected vinyl records with insect, bird, and animal noises). Or maybe these musicians used the call regularly to get into the building. Pianist Hampton Hawes, in his memoir, *Raise Up Off Me*, wrote that drug users whistled the first three notes of Charlie Parker's tune "Parker's Mood" to signal a seller. But the chuck-will's-widow call is too complex for this kind of usage. It takes a master whistler to pull it off.

Amoss goes to the window to see who it is.

AMOSS: Who's there?

There is a pause and some inaudible conversation from the sidewalk.

AMOSS: Forget it, nothing's happening. Amoss then recognizes the men.

AMOSS: Oh, hey, Walter.

Faint voice from the sidewalk.

AMOSS: Forget it, man. It's too late. That's all I can tell you.

Faint voice from sidewalk again.

AMOSS: Everybody's in bed here, man. See you later, Walter.

SMITH (*giggling at Amoss's negative response*): Oh, come on! I'll put some of my percussion music on again.

AMOSS (*mocking himself in second person*): So, you don't like jazz, huh?

He goes to the back of the fifth floor to the Stevensons' space.

AMOSS: That was Walter Davis Jr. and Frank Hewitt trying to get in here.

Davis and Hewitt were both African-American pianists, age twenty-nine and twenty-five, respectively. Davis was

*The Stevensons had recently moved to New York from their native Detroit so that Jimmy could pursue a career as a musician.

born in Richmond, Virginia, and Hewitt in New York. Davis probably whistled the bird call, given his Southern childhood, but Hewitt could have visited Southern relatives as a kid, too. Ironically, on September 29 Robert Shelton published in the *New York Times* the first-ever notice of a young new artist named Bob Dylan, who performed at Gerde's Folk City that same week. Shelton wrote: "He is consciously trying to recapture the rude beauty of a southern field hand musing in melody on his porch." Surely, Minnesota native Dylan wouldn't have known firsthand the call of a chuck-will's-widow.

Smith turns off the live microphone, but his recorder keeps recording. The equipment receives a frequency and records it on the tape inadvertently. The transmission comes from an early version of a twenty-four-hour paging service, used primarily by police and fire departments but also doctors and paramedics who respond to emergencies. A droning female voice reads numbers.

VOICE: 44 . . . 22 . . . 36 . . . 19 . . . 54 . . . 68 . . . 71 . . . KEA Page Boy. New York. [*pause*] 23 . . . 34 . . . 19 . . . 93 . . . 73 . . . 48 . . . 65 . . . KEA 860 Page Boy. New York. [*pause*] 46 . . . 24 . . . 56 . . . 19 . . . 34 . . . 12 . . . 64 . . . KEA Page Boy. New York. [*pause*] 33 . . . 64 . . . 17 . . . 39 . . . 62 . . . 28 . . . 24 . . . KEA 860 Page Boy. New York.

The numbers are the only sounds on Smith's tape for forty-five minutes.

Finally, Smith installs a new live microphone in his loft and in the stairwell landing area. It is three or four o'clock in the morning by now. The Sixth Avenue bus slugs by. Water drips and trickles steadily in Smith's darkroom basins. He was comforted by water, the sound of it,

and it's a reason why he worked for hours and days at a time in the darkroom.

A few minutes later several people open the sidewalk door with a key and hike loudly up the stairs, talking. Smith hears them coming and turns up his microphones in the fourth- and fifth-floor stairwells.

Amoss, who is still awake, greets the newcomers in the hallway. They are pianist Sonny Clark, saxophonist Lin Halliday, and Virginia "Gin" McEwan.

Clark was a thirty-year-old African-American piano player from rural western Pennsylvania, his father having been a coal miner who died when Sonny was an infant. The touch of Clark's right hand on the piano was one of the most beautiful sounds in all of jazz: light and supple, yet propulsive and soaked in blues. Halliday, a white man, was a twenty-five-year-old saxophonist from the Ozark Mountain foothills in Arkansas. He worshipped Sonny Rollins and could play like Rollins at times, but he had a hapless manner of self-destruction that limited his professional career. Clark and Halliday were close friends and heroin addicts. McEwan, a seventeen-year-old white woman from Wilmington, Delaware, by way of Chicago and Cincinnati, was Halliday's girlfriend. Like many couples who lived on the streets, they said they were married but they really weren't.

Clark was a small man, maybe five-foot-five. Halliday was six-foot-four. Both men were poorly nourished and gaunt. McEwan was always the tallest girl in school, a tad under five-ten, and pretty. Halliday's size made her feel feminine, and his warm playing moved her. She spent much of her time from May to November 1961 keeping those two men

alive, and fixed. The three of them squatted in the hallway and stairwell of the loft. McEwan kept a trunk of clothes on the fifth floor and completed lessons for high school correspondence courses in dirty bars while Halliday played and got fixed. When things got really bad in November, she left town abruptly and never came back, pregnant with Halliday's baby.

In the October 1961 issue of *Coda* magazine, Jack Batten described his mid-September visit to the East Village dive the White Whale, where the Sonny Clark Trio was appearing with Billy Higgins on drums: "The White Whale turned out to be a cheerfully noisy place crowded with weekend hipsters, slumming up-towners, and maybe an authentic Beat or two—the disguises all seemed the same to me. A couple of poets declaimed their stuff, rather poorly, early in the evening, and later Sonny Clark played his stuff with much more style and wit. Billy Higgins, who has a serious narcotics problem according to *Jazz Journal*, nevertheless showed that he is one of the important young drummers around."

It's probable that Clark, Halliday, and McEwan went to the loft from the White Whale on this night in September 1961. Halliday probably sat in with Clark's trio, which included Higgins and had Butch Warren on bass.

AMOSS (*to Clark*): I'm planning on getting the piano tuned first of the week, then you can play some.

CLARK: Yeah. A cat was telling me that Walter Davis was up here last Friday night.

AMOSS: Walter's been around. Walter was around earlier tonight, but nothing was happening. He was around here last weekend for a couple of days.

CLARK: Well, he needs to play all that he can play.

AMOSS: He and Frank Hewitt were here about an hour ago.

CLARK: Oh yeah?

AMOSS: Everybody was ready to go to bed, so they went away.

McEwan says something inaudibly.

CLARK: You got anything to drink that's sweet?

Heroin addicts crave sweets, especially sugar-filled sodas.

AMOSS: Just water. I don't have any soft drink or nothing.

Footsteps indicate that another man enters.

AMOSS (*closing his door on the fifth floor*): Okay folks, see you later.

Clark, Halliday, and McEwan walk down one flight of stairs and run into Smith, packing for Japan, on the fourth-floor landing. Clark sticks his head into Smith's door.

CLARK: I thought they were exaggerating when they told me you had all that shit in your room, man.

SMITH: Well, I've been shitting for a long time [*group laughter*].

CLARK (*laughing*): I can see that.

McEwan notices that Smith is wearing two watches, one on each wrist.

McEWAN: Two watches? You have on two watches?

SMITH: Well, see, neither one of them are very reliable. They remind me to ask for the correct time.

CLARK (*to Smith*): You like to smoke pot?

SMITH: No, thank you.

CLARK: Come on, man, I got a joint here. A few seconds pass.

HALLIDAY: You leave in the morning, Gene?

SMITH: Today.

HALLIDAY: Man, when you come back are

you going to be all up in the air, hifa-lutin, and rich and Cadillacs and all that shit?

SMITH: But you don't realize how remarkable I already am [*laughter*]. Halliday and Clark whisper to each other and then move to another room to shoot heroin. Behind them the screen door closes. McEwan and Smith are alone in the hallway.

McEWAN: What's the "W" stand for?

SMITH: Wonderful.

McEwan laughs.

SMITH: You don't believe me? Why, you sit right there.

Smith walks through the spring-loaded screen door and then returns, handing McEwan a T-shirt with the words "Wonderful Eugene Smith" printed on it.

SMITH: Of course, there are some who say it stands for "worship."

McEWAN: Oh, me.

SMITH: Of course, sometimes I'm sure people would tell you it means the opposite, you understand.

McEwan laughs.

SMITH: I never was very good at jigsaw puzzles. I arrived in Africa with something like thirty-eight bags.

McEWAN: Sounds like my mother. She'd arrive in Cincinnati with thirty-eight bags, coming from Columbus.

Smith goes back into his loft behind the screen door.

(It is unknown how many bags he took with him to Japan, but a year later—on September 19, 1962—Smith put forty-four bags weighing 2,889 pounds on a freighter back to New York, at a cost of $238.91. He and Carole bunked on the ship for the two-month journey.)

For the next twenty-five minutes the only sounds are of McEwan turning pages of a book in the hallway and the periodic sound of the Sixth Avenue bus outside, and occasionally Smith opening and closing the screen door.

Suddenly, the stark, New England voice of a woman reading poetry, with hints of a formal British accent, intones dramatically from behind Smith's screen door:

"All I could see from where I stood
Was three long mountains and a wood;
I turned and looked the other way,
And saw three islands in a bay.
So with my eyes I traced the line
Of the horizon, thin and fine,
Straight around till I was come
Back to where I'd started from;
And all I saw from where I stood
Was three long mountains and a wood."

Smith had put on his turntable a vinyl record of Edna St. Vincent Millay reading her poetry. Caedmon Records released it earlier in 1961, continuing a surprisingly popular series of poetry records, with Dylan Thomas, Ezra Pound, T. S. Eliot, W. H. Auden, and others. These LPs were priced at $5.95, more than $40 in 2009 money. By contrast, music LPs from the time, for example by Thelonious Monk or the New York Philharmonic, were listed at $1.95 to $2.95.

For an hour and a half Millay's voice haunts the background of Smith's tape—he plays both sides of the record twice—in the way the music in an Italian opera would have haunted the scene: not so much the explicit words as the elevated tone of formal drama and lyricism juxtaposed with the underground chaos and oblivion of this particular night at 821 Sixth Avenue.

Smith walks through the screen door and back into the hallway. Halliday and

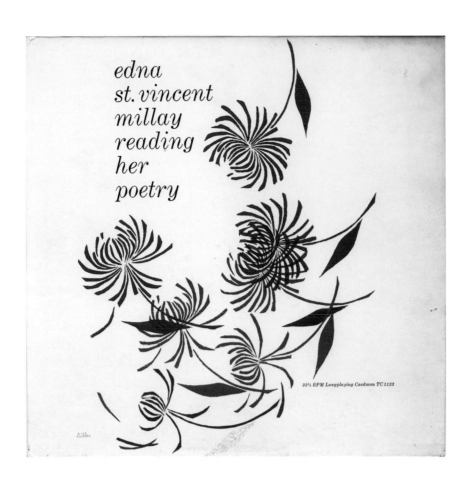

edna
st. vincent
millay
reading
her
poetry

33⅓ RPM Longplaying Caedmon TC 1123

Clark have reemerged from their seclusion of almost two hours.

HALLIDAY: Gene, we're going down for a cup of coffee. Are they open across the street yet?

SMITH: I think they open at seven-thirty. You may have to go to Riker's.*

HALLIDAY: You want anything?

SMITH: Yeah, I'll take a vanilla malt.

HALLIDAY: There's enough here for a hamburger, too, if you want it.

SMITH: Okay, I'll take a hamburger, well done, with mustard.

HALLIDAY: You want pickles on it?

SMITH: No, just mustard.

The screen door swings open, and Smith goes back into his loft space.

Sonny Clark's dose of heroin kicks in,

*A diner at Thirtieth Street and Broadway.

and suddenly his moans suffuse Smith's reel of tape. They are the sounds of incoherence and danger. Millay's formal female voice—the sound of something practiced and performed—mixes with Clark's uncontrolled moans.

> *"We were very tired, we were very merry—*
> *We had gone back and forth all night on the ferry;*
> *And you ate an apple, and I ate a pear,*
> *From a dozen of each we had bought somewhere;*
> *And the sky went wan, and the wind came cold,*
> *And the sun rose dripping, a bucketful of gold."*

Halliday becomes concerned about Clark's consciousness.

HALLIDAY: Hey, Sonny, you want to go outside, man? Sonny!

Clark doesn't answer. A morose groan says something hangs in the balance.

CLARK: Ooooohhhhhrrrrrrrroooohhhhhh.

Halliday's concern grows deeper.

HALLIDAY: Gin? Gin?

A month earlier, Clark had overdosed and fallen into a coma in the stairwell of the loft. McEwan revived him with amateur CPR. She also saved the building from police pressure that would have resulted from a death. Smith gave her five dollars and said, "Thank you for saving Sonny." Clearly, Halliday is concerned that it may happen again.

HALLIDAY: Gin? Gin?

McEwan, who thought Halliday's departure for coffee was imminent, had moved somewhere else in the building.

HALLIDAY: Sonny! Sonny! Gin? Sonny, do you want me to help you? Gin?

Clark's consciousness flickers awake.

CLARK (*mumbling*): Bird, man, that nigger was crazy. Wooooo. Bird, that nigger was crazy.

HALLIDAY: What nigger?

CLARK: Charlie Parker, that's who.

HALLIDAY: He sure was beautiful crazy, huh?

CLARK: He invented fucking music [*becomes inaudible*].

Parker was in many ways the Pied Piper of jazz, having helped create an exhilarating new form of improvisation in the 1940s. But Parker was also a notorious heroin junkie who somehow managed to play beautifully and infectiously despite his self-destruction. Many acolytes followed his lead and became hooked themselves, like Halliday and Clark, to the detriment of their lives and music.

HALLIDAY: Gene's got some tapes of you playing, man, you know, upstairs. You ever hear 'em? You sounded crazy up there, man . . . Hey, Sonny! Get up! Sonny! Get up!

CLARK: Lord, have mercy. Shit!

Clark moans and breathes very fast. Bursts of breath come one after the other—*whew, whew, whew*—interspersed with bursts of incoherent words.

HALLIDAY: Sonny!

CLARK: *Wooop. Woooooooop. Bop. Whip.* [*His hands clap a few times weakly.*]

HALLIDAY: Gin?! Gin?!

HALLIDAY: Gin?!

Millay's voice continues, reading poems such as "The Ballad of the Harp-Weaver," "O Sleep Forever in the Latmian Cave," "I Must Not Die of Pity," and "To the Maid of New Orleans."

Halliday's fear about Sonny's condition is thick. He wants McEwan, but she is not within earshot.

HALLIDAY: Sonny, don't lie down. Sit up! You'll get your pants dirty. Sit up!

When users come close to a heroin overdose, it is crucial to keep them upright and attentive.

Halliday begins scat singing the Dizzy Gillespie tune "Groovin' High" to Clark, making up new lyrics that include Clark's name.

HALLIDAY: *Doo be da, doo be de, doo be da, dee dee, dah dah, bop bop . . .* Sonny Clark is here again. You remember that one, Sonny?

Halliday is trying to keep Clark alive. Next, he scat sings the Ray Charles tune "Hit the Road Jack," which rose to the top of the charts that fall and was all over jukeboxes and radios at the time.

HALLIDAY (*singing*):

Sonny Clark's working at the White Whale Pussycaaaaaat.*

He can't get paid, but he gets his ass a staaaaaash.

He gets his head ripped, and that's all he cares abou-ou-ou-ou-out.

Clark moans deeply and uncontrollably, floating in and out of consciousness.

HALLIDAY: Gin? Gin?

Halliday whistles, trying to attract McEwan's attention from wherever she has gone in the building. He whistles again.

HALLIDAY: Sonny, do you want me to help you? Sonny, are you awake?

Sonny stirs into coherence.

HALLIDAY: Sonny, you trust me, don't you?

CLARK: Shit, yeah.

HALLIDAY: I don't know what white folks you trust. Have I ever hurt you? Have I ever lied to you?

*The White Whale Pussycat was probably a conflation of two different clubs. The Fat Black Pussycat was a coffeehouse on Minetta Street in Greenwich Village, where Clark was known to play at the time. The White Whale was another Village club. Some of Bob Dylan's earliest gigs in New York were at the Fat Black Pussycat earlier in 1961, and he also played the Gaslight Café around the corner.

poems and letters of Emily Dickinson

read by *Julie Harris*

Caedmon **TC 1119**

A few seconds pass.

HALLIDAY: Sonny, let's go. Gene wants a malt and a hamburger, and I told him I'd bring it back to him. Come on, Gene's waiting on us.

Smith walks through the screen door again and into the hallway. Halliday stops him and shows him something. It is a new amphetamine.

HALLIDAY: Hey, Gene, let me show you this. You can put it in your coffee. Or you can inject it in your ass if you have a spike.* You can also put it right in your vein.

SMITH: No, thanks, I'm okay.

A few seconds pass; footsteps are heard going down the stairs all the way to the sidewalk level. Clark shuffles along behind Halliday.

*A syringe.

The Edna St. Vincent Millay record continues to play while Smith packs, and random loft noises are collected on Smith's tape for thirty-five minutes.

Smith puts another record on his phonograph, *Poems and Letters of Emily Dickinson* read by actress Julie Harris, a 1960 Caedmon release. Harris's voice is warmer and more modern than Millay's, but the operatic qualities still transcend the words in effect on Smith's reel of tape.

> *"Because I could not stop for Death—*
> *He kindly stopped for me—*
> *The Carriage held but just Ourselves—*
> *And Immortality."*

Smith owned most of the records in the Caedmon catalog, and he listened to them while he worked in the darkroom. But something about his decision to play Millay and Dickinson at this time seems intentional. These two dark, melancholy poets might have sympathized with the plight of Lin and Sonny, Smith may have thought, and the female voices correspond to McEwan's.

Clark and Halliday return to the loft.

HALLIDAY (*to Clark*): She's pregnant and her mind is fucked up. You know she's pregnant, don't you?

CLARK: I'm pregnant, too. I'm not bothering her.

HALLIDAY: Anything bugs her. You got to leave her alone.

CLARK: What did I do?

HALLIDAY: You scared her. Come on, leave her alone. You're my best friend. She's pregnant. Her nerves are shot. You've got to understand.

Two minutes pass.

HALLIDAY: Where is Gin? Did she split?

CLARK: What are you so worried about?

HALLIDAY: She's my old lady, man. I don't care whether she's wrong or not. She's

pregnant and her nerves are shot. We don't have a pad and I can't leave her on the street. I'm responsible for that little chick. As bad as she is, she's just as good.

CLARK (*moaning again*): Oh, lord, have mercy. Oh, lord have mercy. Oh, lord. Oh, lord.

HALLIDAY: I got everything on my back. I've got to walk around with a chick that don't know what the fuck she's doing and a cat that's out of his head. And I gotta keep them both straight, and both are acting like nuts. I can't have any peace at home, you know, because nobody has any sense. You ain't helping me, Sonny.

CLARK: Bitch.

HALLIDAY: Well, you won't help me, man, you're fucking out of your head. I can't relax and enjoy it, man, because my old lady's here, and she's flipping and you're making it worse, and you can't understand why nobody's having any fun. Shit, I'm sick of everybody, even you when you do me like this. I'm leaving. Police want me to work so I can take care of myself. I can't get into the union because I can't pay the one thousand dollars. I can't get a cabaret card,* so fuck everybody. I can't even clean up. I can't get any clothes.

I got a wife that's nuts, but just as beautiful as she is nuts, so I don't know what to do. My friend's beautiful, but he's fucking out of his head, too. For every bit that you help me you drive me that much crazier. Shit. Thanks a lot. Thank god.

*The New York City Police Department issued "cabaret cards" allowing musicians to play at clubs that serve alcohol.

Smith comes out into the hallway. Halliday has assembled an armful of glass bottles to redeem for deposits.

HALLIDAY: Gene, good luck in Tokyo, man. I got to take my two maniacs, my wife and my maniac friend—both of them are fucking nuts—and get the fuck out of here. I feel like I'm responsible for the whole world, like I'm the only sane person here, and I'm nuts. Good luck, man. Will I see you when you get back?

SMITH: I imagine. You need some help carrying those things?

HALLIDAY: You don't have a bag anywhere, do you?

SMITH: I don't know. Let me see.

Smith comes back out a few minutes later with a bag and many more bottles for Halliday.

HALLIDAY: Aw, man. Crazy. Hey, listen, will you give me your address?

SMITH: As far as I know, Overseas Press Club. Tokyo, Japan.

HALLIDAY: W. Eugene Smith. Overseas Press Club. Tokyo, Japan.

SMITH: Yeah, that's it.

HALLIDAY: I'll probably send you a card. If we have a fire or anything I'll write you.

SMITH: You can think of some other reason than that.

HALLIDAY: No, but I'll sure miss you, man. Good luck. You're about the only person I know in this building or any other building that's got any sense. All my friends are either alcoholics or nuts or something. Even when you are incapacitated you've got some sense about you. Look at this cat [Clark].

You know, he's one of the best piano players alive and he's killing himself. Me? I'm just a very good tenor player. I sure wish I had his

ability. I never get fucked up to where I can't see where I'm going or know which way is up. This fucking cat's got me going nuts. Hey, where's the nearest grocery store, on Twenty-first Street?

SMITH: There's a delicatessen up here about Thirty-first Street.

HALLIDAY (*counting bottles*): Two, four, six, eight, ten, twelve, fourteen, sixteen, eighteen, twenty, twenty-six, thirty. I got thirty-seven.

HALLIDAY (*to Smith*): Hey, when you get over there [Japan], look for some methedrene because, you know, that's where they invented it. When you come back I'll be working. Boy, I wish you all the best. I know I'm corny, but you sure been good to me.

HALLIDAY: You don't have Ronnie Free's number, do you?

SMITH: I don't have the slightest idea where Ronnie is.

HALLIDAY: I think my old lady split on me. Put your hand out there and let me have some skin. You leaving today, this afternoon?

SMITH: If I can finish packing.

HALLIDAY: See you later, Gene.

HALLIDAY: Sonny, get up. Come on, Sonny. Aw, man. You just want somebody to help you. Gene, I'm going to leave this character here.

Clark climbs to his feet and stumbles forward.

CLARK: Gene, I'll see you.

SMITH: Hm?

CLARK: I'll see you. Take care.

SMITH: All right.

CLARK: And . . .

SMITH: And my children have horseshoes, I know.

Clark laughs and stumbles downstairs.

SMITH: You going to make it all right?

CLARK: Yeah.

Postscript

Sonny Clark died of an overdose after playing a gig at Junior's Bar on the ground floor of the Alvin Hotel at Fifty-second Street and Broadway in January 1963. It is unclear if Gene Smith ever saw Clark again. Smith and Thomas stayed in Japan until fall 1962. During the sixteen months between this night and Clark's death, he participated in several classic recording sessions for the Blue Note label, which were released under his own name and the names of Grant Green, Jackie McLean, and Dexter Gordon.

Virginia McEwan left New York a month later and never returned. Today she lives on a peninsula off the Pacific coast of Washington with her husband, bassist Ted Wald, whom she first met at 821 Sixth Avenue. She maintains close contact with her daughter Laura, whom she had with Lin Halliday and put up for adoption.

Halliday survived until 2000, never changing many of his substance habits, and managing to play inspiring music every so often with much younger musicians in Chicago.

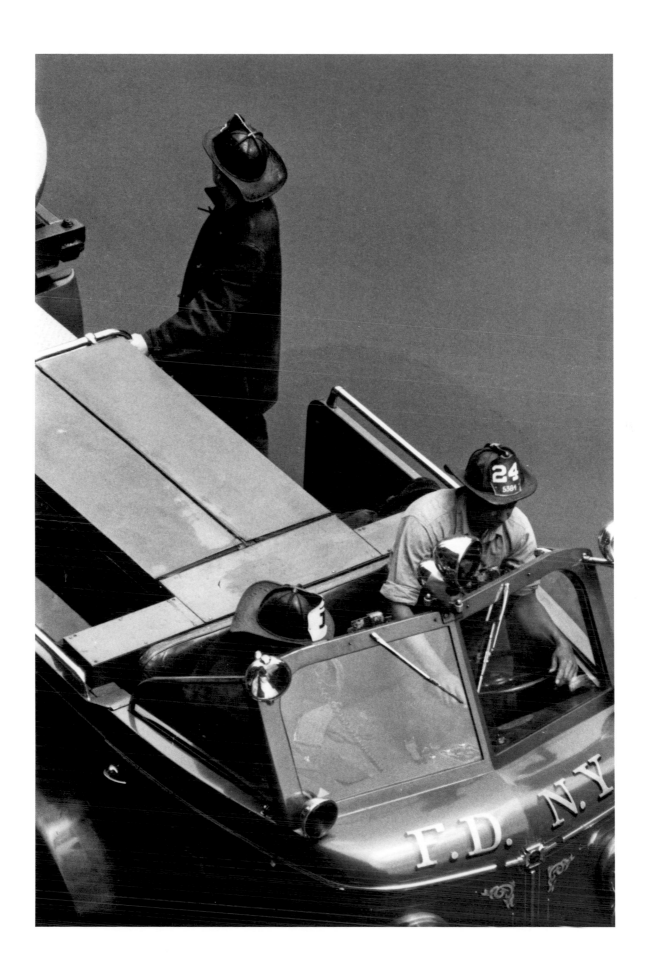

"One day I walked in, I was talking to Jimmy, we were sitting down, just talking. Nobody was playing. I think Jimmy was the only one there and I saw a guy sleeping. This guy was sleeping on a couch. He looked pretty disheveled. He looked like what we describe nowadays as a homeless person. I just saw this guy lying there, and I said, 'Jimmy, who's that, man?' Jimmy said, 'It's Bill Evans. He's a great cat.' I thought, *Bill Evans, damn!* I couldn't believe it. I figured the whole thing out, like with his drug habit or whatever. I got the indication he did that quite often. Jimmy probably let him come up there any time he felt like it. Jimmy was generous to do that. That a guy of his [Evans's] stature would have to do that, that's pretty weird: Bill Evans sleeping on Jimmy Stevenson's couch. It made me think of Charlie Parker not having a place to sleep."

—IRA JACKSON, saxophonist who knew Stevenson from their youths in Detroit

"One time I remember Wilbur Ware going in the bathroom and staying for an hour and a half. When he came out he picked up one of the basses that was in the loft and played it more beautifully than you can imagine."

—DAVE SIBLEY, bass player and loft resident

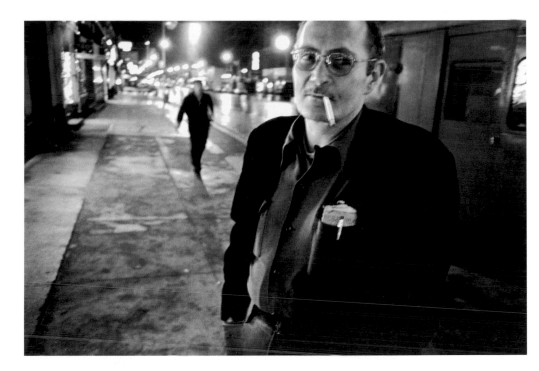

"Well, you open the door to his studio and it was like an actual warehouse. I've never seen so many cameras in one place. It's like going to the back of a camera store. And you walk around and there were cameras everywhere, camera equipment, photographic equipment. So he let two musicians stay there while he was gone once, and when he came back a couple of very expensive cameras were missing. He never said a word about it. He taught me a lot. I loved him for that. He understood. He thought, *They needed those things more than I did.* It wasn't that they were thieves in his mind. It's that they thought they had to have it, and he didn't care."

—DAVE SIBLEY

"I had been visiting Ralph Steiner, just a social visit, and I was walking home. It was beginning to rain. And there was Gene standing in front of a lighted store, where they sold yarn or something, and he was looking the way he looks in the picture. He had just been robbed. His cameras were stolen and, what was worse, cameras with film in them. Because, well, in the loft he had got involved with junkies, and the junkies were stealing the cameras. I didn't know at that time that Gene was a junkie himself, because he didn't tell that to anyone except other junkies."

—DAVID VESTAL, photographer, writer, and friend of Smith's

W. Eugene Smith, Sixth Avenue, New York City.
Photograph by David Vestal, March 1965.

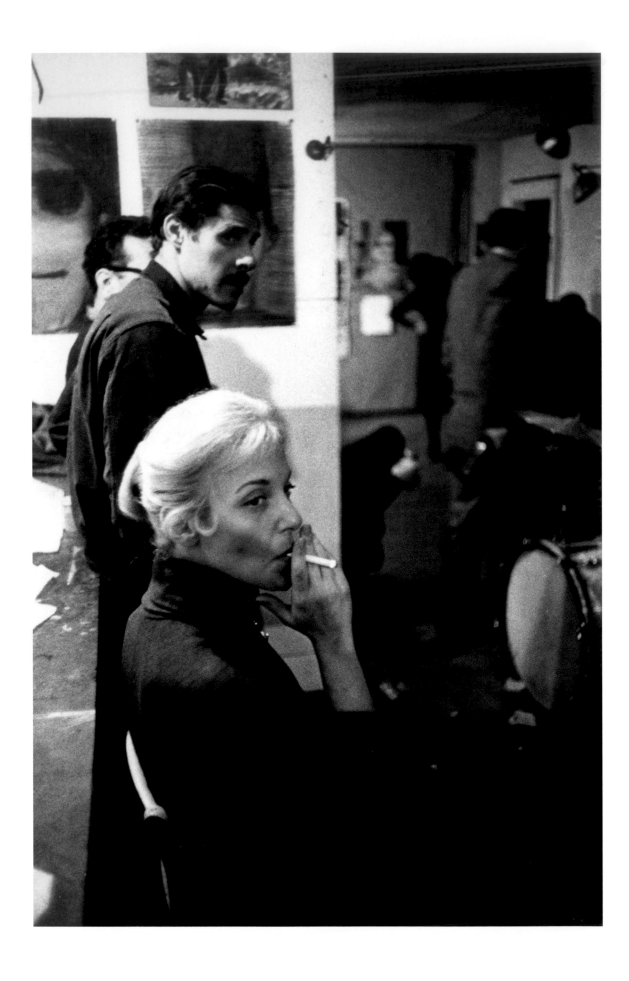

March 5, 1963

Smith recorded the end of an uniden
tified program on Picasso and, following
that, actor Jason Robards reading
F. Scott Fitzgerald's 1936 autobiographi-
cal essay *The Crack-Up*, from WNEW
television Channel 5 in New York.

Guernica is important as a painting
aesthetically and culturally. But
beyond this it is significant because
Picasso did some sixty sketches for it,
which he carefully dated and num-
bered. It is the first time in recorded
history that an artist has created and
preserved such an extensive series of
preparations. As we look at these
sketches, we may ask at each step,
"Why did he do this? Why did Picasso
select the subject matter he did, the
cast of characters in the mural? What
sort of visual thinking led him from
the first concept to the finished
work?" The sketches should tell us
something about Picasso as an artist.
They should tell us even more about
the creative process in general.

Smith changes channels and ends up
settling on Robards reading.

*Of course all life is a process of breaking
down, but the blows that do the dramatic
side of the work—the big sudden blows
that come, or seem to come, from outside—
the ones you remember and blame things on
and, in moments of weakness, tell your
friends about, don't show their effect all at
once. There is another sort of blow that
comes from within—that you don't feel
until it's too late to do anything about it,
until you realize with finality that in some
regard you will never be as good a man
again. The first sort of breakage seems to
happen quick—the second kind happens
almost without you knowing it but is
realized suddenly indeed.*

*Before I go on with this short history, let
me make a general observation—the test of
a first-rate intelligence is the ability to hold
two opposed ideas in the mind at the same
time, and still retain the ability to function.
One should, for example, be able to see that
things are hopeless and yet be determined to
make them otherwise. This philosophy fitted*

*on to my early adult life, when I saw the
improbable, the implausible, often the
"impossible" come true. Life was something
you dominated if you were any good. Life
yielded easily to intelligence and effort, or to
what proportion could be mustered of both.
It seemed a romantic business to be a
successful literary man: you were not ever
going to be as famous as a movie star, but
what note you had was probably longer-
lived; you were never going to have the
power of a man of strong political or
religious conviction, but you were certainly
more independent. Of course within the
practice of your trade you were forever
unsatisfied—but I, for one, would not have
chosen any other.*

January 1964.

Uher overlapping with Tandberg. Blind Roland Kirk, Paul Bley, Jay Cameron, etc. Additional musicians on the recording are Edgar Bateman and Eddie De Haas. Tunes played included "The Donkey" by Carla Bley.

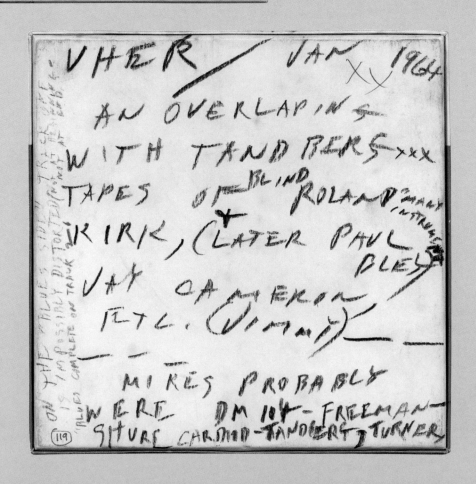

January 1964

When Smith taped this discussion with loft resident Jimmy Stevenson, Smith was forty-five and Stevenson was twenty-four. The discussion concerns keys to the loft building and recurring thefts by, among others, a folksinger. In 1969, when Smith put together a monograph of his life's work for *Aperture*, he included a photograph of Bob Dylan in his loft section. The photograph was made in the studio of Columbia Records, which was only a few blocks away from 821 Sixth Avenue, but Smith's placement of the photo in the book indicates Dylan may have been at the loft. In the late 1930s Smith had roomed with Pete Seeger in New York, and Smith's collection of folk records was extensive. Drummer Ronnie Free, who lived in the loft for two years, remembers folksingers being in Smith's loft. There is a singer of Jewish folk songs, Nehama Hendel, recorded on Smith's tapes. In 2005 Dylan, who was known to walk off with people's vinyl records, had no recollection of being in the loft.

SMITH: I don't intend to take any more chances with my stuff up here. I mean, you just think about how much of my stuff I've lost to people who are supposedly reputable that I've trusted. You might worry about who you lend out keys to, various people.

STEVENSON: Anybody could break in, anybody who comes by here, Gene, could break in here. Any one of your friends could break in. When I moved in here . . . all I know is that you had given keys to Will Forbes, and you had given keys to that other woman— what's her name?

SMITH: Well, if there's anyone in the world I trust it's Ruth [Fetske].*

STEVENSON: If you are gonna constantly be worried about stealing you can never leave the place.

SMITH: I can give you the name of a reputable folksinger who, understand, who has a high reputation, et cetera et cetera, that, um, can also print somewhat and was working for me one weekend and who walked off with a camera. And then he said, "Well, gee, I saw them all there and I didn't have one and I just couldn't resist."

STEVENSON: Well, let me ask you this here. Do you know of anybody I've allowed up here that's ever taken anything out of here?

SMITH: Uh, well, you've said yourself that people who've been up here at the time you were in possession of the place . . . I mean, uh, not possession of it, but with other people, uh, musicians . . .

STEVENSON: When I first moved in here it was nothing but a dope fiend pack of rats up here, all kinds of weird people who were up here when I first came up here. I mean it was just like, it was open havoc. I mean, it was ridiculous. And I myself changed the lock on it and ordered all those people away from this place. You know, because there wasn't any door downstairs. You had thousands and thousands of dollars of equipment, and there wasn't

*Fetske worked for an advertising agency near 821 Sixth Avenue. She helped Smith manage his bank accounts, pay his bills, and organize his materials, especially while Smith and Carole Thomas were in Japan in 1961 and 1962.

even a door downstairs to lock at night.

SMITH: I know, that stuff was taken from inside by . . .

STEVENSON: Well, that's an inside job, some inside people then.

SMITH: All right. But that's exactly why I don't want keys so loosely played out to my place. I've been paying rent on this.

STEVENSON: You've been paying rent a long time, but you can't trust your own people.

SMITH: I would be an ass to go ahead and take more chances like this.

Telephone rings; Smith answers.

SMITH: Hello? Uh, yeah, he's right here. [*Hands phone to Stevenson.*]

STEVENSON: Hello? Well, all I can say is that, is that, uh . . . yeah, I'll be there shortly.

"We helped because he was so talented. And he was sick. He was sick. He had this terrible wound to his head during World War II; he was in great pain. They gave him narcotics to ease the pain, and I think he continued with the narcotics, both for pain and for pleasure. When you see somebody with such great talent— and he had enormous talent—who kind of couldn't get out of his own way, you wanted to help him. All of us— everybody who was helpful—were all photographers ourselves, and so it was a pleasure to help. And I think Gene was a great salesman of himself. There were a lot of people who didn't like him because they felt used. But nobody can use you if you don't stand there and be willing."

—RUTH FETSKE

January 1964

Conversation between twenty-seven-year-old multi-instrumentalist Roland Kirk (later known as Rahsaan Roland Kirk), who was blind, and thirty-five-year-old baritone saxophonist Jay Cameron. The club environment for jazz musicians in New York was never very comfortable. Sometimes they performed five or six forty-five-minute sets per night, from nine p.m. until three a.m., and they'd go home with promises that they'd get paid later. But the situation got even worse when rock and roll, folk, and rhythm and blues dispersed and diluted much of the audience.

ROLAND KIRK: I'm gonna tell you one thing . . . I'm gonna get me a club . . . It's the only solution.

JAY CAMERON: I got a great location for you. They took over a building over on the Bowery across the street from where the Five Spot* used to be, you know, and they completely refurbished it. It used to be a bank at one time, yeah, they made a theater out of it, you see. The people that redid the building were thinking of a theater, but they did a basement, too. Man, they fixed it up completely, and it's just standing there waiting for somebody to come in.

KIRK: Big place?

CAMERON: Well, I'd say it's about as big as the old Five Spot.

KIRK: I want a place where people have to crowd in, like the old Five Spot.

CAMERON: Well, this place could fit that. It's very hip in this place. . . . Any

*An important club at Cooper Square that had about a hundred seats.

kind of thing like this you've gotta have some bread.

KIRK: Well, I know it takes money, yeah.

CAMERON: And be ready to kind of stick to it for a while, you know?

KIRK: Well, that's what I'm saying, as long as I'm playing in it, man, every weekend, I'll be willing to stick it out. Bass starts bowing in the background. It's probably Henry Grimes.

KIRK: Well, I still got a feeling about if you go about something the right way, it eventually will pay off. And then there'd be sessions. See, I wanna have sessions. [Today] there ain't no way to jam—I'm talking about relaxed—without some kind of hassle going on or a cat telling me what bands are going to play.

CAMERON: Of course. There was a club like that, and they kind of gave jazz a pretty good chance to draw just on the basis of the sessions, but they were still too organized.

KIRK: Well, you'd have a different thing every day. And then at the last part of the night cats would jam, everybody accepted, six nights or seven nights. Everybody'd have a chance to play because there wouldn't be just no set kind of groups. There would be all kinds of groups.

Here's what I'm saying. Look, I know, like, it's going to take a lot of work. But I hope to the man upstairs, when I get fifty years old, I don't have to keep walking around paying rent to somebody else and I don't own nothing of my own. When I get to forty or fifty years old I don't want to be working for anybody else, man, but myself, you know. Because I'm tired of people capitalizing off of me, man, you know, taking my thing and then

that's it. When they get tired, you know, I'm off again, and you know, like, "We gotta get somebody else." But if I got my own joint, man, I can always be out there.

I mean, if you want to play music, you've got to think about it in more than one way. You've got to think more than just going in somebody else's club, man. I mean, I may not do it in the next five years, but I'm going to do it before I pass away, you know.

CAMERON: If you want to look at this joint anytime, just give me a buzz.

Postscript

Kirk died in 1977 at age forty-one.

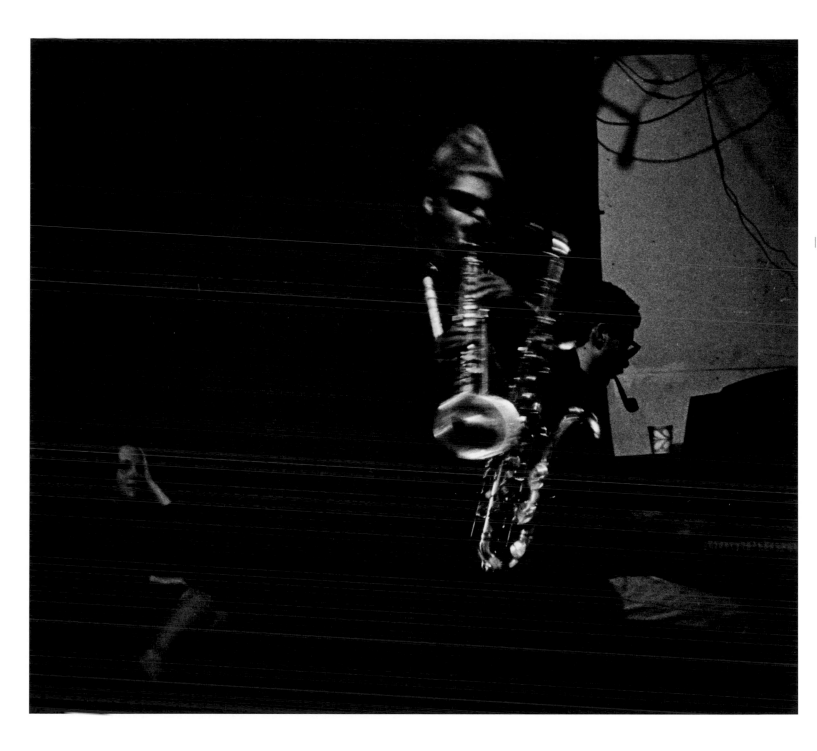

Patty Waters, Roland Kirk, Paul Bley

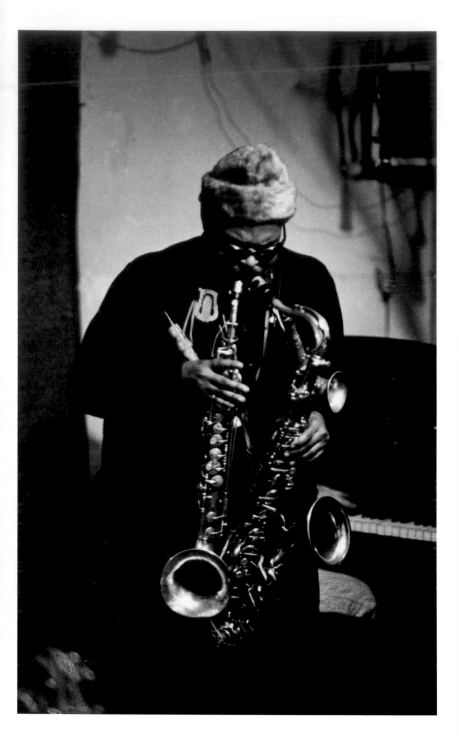

Roland Kirk

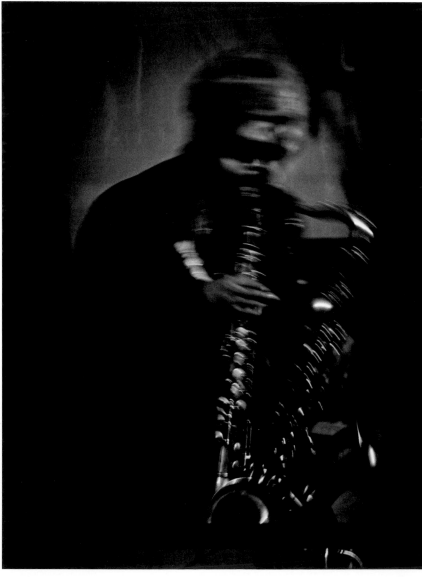

May 8, 1960

Smith randomly recorded loft dialogues and TV programs. On this tape you can hear him changing channels. He stopped at Edward R. Murrow's program on CBS (Channel 2 on the dial), *Small World*, in which there is a roundtable discussion on art and culture with Murrow, American playwright Tennessee Williams, Japanese novelist Yukio Mishima, and British film critic Dilys Powell. Smith deeply admired Williams's work and photographed him for *Life* magazine. He also had a lifelong obsession with Japanese culture, so it's little wonder he turned up the volume of this program when he came upon it.

Smith's recorder picks up the show during a discussion of Japanese cinema. Throughout the recording, the fourth-floor loft windows are wide open—temperatures that week approached seventy degrees—and the periodic chug of the Sixth Avenue bus is recorded from the street below.

POWELL: The point I should like to make is, how difficult it is for the ordinary European audience to accept the difference in approach, as it seems to us, the very complicated mode of expression and of thought. They seem to the ordinary Western European, I think, very complex, the modes of thought in Japanese cinema.

WILLIAMS: Miss Powell, you have to be a decadent Southerner to understand the Japanese cinema [*general laughter*].

POWELL: Well, it is difficult for the ordinary person.

MISHIMA: Miss Powell, I think a characteristic of Japanese character is just this mixture of very brutal things and elegance. It's a very strange mixture,

and may I say your country's culture lacks similar characteristics of culture, doesn't it?

POWELL: What, of extremes of brutality and elegance?

MISHIMA: Shakespeare's plays have beautiful delicacy and elegance.

POWELL: If Shakespeare were to write today, I think he would have a terrible flop in England. I think, you see, that there is a great barrier between countries because of the difficulty of understanding their art. You see, art should help us understand one another, shouldn't it? But very often I think it makes it more difficult.

MURROW: I'm terribly sorry, but I must bring down the curtain for one moment while we have a word from Olin-Matheson.

ADVERTISEMENT (*read in a vintage mid-century authoritative male voice*): The world's strongest gun barrel is now made of glass [*shot blasts*]. From Olin-Matheson research comes the first change in basic materials in six hundred years, a shotgun barrel made of glass fiber. Five hundred miles of glass fiber, finer than silk and stronger than steel, are wound around a thin steel tube to form the world's lightest and strongest shotgun barrel. Now featured on the new Winchester Model Fifty-nine. Test-proven under every extreme of moisture and temperature, this new Winchester performs perfectly [*shot blasts*]. Remarkable strength, one of the fastest-handling, fastest-firing twelve-gauge shot automatic shotguns, the Winchester Model Fifty-nine is another example of how imaginative research and craftsmanship at Olin-Matheson provides famous Winchester sporting arms for

the recreation of millions. This is the work of Olin-Matheson.

MURROW: Now, back to our conversation.

WILLIAMS: Yukio, you were talking about brutality and elegance. I think I understand what you mean. I'm not being snobbish when I say that, but I think that you in Japan are close to us in the Southern states of the United States.

MISHIMA: I think so.

WILLIAMS: And I think I am able to understand how you put those two terms together, brutality and elegance. I could not define why. You in Japan have certainly achieved that. I think what you meant is that we must depict the awfulness of the world we live in, but we must do it with a kind of aesthetic, you know?

MISHIMA: Yes, I know.

WILLIAMS: A kind of beauty and grace. So that although it is horror it is not just sheer horror, it has also the mystery of life, which is an elegant thing.

MISHIMA: Yes, we have mystery. But even in contemporary Asia we are always looking for such a pure, genuine elegance that when—

POWELL (*interrupting*): This, this is too much for me. I'm suffering here, I'm suffering terribly. Brutality and elegance, all right, I accept it in your plays, Tennessee, and I accept it in Japanese cinema, but you say that the Southern states of America have perhaps a kind of fellow feeling with Japan because of this kind of congruity of brutality and elegance?

WILLIAMS: I think we are a little less

abhorrent of it—of the combination of it—than you in England are at the present time. I think you are still a little frightened of perceiving brutality in a sensation which is almost elegant or graceful.

POWELL: I do think that violence is getting an appalling hold on art, particularly in America. You in America have gone much farther with violence than we have. . . . I really do shrink from brutality and violence. . . . I accept brutality and violence, but I feel the movement is getting out of hand.

WILLIAMS: Darling, when we depict violence do you think we are praising it or denigrating it?

POWELL: Sometimes you are . . . under the cover of denigrating I think you are exalting it.

WILLIAMS: You have a possible point, darling, provided we are all masochists [*laughter*]. Let us all not deny all the dark things in the human heart, but let us try to cast a clear light on them.

MURROW: We must quietly culminate this conversation that we have had this evening. Thank you all very much.

ADVERTISEMENT: Americans at work. Thinking. Making. Doing. Solving. And because good health is fundamental to good work, here at Squibb, the fight against enemies of health is constantly waged. Scientists and technicians at the Squibb Institute for Medical Research are working on many fronts: cancer therapy, hormone research, and even atomic energy.

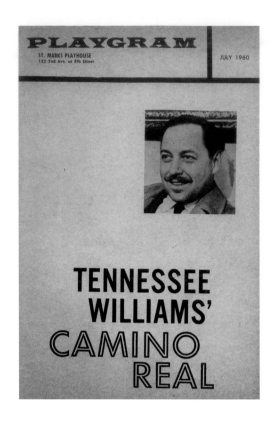

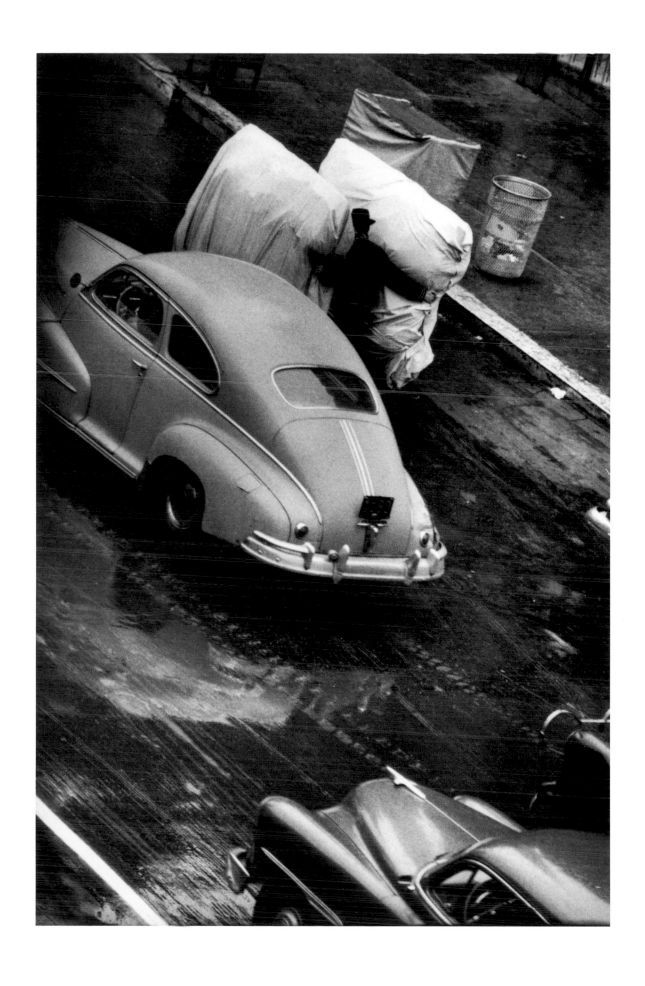

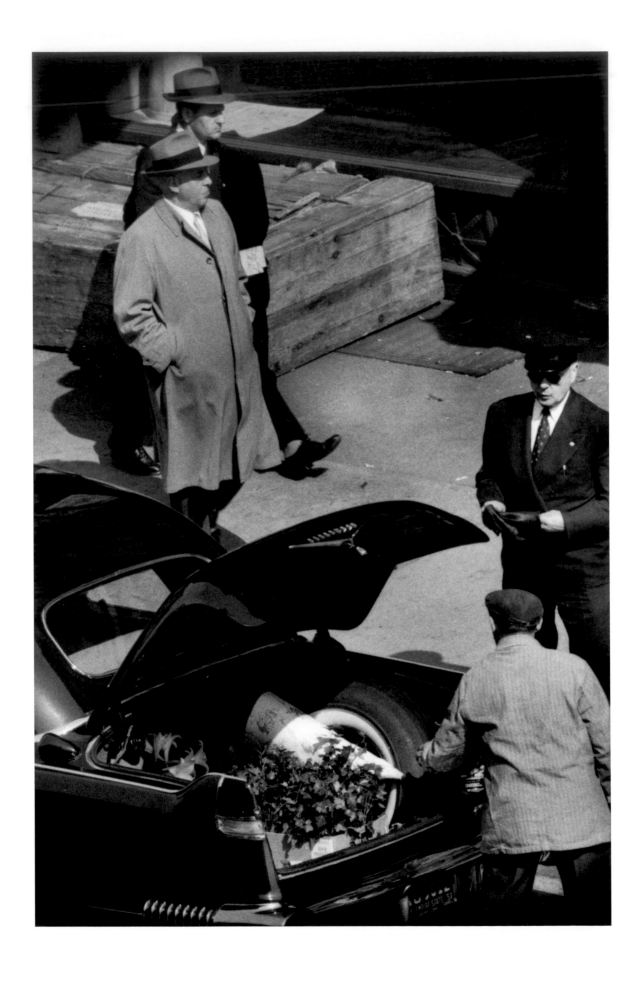

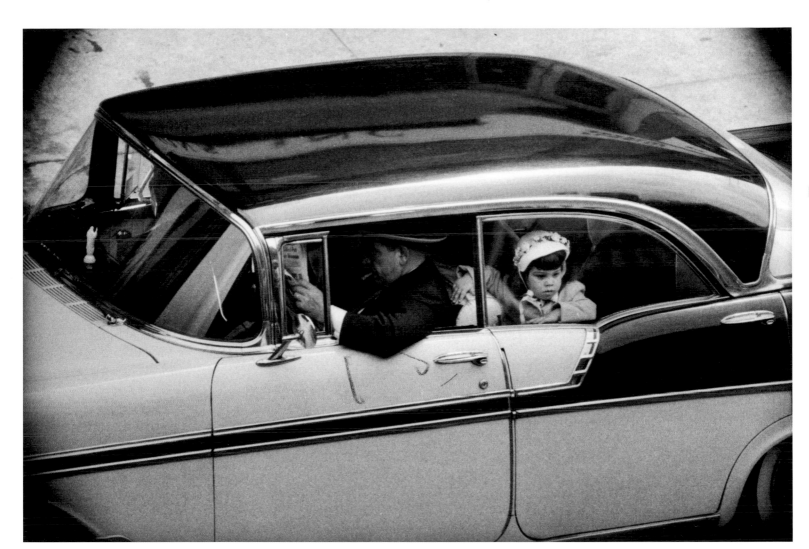

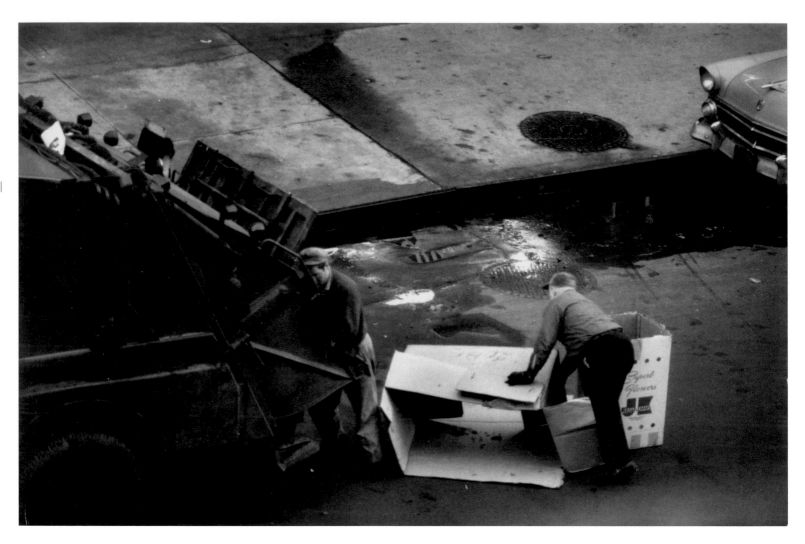

"Gene was a theater nut. You see the drama—and at its worst, the melodrama—in his photographs. If you look at the people associated with Gene you see a great deal of the nonverbal—because acting is nonverbal: the playwright does the words for you. If you look at Gene's culture—musicians, actors, playwrights—remember Carole was coming from acting.

"Music was so important for Gene. I mean, diffusion—everybody says Gene had this little wire screen he used to hold under the enlarger lens, which is perfectly true, but he also had two bass reflex cabinets in the darkroom, and when he cranked up a little Bach, the enlarger would shake. I swear to God, half of his diffusion was Bach-inspired."
—**BILL PIERCE,** photographer and student of Smith's who had come out of a community theater in upstate New York, where he first met Carole Thomas

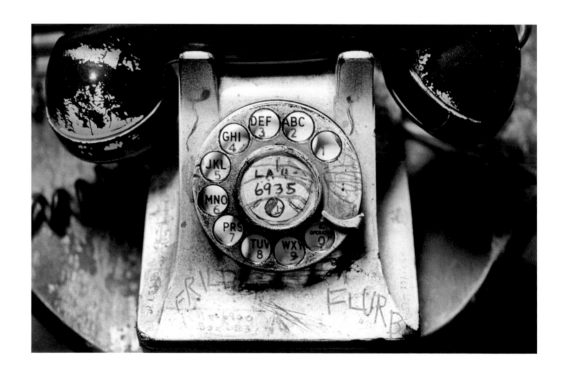

Gene's loft phone. Photo © by Sonia Katchian.

Circa 1963

Smith photographed Charlie Chaplin for *Life* magazine on the set of *Limelight* in 1952. He was drawn to Chaplin's visual poetry and his complete control of the creative process: acting in his films, shooting thousands of extra feet of film for each scene, writing his own music, editing the final product. Plus, Chaplin's moral imperative no doubt impressed Smith, who may have seen something of himself in the Tramp. Carole Thomas has suggested that Smith should have been a filmmaker, that the rhythms and sequences he sought for his photo stories were more suited for cinema.

On the label of this undated reel Smith wrote, "Last attempt to call Chaplin."

Why was Smith making this telephone call? There is no way to be sure. He often wrote long, melodramatic letters to other artists—Elia Kazan, Haniel Long, Ansel Adams, Sidney Lumet, Leopold Godowsky Jr.—seemingly in an attempt to find sympathy. Of course, Chaplin was married to Eugene O'Neill's daughter, Oona, and Smith was a passionate fan and, he said, disciple of O'Neill's work.

There are many possible motivations to try to reach Charlie and Oona Chaplin, but a more mysterious question is, Why did Smith record the effort?

"Your station for news. WOR AM and FM, your RKO general . . . at the time tone, exactly five a.m. [*brief silence; dial tone, rotary dialing sound*]."

SMITH: I wish to make a long-distance call to Switzerland.

OPERATOR: Switzerland?

SMITH: Yes, please.

OPERATOR: Just a moment, please. [*To another operator:*] Switzerland, please. One-one-three-three-one, one-one-three-three-one. Thank you. [*Ringing.*]

SMITH: Hello? [*More ringing, after immediate transfer.*]

OPERATOR: I guess they're out to lunch.

SMITH (*chuckling*): Who?

OPERATOR: Overseas operator one-one-three-three-one.

OVERSEAS OPERATOR (*finally responding*): Overseas three-three-one.

OPERATOR: Area code two-one-two to Switzerland.

OVERSEAS OPERATOR: Overseas, may I help you?

SMITH: I wish to call Mrs. Oona Chaplin at Vevey, is it? Vevey, Switzerland?

OVERSEAS OPERATOR: Where in Switzerland?

SMITH: V-E-V-E-Y. It's near Bossonnens. And the number is five-one-zero-three-five-one.

OVERSEAS OPERATOR: Five-one-zero-three-five-one.

SMITH: Yes, and that's Mrs. Oona Chaplin.

OVERSEAS OPERATOR: Runa, did you say?

SMITH: Oona. O-O-N-A, Charlie Chaplin's wife.

OVERSEAS OPERATOR: Thank you, and may I have your number?

SMITH: L-A-four-six-nine-three-five.

OVERSEAS OPERATOR: And your name, please?

SMITH: W. Eugene Smith.

OVERSEAS OPERATOR: Thank you for calling. [*Pause while the operator calls the Chaplin household.*]

OVERSEAS OPERATOR: Mr. Smith?

SMITH: Yes?

OVERSEAS OPERATOR: Mr. Smith, Mrs. Chaplin is not in, and they do not know when to expect her. Would you like us to leave word?

SMITH: Yes, please. If she's coming back tonight, anytime tonight would be all right.

OVERSEAS OPERATOR: All right, Mr. Smith. And we'll leave word, and we'll call you as soon as we hear from the party.

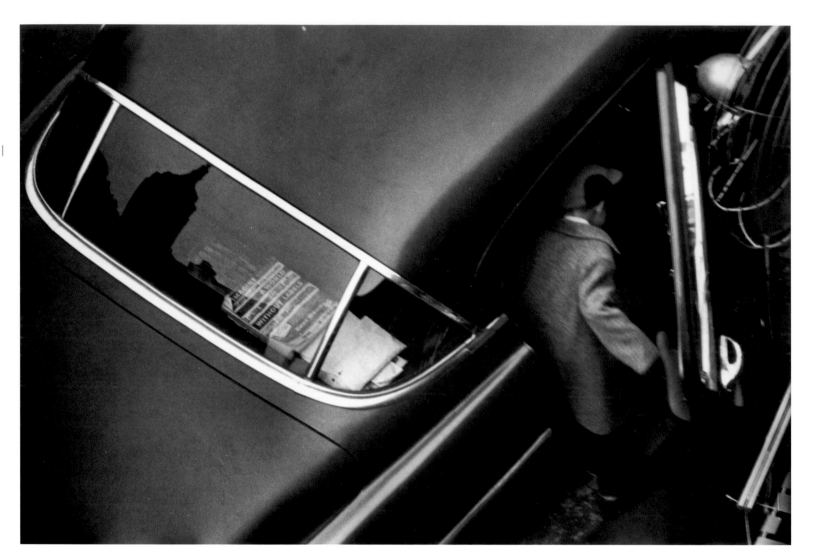

#2

PAWN TICKETS

W. Eugene Smith

photographer ⋄ photographic journalist

821 Ave. of The Americas, New York 1, N. Y.

*some immediately important—
but must be re-thought out*

TOTAL $ 1980.00

#2 LIST OF EQUIPMENT

✗ 51271 – 350mm (NIKKON TELE.) lens	$	100.
51269 – NIKKON F { 35mm f=2.8 lens	$	80.
✗ 53425 – NIKKON F { 28mm f=3.5 (?) + motor back + battery case	$	125.
52393 – 2 NIKKON F { 55mm f=1.4 / 105mm f=2.5 ONE ZEISS TURRET FINDER + 2 Leitz UNIV. Finders	$	200.
✗ 51272 – NIK. ZOOM lens	$	100.
51267 – P-CANNON with Fuji lens + 90mm F=4 Leitz collapsable lens	$	75.
51270 – NIKKON F { 55mm f=3.5 micro-nikkon	$	75.
51808 – (3 cameras, 5 lenses) 24mm MIRANDA, ROBOT, CANNON 135mm NIK + others (see list attached to ticket)	$	250.
51265 – 3 lenses { NIKON – 21mm / CANON – 100mm F.2 / KOMURA – 200mm	$	125.
52698 – KOMURA 300mm lens Sekonic Exp. meter, 2 light meters	$	60.
51907 – Leica M3 { Biogon 21mm + 9 Finders Retina Asahi Pentax { TAKUMAR 35mm F=3.5	$	140.
52062 – M3 50mm f.2 / M3 85mm 1.9	$	150.
51268 – NIKKON S.P. { 25mm f=4	$	100.
53109 – Asahi Pentax w/auto Takumar 35mm 2.3 ✗ 4 lenses – 53mm 4.5 Biogon / 210mm 6.8 Angulon / 90mm 8 Super Angulon / 135mm W.F. EKTAR light meter, Bellows (NIKON F slide copy) + attachment in case [see ticket]	$	200.
52615 – LEICA M3 { Cannon 50mm F=1.8 4 lenses – view – 100mm EKTAR / 65mm S. ANGULON / 210mm SYMAR / 360mm TELEMAR + finder	$	200.
TOTAL	**$**	**1980.00**

① 24173 Nov 3, 1959

Camera – Hasselbled wide angle
4.5 biogone lens

(A SECONDARY) C119436
YES C1W1185
 FINDER, 1074492 $ 100
 ($150.)

② 24175 Nov. 3, 1959

Lens in case
Cannon 4.5 400mm.
 10146
YES $50.00

③ 24176. Nov 3, 1959

3 lenses
NO ① Schneider Xnar
 45 10.5 CM
 794985
NO ② Telezera
 55 1462-860
(A SECONDARY) ③ Kilfitt Telekilar
YES 56 300 mm
 208 3972

Smith's pawn-ticket envelope and list

Left: Smith's list of pawned equipment

October 17, 1959

Gene Smith walked fourteen blocks up Sixth Avenue to Forty-second Street. There, across from Bryant Park, he spent $186.89 (about $1,400 in 2009 money) at Marboro Books, a local chain. He bought more than fifty books, a dozen art prints, some art stencils, and a 1960 calendar.

Various artists and writers were represented in the purchase: Aristide Maillol, Albrecht Dürer, Raoul Dufy, Paul Klee, Marc Chagall, Henry James, Marquis de Sade, Bertolt Brecht, Stéphane Mallarmé, Eartha Kitt, and George Bernard Shaw.

Additional book titles included:

The Art Director at Work: How 15 Medal-Winning Exhibits Were Conceived and Executed
Language and Myth
English Poetry
Treasury of American Drawings
Your Memory: How to Remember and Forget
Scientist of the Invisible: An Introduction to the Life and Work of Rudolf Steiner
Mind the Stop: A Brief Guide to Punctuation
Think Before You Write
Unconscious Motives of War: A Psycho-analytical Contribution
Painting and Reality
Learn to Draw
Work and Its Discontents
The Seven Lively Arts
Man and Shadow: An Allegory
Thistle and Pen: An Anthology of Modern Scottish Writers
Magic and Schizophrenia
The Tulane Drama Review
The Naked God: The Writer and the Communist Party
What Life Should Mean to You
Art as Experience
Essays in Philosophy
Man into Wolf: An Anthropological Interpretation of Sadism, Masochism, and Lycanthropy
The Parade: A Story in 55 Drawings

Two weeks later, on November 3, Smith took a box full of camera lenses to the Joseph Miller pawnshop at 1162 Sixth Avenue (at Forty-fifth Street) and received two hundred dollars in exchange. He parted with a Hasselblad wide-angle lens, a 400mm Canon, a Schneider 10.5cm, a Telescna, and a 300mm Kilfitt, among others.

On November 18 saxophonist Ornette Coleman's quartet opened a three-month engagement at the Five Spot Café downtown. It was the band's electrifying, nearly riotous first appearance in New York (they moved from Los Angeles). Coleman's controversial music marked the onset of "free" jazz, in which the standard forms and structures no longer applied, but it was deceptively traditional, blending elements of gospel, blues, and country with jazz and avant-garde classical.

On November 30, 1959, Smith pawned another $500 worth of camera equipment at Joseph Miller ($3,600 in 2009 money), and on December 4 another $165 ($1,200).

A short time after their arrival in New York, Coleman and his musicians—bassist Charlie Haden, drummer Billy Higgins, and pocket-trumpet player Don Cherry—found their way to 821 Sixth Avenue. Smith and Carole Thomas befriended Coleman, and by the mid-1960s, when they took over the fifth floor of 821 Sixth Avenue, Coleman would let himself into the loft at all hours to play and compose on the Steinway B piano in the back half of the fifth floor. "He was always so polite," says Thomas today, "so concerned that he was bothering us when we were trying to sleep. But it was our pleasure. We loved having him use the place that way." Coleman eventually had his own loft on Prince Street in SoHo with a similar welcoming policy. Smith was an adviser on Coleman's successful 1967 application for a Guggenheim Fellowship.

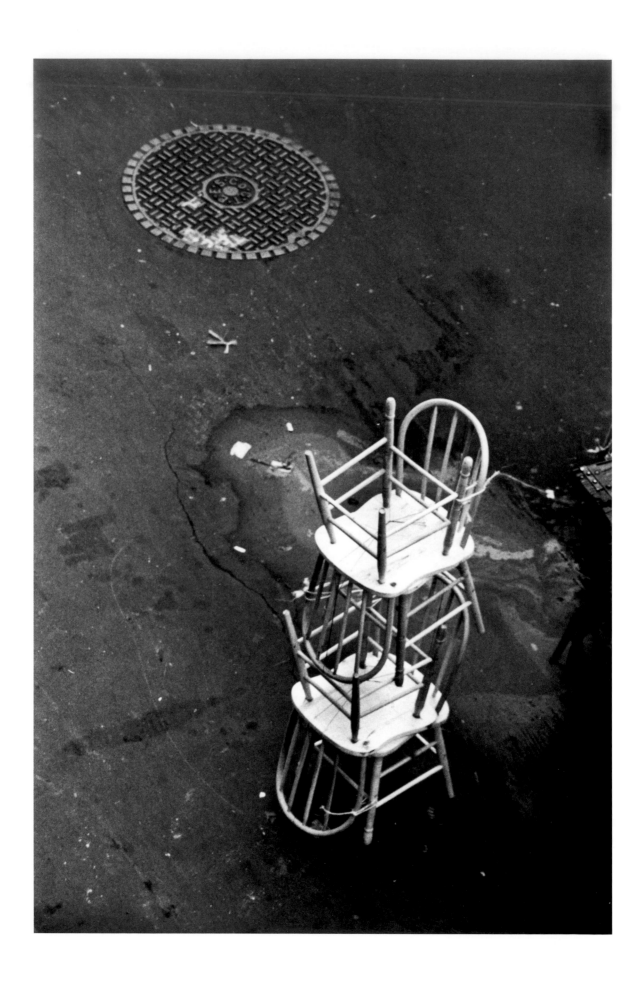

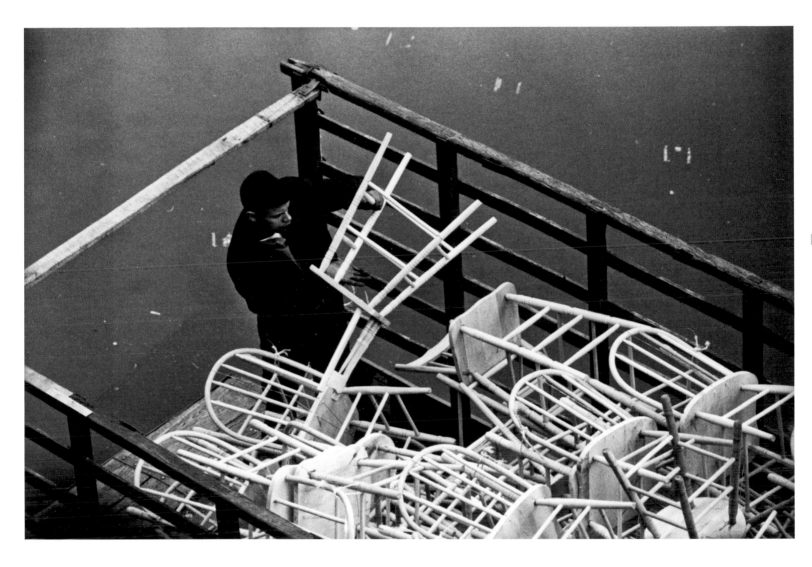

February 28, 1964

A reel recorded on this day contains a theatrical production of *Cyrano de Bergerac* taped off television and many news items taped off New York's WNEW television and off radio, including stories on the space race, the Vietnam War, Medgar Evers's murder the previous year, and civil rights demonstrations in Atlanta. The high temperature for the day in New York City is forecast to be forty-one degrees.

A neighborhood beat cop enters 821 Sixth Avenue, clearly familiar with Smith.

SMITH: I would actually, I would need about, the space of one and a half . . . a good place, fairly big, where I could get it organized properly. Because this goddamned place keeps me so jittery . . .

COP: I don't blame you. You've got a lot of things invested in here.

SMITH: . . . and I'm really spending about three-fourths of my time just struggling with this goddamned building, which is not getting me too much of anywhere except getting me exhausted.

COP: All right, Gene, let me look around and maybe I'll find something for you, maybe something that's a little more substantial than this building here anyway.

July 16, 1960.

Starts in a way. Paul Bley, Freddy Greenwell, Gary
Hawkins, Jimmy Knepper. Orson Welles reading
Emile Zola, Thomas Jefferson, Thomas Paine, and
John Donne on a vinyl record played by Smith.
Tunes played in the jam session include "Oleo" and
"After You've Gone."

Smith's note-card label of a reel, *Alice [McLeod Coltrane] and Jimmy [Stevenson] discuss recording.* Tabun, Smith's cat, meowing.

September 1961

Loft resident Alice McLeod, a pianist who later married saxophonist John Coltrane, and Jimmy Stevenson are discussing with Gene Smith the ethics of amateur tape recording in the loft.

STEVENSON: You couldn't do it, you couldn't do it without going through the union somehow.

SMITH: I don't mean escaping the union or turning it to legality. But, uh, let's just say, some of the stuff that I have taken [recorded] here with Ronnie and Fred.* Now, they were here playing together, you know, just a midday session. I mean, it wasn't a recording session, but some of the stuff was absolutely magnificent. Well, let's suppose something of Charlie Parker was to come out now, a private session . . .

STEVENSON: They'd clear all that shit and leave it to the estate of Charlie Parker.

SMITH: Yeah, but not before they discovered the tapes and decided it was worth being commercial.

*Drummer Ronnie Free and saxophonist Freddy Greenwell.

STEVENSON: Oh, you couldn't just bring 'em out without settling with the estate of Charlie Parker.

SMITH: Of course, this you've got to do. I'm not, I mean I'm certainly not saying skirt the union or anything else. Heavens, no.

McLEOD: That's the only way.

SMITH: I'm not trying to find a way to beat it. I'm just trying for my own information. [*Pause.*] Now, let's just say that I have my mikes up there like I previously had. And one day you said, "We're sounding pretty good, let's really tape it today," for your own pleasure, whatever you want. There's no law against this, so far, is there?

STEVENSON: No.

SMITH: No. Then you look at it and you say, "Gee, I think this is good enough for a commercial release." Then, are you still in any trouble, then, if you take it, go to the union and get it cleared that way?

STEVENSON: Well, I mean if everybody concerned knows what is happening and you can say that you paid them, I suppose.

SMITH: This is where it is, the beginning. I'm a nonprofessional, and that would be my hobby. They were playing in my

place, I was working on a book, and they were playing, and I recorded it. It became an extraordinary session.

McLEOD: Well, what would happen right now, if he just cut the tape and, uh, made a double?

SMITH: I mean, there's nothing that says in the bylaws or anything that says one of these sessions can't be taped, is there?

STEVENSON: No, but I mean as soon as you start bringing out a tape, and putting it on records, then you have to go through the union.

SMITH: Oh well, I know, no one's even thinking of bypassing the union on that. It's only stating that an issue of expense to make . . . they have something that everybody feels is worth backing and putting up that dough for.

STEVENSON: I know what you're talking about, and you're talking about making a demo, in other words.

SMITH: Well, that's the thing. What you'd lose there is the very quality I'm after. The wonderful spontaneity, the addition of dialogue that happened, you couldn't duplicate it, you see. It's just something that couldn't be repeated, including the cat in heat wandering around, the wonderful side effects.

Jay Cameron, baritone saxophone.
The bass player in the mirror is
Steve Swallow. The time is 4:08 a.m.

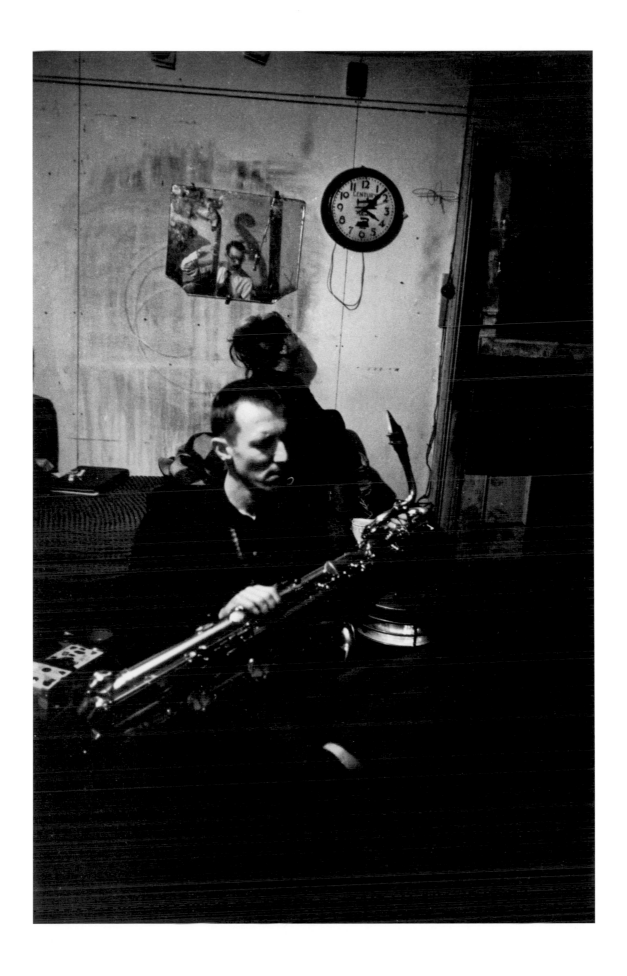

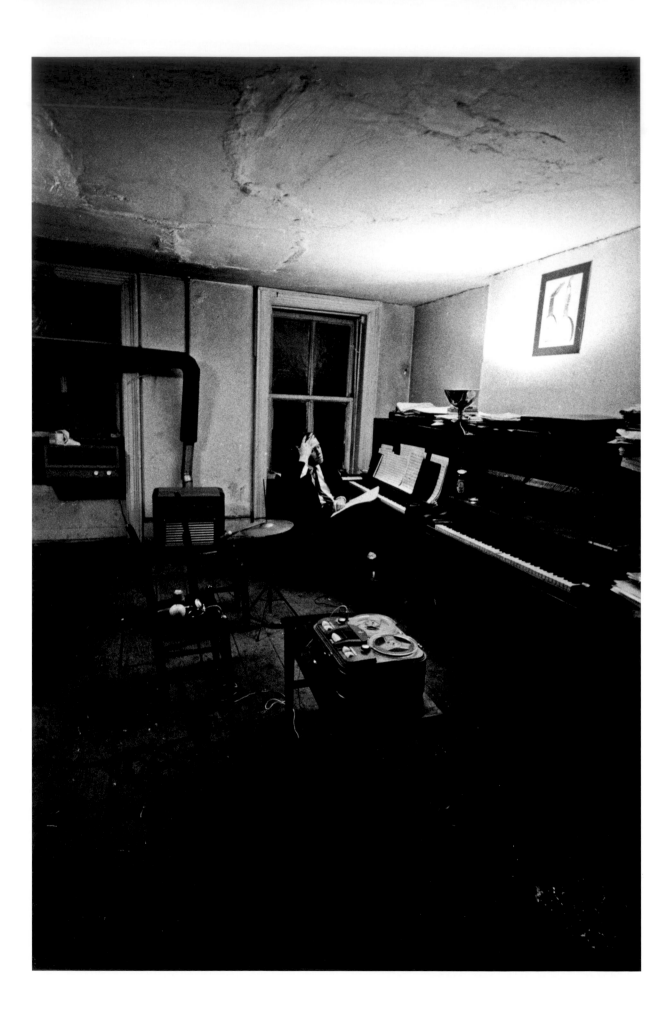

December 1963

Several unidentified musicians milling around the loft after Smith has just left the room:

"Is that who did all that? What is it, six, eight? There's about ten microphones."

"He's out of his mind."

"Why so many? They don't have that many in record studios."

"He must be trying to make a Christmas tree. All those microphones, I bet he could record twenty things, at least."

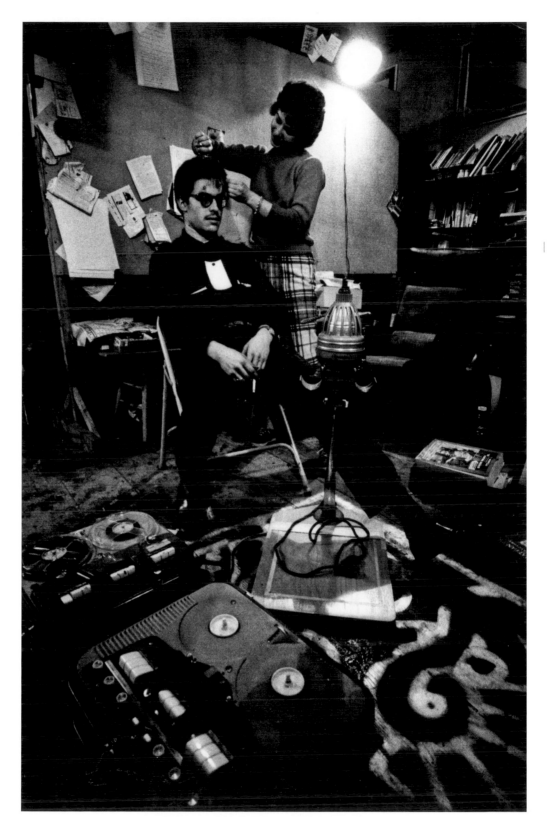

Opposite: Hall Overton, with Smith's recorder

Carole Thomas cutting hair, with Smith's recorders

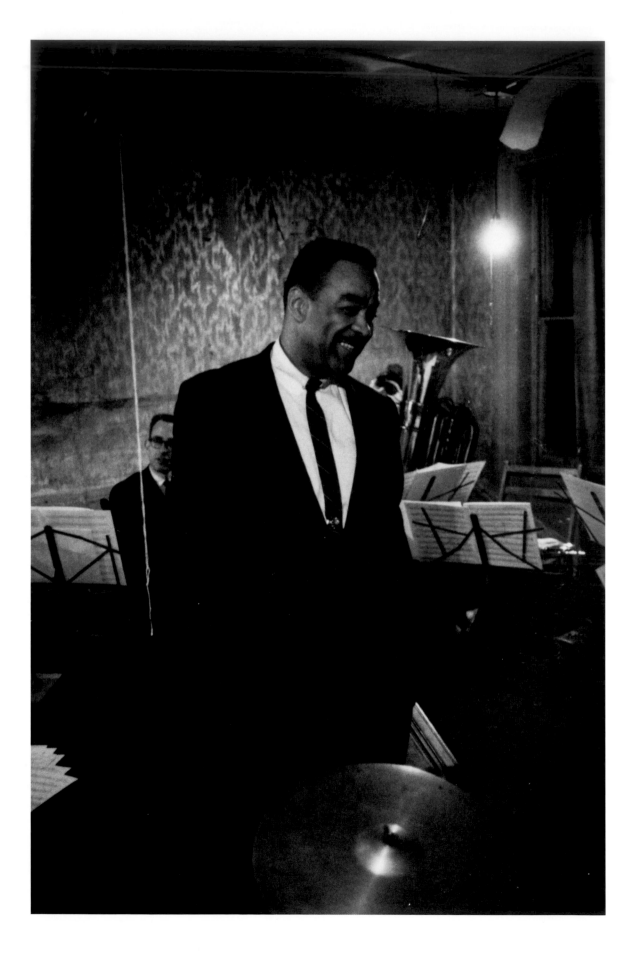

Buck Clayton

Dave McKenna

Summer 1963

Smith had a solid-state radio in his darkroom, which he listened to while he was making prints. He also had a television, which he covered with a red filter so light from the screen would not damage his photographic materials. Smith operated his taping system out of his darkroom, with holes drilled through floors and walls, and wires running all over the five-story building. Sometimes he let the tapes roll, recording things randomly. Other times the recordings were quite purposeful.

One tape contains "Freedom Now!," a radio documentary broadcast on the New York independent station WBAI in the summer of 1963. The program was produced from field recordings made in Birmingham, Alabama, and in New York City by Dale Minor, between May 11 and May 14 of that year, during the height of African-American demonstrations after bombings in Birmingham.

REPORTER: Mayor Hanes, would you address yourself to these bombings?

BIRMINGHAM MAYOR ART HANES: I'll address myself to the bombings. Of course, we have no idea who has done it. We've got strong reason to believe—and I think the FBI would bear this out—these are not just bombings in the past that's been occurring in Birmingham. We know it was done, we feel reasonably sure, was done by King and his crowd and the Communists, uh, to stir up trouble. You see, King and that mob, uh, can't, uh, stay in business if everything is peace—peaceful and calm and there is tranquillity. If there are no incidents for them to attach themselves to, to appeal to the people of the country to donate and hold rallies in Madison Square Garden and here, there, and everywhere to raise funds, then they have to create something, you see.

ANNOUNCER: Four hours before Mayor Hanes's press conference, the Reverends King and [Ralph] Abernathy began a walk intended to make the rounds of the local Negro pool halls.

DALE MINOR: The procession is now proceeding up Seventeenth Street. Dr. King and Dr. Abernathy in the lead, and we're now entering a pool hall. We are descending a flight of stairs into the basement, and we're now in a colored pool hall.

REV. MARTIN LUTHER KING JR.: We want to thank you for taking time out of your pool games to allow us to say these few words to you. Now, as has been said, we are engaged in a great struggle, a mighty struggle for freedom and human dignity. We must make it clear that we don't like these bombings and that something should be done about it. In the last five years, twenty unsolved bombings have taken place at Negro churches and homes in Birmingham, more than any city in the United States. Now, we've got to say that we don't like this and we want something done about it.

CROWD: That's right.

KING: And I've made that very clear to the attorney general—Attorney General Kennedy, yesterday, and to other officials who have the machinery to do something about it. Now, we must do something in order to make it clear to this nation that we are gonna win our freedom in a peaceful, nonviolent manner. Now, I can well understand how impatient we are. I can well understand how these dread and

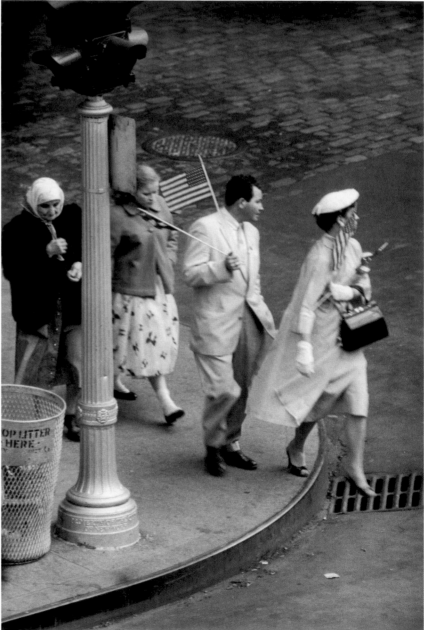

deep-seated resentments well up in our souls. I can well understand how we are often driven to the brink of bitterness, and even despair, because of the way we are treated by policemen and highway patrolmen, and the way we are bombed and our children are exploited and we are exploited. I can understand how we feel, but we must make it clear that it is possible to stand up against all of these evils and injustices without fighting back with violence.

Now, I believe in nonviolence as a creed. In other words, I believe that violence is immoral, but I go beyond that, and I hope you will see this. That not only is violence immoral in our struggle, but it is impractical. We can't win with violence. Now, we must not beat up any policemen, as brutal as they may be. We must not burn down any stores. We must not stab anybody. For we have a greater weapon than all of this. We have the power of our souls, the power of our standing up together, and this amazing unity and this soul force is the thing . . . are the things that will free us in this day.

So tell everybody—your friends and your neighbors and your relatives—that this is a nonviolent movement and that, even if they bomb some more houses or businesses, that we are going to still stand up for our freedom and yet we're not going to use violence. Let us not become so angry that we lose our heads. Let nobody put us so low as to make us hate them, or as to make us use violence. Let us go out on the wings of nonviolence, and, through this way, we will be able to land in this great City of Freedom.

God bless you and thank you for this wonderful opportunity. [*Applause.*]

On the same reel, Smith recorded a broadcast of Verdi's *Requiem*, performed by conductor Herbert von Karajan with Leontyne Price, the groundbreaking African-American opera star who helped integrate the Metropolitan Opera. The performance Smith taped was from a festival in Salzburg, August 9, 1962.

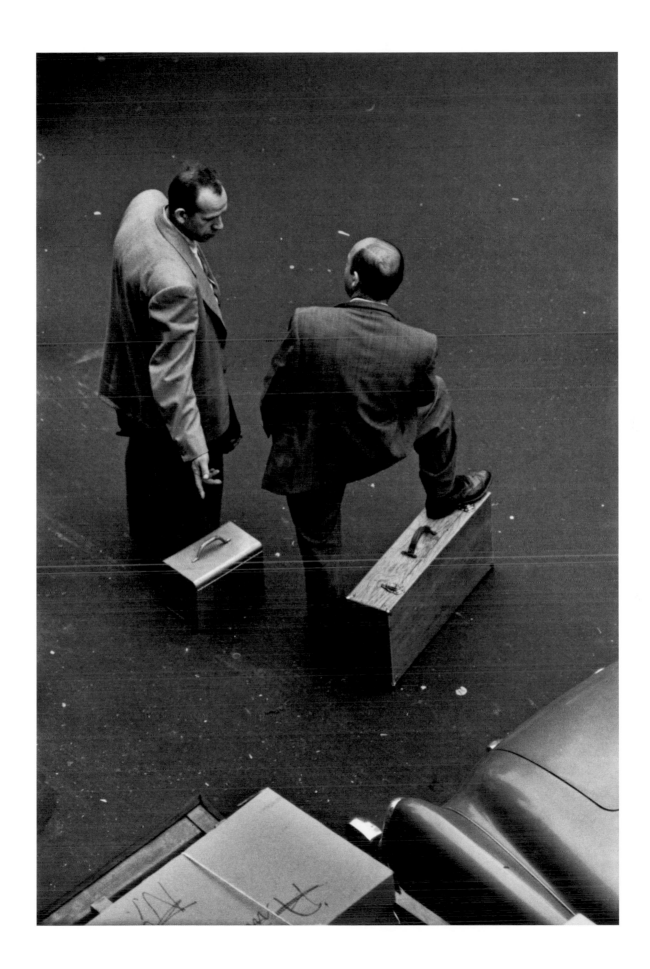

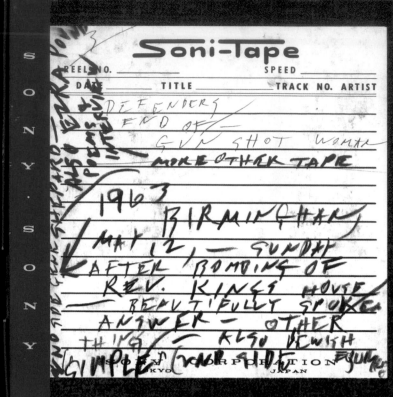

RCA SOUND TAPE

SIDE #1		SPEED	INCHES PER SECOND	DATE
TITLE	ARTIST		LENGTH	COUNTER NUMBER

MONK ORCH
IN REHEARSAL —
— PROBABLY 1964
MAYBE 1963

SIDE #2		SPEED	INCHES PER SECOND	DATE
TITLE	ARTIST		LENGTH	COUNTER NUMBER

SOME GOOD

RUNNING TIME—RCA SOUND TAPE
(7" REELS)

(109)

TAPE LENGTH	SINGLE TRACK		DUAL TRACK	
	3¾ IPS	7½ IPS	3¾ IPS	7½ IPS
1200 FEET	60 MIN.	30 MIN.	120 MIN.	60 MIN.
1800 FEET	90 MIN.	45 MIN.	180 MIN.	90 MIN.
2400 FEET	120 MIN.	60 MIN.	240 MIN.	120 MIN.

RCA RADIO CORPORATION OF AMERICA

Trade Mark(s) ® Registered Marca(s) Registrada(s) Made in U.S.A.

VIBRANT SERIES

REGULAR PRICE
OUR PRICE
2⁸⁸
CAMERA BARN

RCA

MAGNETIC RECORDING
SOUND TAPE
STEREOPHONIC OR MONAURAL

Du Pont Registered Trademark

2400 FEET · TENSILIZED MYLAR* · 710CI

HIGH FIDELITY

Shamrock
recording tape

1962
or
1967

HALLWAY TRAFFIC
COULD BE ERASED
A SESSION STARTING
(MAYBE HALL + MONK)
STEREO PART WAY
PART WAY
MUCH DRUG STORE RADIO
+ SOME BACKGROUND
JAZZ
MUCH RUNNING
UP + DOWN STAIRS
ONE LITTLE SEGMENT
VR. — MEANING
+ SMITH TALKING
TO IT.

CHECK REST OF TAPE

(2ND SIDE — FIRST TRACK)
A. ANSEL ADAMS (ABOUT ¾")
B. ON T.V.
FIRST TRACK — PART OF JAPANESE OPERA THEN BLANK
"THE BLACK SHIPS"
2ND TRACK BLANK

MANUFACTURED IN OPELIKA, ALABAMA, U.S.A.

Previous spread

Left, top: May 12, 1963.

Sunday after bombing of Rev. King's house, beautifully spoken answer. Second side Gene Shepard [Jean Shepherd], also Ezra Pound poems & interview. Defenders, end of gunshot, woman.

Left, bottom: June 1963.

Public television documentary *The Negro and the American Promise,* featuring Martin Luther King Jr., Malcolm X, and James Baldwin, also the audio from the *Grapes of Wrath* movie.

Right, top: June 4, 1964.

Monk Orch. in rehearsal. Thelonious Monk Orchestra rehearsing at 821 Sixth Avenue for a concert at Carnegie Hall on June 6, 1964.

Right, bottom: May 1964.

Hallway and traffic, could be erased. A session starting (maybe Hall & Monk) part way. Much drugstore radio & some background jazz. Recording includes Smith's cat Junior meowing and Smith talking to it; photographer Ansel Adams on television; and the Japanese opera *The Black Ships* (*Kurofune*), by Kosaku Yamada, taped from the radio.

Spring 1963

Boston public television producer Henry Morgenthau III's *The Negro and the American Promise,* featuring interviews with Martin Luther King Jr., Malcolm X, and James Baldwin, made headlines in the spring of 1963. Smith taped the audio of the program from WNET, New York's public television Channel 13. The program aired in a climate of racial conflict, just months after Alabama governor George Wallace's defiant support of "segregation forever," before a crescendo of bombings of African-American homes in Birmingham, and before the March on Washington.* The *New York Times* described the James Baldwin segment as "a television experience that seared the conscience."

JAMES BALDWIN: I think that one has got to find some way of putting the present administration of this country on the spot. One has got to force, somehow, from Washington, a moral commitment, not to the Negro people, but to the life of this country.

It doesn't matter any longer, and I'm

*The March on Washington took place on August 28, 1963.

speaking for myself, for Jimmy Baldwin, and I think I'm speaking for a great many Negroes, too. It doesn't matter any longer what you do to me: you can put me in jail; you can kill me. By the time I was seventeen, you'd done everything that you could do to me. The problem now is, How are you going to save yourselves?

A boy last week, he was sixteen, in San Francisco, told me on television—thank God we got him to talk—maybe somebody thought to listen. He said, "I've got no country. I've got no flag." Now, he's only sixteen years old, and I couldn't say, "You do." I don't have any evidence to prove that he does. They were tearing down his house, because San Francisco is engaging—as most Northern cities now are engaged—in something called "urban renewal," which means moving the Negroes out. It means "Negro removal," that is what it means. The federal government is an accomplice to this fact.

Now, we are talking about human beings, there's no such thing as a monolithic wall or some abstraction called the "Negro problem." These are Negro boys and girls, who at sixteen and seventeen don't believe the country means any-

thing that it says and don't feel they have any place here, on the basis of the performance of the entire country.

My mind is someplace else, really. But to think back on it, I was born in Harlem, Harlem Hospital, and we grew up . . . first house I remember was on Park Avenue, which is not the American Park Avenue, or maybe it is the American Park Avenue, Uptown Park Avenue, where the railroad tracks are. We used to play on the roof and in the—I can't call it an alley—but near the river, it was a kind of dump, garbage dump. Those were the first scenes I remember. I remember my father had trouble keeping us alive—there were nine of us. I was the oldest so I took care of the kids and dealt with Daddy. I understand him much better now. Part of his problem was he couldn't feed his kids, but I was a kid and I didn't know that. He was very religious, very rigid. He kept us together, I must say, and when I look back on it—that was over forty years ago that I was born—when I think back on my growing up and walk that same block today, because it's still there, and think of the kids on that block now, I'm aware that something terrible has happened which is very hard to describe.

I am, in all but technical legal fact, a Southerner. My father was born in the South, my mother was born in the South, and if they had waited two more seconds I might have been born in the South. But that means I was raised by families whose roots were essentially rural, Southern rural, and whose relation to the church was very direct, because it was the only means they had of expressing their pain and their despair. But twenty years later the moral authority which was present in the Negro Northern community when I was growing up has vanished, and people talk about progress, and I look at Harlem which I really know—I know it like I know my hand—and it is much worse there today than it was when I was growing up.

October 24, 1963

Less than a month before JFK's assassination, Smith recorded a segment of this unidentified radio program, probably off WBAI, New York radio's center of the progressive, countercultural movement. Author Nelson Algren, who won a National Book Award in 1950 for his novel *The Man with the Golden Arm*, was a guest on this particular show along with Norman Mailer.

HOST: What are you going to do about this problem that I've thought about a great deal? We obviously have a political dialogue going on. We also have the art of politics being practiced that's supposed to be the art of the possible politics. Now we have a president who is driving towards civil rights with the best effectiveness he can muster, in practical political terms. This rhythm or tempo of his push is so behind the militancy of the Negro today—his demanding, fulfill now. How are they going to come into some kind of harmony?

NELSON ALGREN: Well, let me say this, that I'm not personally acquainted with [James] Baldwin. I met him once, and I asked him, "What's wrong with this country?" Before I finished asking him "What's wrong with this country?," he put me down very fast. He said, "Go ask a jazz musician." I mean he was busy, you see. But I say that because I'm not a, what you might call a personal admirer, but I will say following him that this isn't quite as dizzy a statement, although he said it

very flip, "Go ask a jazz musician." But Baldwin is of much more value to the country, I think, even than [Asa] Randolph, or even than Kennedy, because he's, simply, because he is inexperienced in politics. He started a fuse and he doesn't know where it's going to end. Like Harriet Beecher Stowe. I mean, you could spend the whole evening saying what's wrong with Baldwin, but the fact is that he started something that is—and this is the wisest thing a writer can do—can take such a risk as he's taken, and so far, he's put, he's not talking in terms anymore of justice and freedom, you're talking in square terms. And he's talking in terms of poverty, who has it and who hasn't, which is much more specific. And I think this guy is absolutely invaluable. I mean, he's always right, I mean generally. I mean he's wrong almost all the time. But he's one of these people whose flaws, whose flaws are so rich that you find out what's wrong with the whole country through one mistake that he made.

On November 18, 1963, a few days before JFK's assassination, saxophonist John Coltrane went into Rudy Van Gelder's studio in Englewood Cliffs, New Jersey, and recorded the ultimate answer to the question of what's wrong with this country. It was the tune "Alabama," a powerful incantation supposedly based on the cadences of a sermon by Dr. Martin Luther King Jr.

August 14, 1965

Smith is on a telephone call with Red Valens, taped by Smith.

SMITH: That seeing, thoughtful soul Sean O'Casey causes me to be . . . when I run out of imagination or I'm just dead against a wall—I can't function, I can't think right, I have no probe, if I read O'Casey for a little while and I'm usually back to seeing and searching, and things start pouring out. Very few writers can do that to me. Faulkner can do it to some extent. O'Casey is my old standby.

I'm so sorry somebody swiped my old copy of *Finnegans Wake* with all those corrections in the back. When I used to get really discouraged I'd go over and open that and look at all those corrections of words that nobody in the world could possibly understand and I'd say, "Gee."

Unknown Date

Smith is being interviewed by an unknown, unnamed female in the loft.

SMITH: I personally have always fought very hard against ever packaging a story so that all things seem to come to an end at the end of the story. And I have always wanted to leave it so there's tomorrow and what happens tomorrow. You know, that it doesn't end with my story but this is something that came out of there and suggests perhaps, what is—what might happen tomorrow or at least say all things are not resolved and this is life and it is continuing. I always have had trouble with editors and with layout people in this manner because they wanted it more conclusive, because I had no endings. Of course I didn't have endings. I didn't want endings. I had endings that would suggest that life was going on. But I didn't have any that said, "Now this is the end of our fairy tale," you know.

INTERVIEWER: There is a distinction that you sometimes make that I think is important in saying, and it's like playwriting. With playwriting, the plot or the story comes from the imagination, whereas with the photo-essay it has to come from what's happening there.

SMITH: Well, yes, I take it for granted, that it is kind of a form, you are right. I do make that point. That is, an author in his imagination owns his characters. They may own him, too. But a journalist in doing a story, an essay, does not own his subject, and he is deeply responsible to that subject, that he understand as best he can and be fair in that interpretation of that subject. The playwright can let his imagination control. No matter how much of a photographer you are, how dominant your personality, how passionate your feelings, the subject must dominate what your result is.

March 1961

Smith recorded a Long John Nebel radio program, with Nebel's regular guest Jean Shepherd, who hosted his own popular radio program.

JEAN SHEPHERD: People always have a tendency—people who listen to my shows—they always maintain that shows I used to do were better than the ones I do now. And occasionally I puncture that myth by putting on a tape of a show that I did seven years ago, and they are awful.

LONG JOHN NEBEL: That's dirty pool.

SHEPHERD: I know. People do not want to be presented with the reality. This is the basis, incidentally, of *Krapp's Last Tape,** which is a very interesting thing, you know, the Beckett play. . . . More people have a tendency to confuse their own salad days with everything that's good around them.

NEBEL: The halo effect.

SHEPHERD: Yes, somehow baseball teams were always better in the past. Tomatoes were better. They've done something terrible to tomatoes recently, you know. And so on down the line.

NEBEL: When a hundred years from now they dig up tapes of the Long John show, they'll realize all the shows were bad.

*A one-act play by Samuel Beckett, which had its New York premiere in 1960 and was performed at the East End Theater on East Fourth Street in 1961.

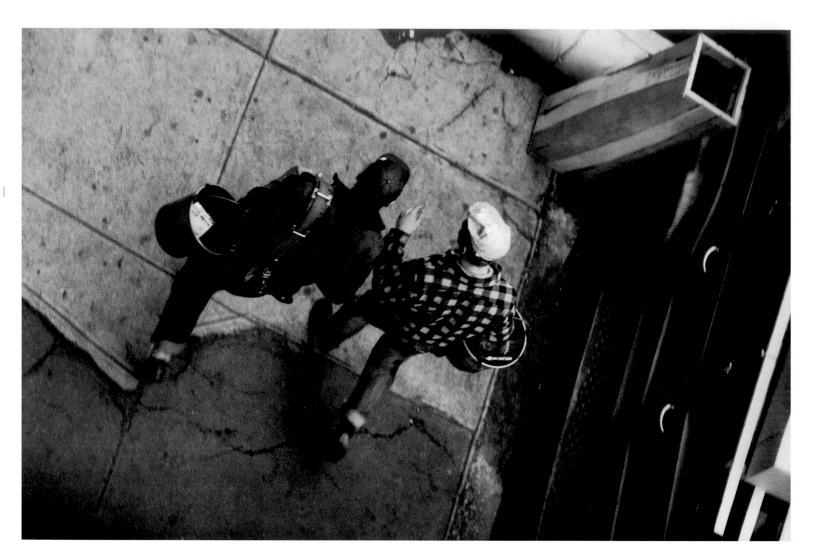

March 1–2, 1964

Elvis, Bob Dylan, Chuck Berry, Buddy Holly, Ray Charles, James Brown, and many others had siphoned off the young audience from jazz. Three weeks earlier, on February 7, the Beatles made their first visit to New York City, with never-before-seen fanfare propelled by the maturing industry of television. There was no way a magnificent, prime, thirty-eight-year-old jazz musician like Zoot Sims could compete for the favor of young fans with the telegenic, twenty-one-year-old Paul McCartney.

Sims had grown up in a family of vaudeville performers during the Great Depression, a disappearing world in which parents and children listened to the same music. Beginning with Elvis and postwar radio and television, children listened to different music than did their elders. Who wanted to go back to the Great Depression and World War II and Jim Crow, anyway? Even Miles Davis was compelled to don leather outfits and big sunglasses and create a new, electronic fusion of rock and jazz in the late 1960s.

But the truth is that jazz was never all that popular in the first place. Musicians such as Charlie Parker, Thelonious Monk, John Coltrane, and Zoot Sims—among the most dedicated and skilled craftsmen in the history of American music—were relegated, in the so-called golden age, to basement clubs with seventy-five to one hundred seats, where they played six forty-five-minute sets per night until three in the morning. Today, you can hear Chet Baker or Miles Davis playing muted trumpets in Pottery Barn or Restoration Hardware, and these stores sell coffee-table books with pictures of jazz musicians in smoky bars.

But those bars were hellholes, and the musicians, especially African-Americans, were jerked around. The clientele for these dingy joints were posing hipsters or disappointed men who hated their bosses and took advantage of their secretaries, like the characters in a Richard Yates novel. Jazz—like most great art going back to antiquity—needed benefactors. Lofts like 821 Sixth Avenue served that purpose. There was some artistic freedom and camaraderie and some dope to be smoked. The loft was where you went when you had no gigs. It was where you went after your gigs, where you could play whatever you wanted to play without a club owner complaining. But you had to be good. As on a playground basketball court, if you weren't good enough, you were on the sidelines.

That this particular early-morning scene took place is not all that unusual. But that it was documented like this is astonishing. The melancholy pall cast by a dwindling jazz scene, the recent Kennedy assassination, the Cold War, and remnants of a fading loft routine are palpable. Loft resident Jimmy Stevenson returns at four in the morning after working at an East Side supper club called the Apartment (no doubt named after the Billy Wilder film of a few years earlier), and he finds a stranger in the form of Zoot Sims in his fifth-floor loft space.

Sims was a musician's musician; players white and black loved him. If he'd been a writer, he'd be Yates or Joseph Mitchell: plainspoken, but just plain better than everybody else. African-American saxophonist Clarence Sharpe also shows up with his wife, Shofreka. The Civil Rights Act would be passed by Congress and signed by President John-

son four months later, but jazz was decades ahead of the rest of the culture in terms of race, and this loft, with a tone set by the sensitive Hall Overton and the compassionate crusader Gene Smith, was ahead of jazz in general. This transcript picks up at about three o'clock in the morning, with Sims, bassist Vinnie Burke, drummer Dick Scott, and at least one other musician (unidentified) talking about the dwindling jam-session scene. The guitarist they are waiting for is Jim Hall, who was working at the Half Note club earlier that night.

SIMS: I'll tell you one thing; it's good for you to play this way. You know, if you're working on a gig all the time you get away from jamming. But when you're jamming like this it sure helps you, because you play different things, experiment with things, you know.

SCOTT: Whatever happened to that kind of playing, Zoot? People don't want to go out and play like that anymore.

BURKE: No, it's true, everybody's so down they're all afraid; they don't want to go out there and try. You should hear the answers I get when I call up and talk to people.

SCOTT: Things can't get much worse.

BURKE: You know, John Bunch has got a piano, a bass, and drums right in his own apartment, just ready.

SCOTT: Yeah, but he can't blow after ten o'clock at night.*

BURKE: Nobody likes to play anymore, Zoot. Nobody.

SIMS: There used to be a lot of playing up here [*in this building*].

*Bunch's apartment was in a residential neighborhood.

SCOTT: Yeah, right, all the time.

SIMS: Ten years ago, we'd get ten, fifteen guys in here.

SCOTT: Whenever they knew there was a session, everybody went. It was, like, the place to go.

BURKE: Well, this is a bad time, a bad time in history. It's like Lincoln repeating itself. When Lincoln was killed they said the atmosphere is almost identical.

SCOTT: Yeah, shit. It's like, you know, now we're only more neurotic, I believe, because we're more progressive. It's almost like a button can blow the whole thing up, you know.

BURKE: Oh, yeah.

SCOTT: So, we're torn between it . . .

SIMS: Yeah, but you can't stop living, man. For a lot of big stars today—Miles included, and Mulligan, and Monk—I think the worse the times are, the more they play, though. So we ought to start playing again.

The conversation changes to discussions of random clubs and bars where the musicians have worked. Sims opens the window and the ever present chug of the Sixth Avenue bus can be heard on the street below. Scott describes a recent gig he played with belly dancers. These are the kinds of gigs desperate jazz musicians take in these times.

SIMS: They called me for a job in Boston, man. They didn't say what kind of place it was. I just figured it was a joint. But they offered very good money. So I went. So the first thing I see when I get in the place is a chick stripping. And there's a bar all around there, one of those things, you know, a big, stadium-shaped bar, you know, and this big stage in the middle, the runway. And they had

four chicks in a row take their clothes off. And then they had a couple of chicks sing. Then the star stripper would go on. Then the band would play a tune and I'd play three tunes and get off [the stage] and was off for an hour and a half.

The door suddenly opened and the conversation halted. Gene Smith had microphones in the hallway and sometimes he recorded on more than one channel, so you can hear people hiking up the stairs on some tapes. Not this time. A new voice enters the room abruptly. Jimmy Stevenson entered his own place to find people in there he'd never met.

STEVENSON: Hello. What is this? What have we here?

BURKE: Oh, just a get-together.

The warm, tangy aroma of smoked marijuana—like cooked collard greens with garlic and vinegar—was thick and familiar.

STEVENSON: Certainly smells good [*laughter*]. My name is Jimmy Stevenson.

SIMS: Jimmy? I'm Zoot.

STEVENSON: Hey, Zoot; how are you? Bobby Parker told me about you. I mean, that's the only personal contact I've had, other than your records.

SCOTT: I met you over at the Apartment a couple of weeks ago. You working there?

STEVENSON: Yeah, right. [*Pause in the conversation.*]

STEVENSON: Okay. Yeah. Is Edgar [Bateman, a drummer] here?

BURKE: Eddie was here. Is his name Edgar?

STEVENSON: Edgar.

SCOTT: Well, he left about two hours ago.

STEVENSON: And then there was another fellow named C-Sharpe?

BURKE: Not when we were here.

STEVENSON: Oh, I see.

SIMS (*continuing earlier story*): Okay, anyway, out of the whole audience there'd be like three people were there to hear me. Everybody's there for strippers. That type of people, you know.

BURKE: The strippers are the thing.

SIMS (*to Stevenson*): You want a beer?

STEVENSON: Yeah.

SIMS: Help yourself.

STEVENSON: Oh, I'm not intruding on anything, am I?

BURKE: No, we're just waiting for a guitar player, for a call from a guitar player.

A bottle top is popped, and the cap bounces and rolls on the wood-planked floor.

SIMS: Do you have the correct time?

STEVENSON: I don't know. It's about . . . three-thirty? No, it's later than that. It's about four.

SIMS: What time did we come here tonight?

BURKE: Eleven-thirty, right?

There are sounds of noodling from the piano and of somebody picking strings of a bass.

There are five minutes of random, barely discernible comments and loft noises, people milling around.

SIMS: Let's blow one.

The group—Sims on tenor saxophone, Scott on drums, either Burke or Stevenson on bass—cranks into the Gershwin tune "I Got Rhythm" for eight and a half minutes. Sims plays an eloquent, relaxed, and swinging solo.

The tune ends; someone says, as if aiming the comment off into the distance, "You get that, Gene?"

Laughter.

"He's probably asleep."

There is a sudden knock on the door.

STEVENSON: Who's there?

AN AFRICAN-AMERICAN MALE VOICE: C-Sharpe.

STEVENSON: Yeah, this is the alto player I was asking you about.

The door opens and in walks saxophonist Clarence Sharpe and his wife, Shofreka.

STEVENSON: Hey, hey man. How you feeling?

SHARPE: Rehearsing? You rehearsing?

STEVENSON: No, we're just playing.

SHARPE: Oh, okay. Go ahead and play then.

STEVENSON: C-Sharpe, this is uh . . . uh . . .

SHARPE (*to Sims*): Heeey, I know who this is.

STEVENSON: Zoot Sims. C-Sharpe . . . and uh . . .

SHARPE: Zoot Sims. How you feel? This is my wife, Shofreka.

SIMS: Hey, how are you? How you been, man?

There are more introductions, more cordial "hellos" and "how you feelin's."

SIMS (*to Sharpe*): You worked tonight, right?

SHARPE: Yeah, sure did. Every night I work, each and every night. I'm getting afternoon gigs together now. Take about a week of steady playing to get ready for these afternoon gigs. Them afternoon gigs are heavyweight.

SIMS: Well, why don't you get your horn out. This might be one of the last two tunes tonight.

SHARPE: Okay, fine.

SIMS: That's all right. We'll play some minor blues.

SHARPE: Yeah, sure, why not? That sounds nice.

SIMS: That suit you, some minor blues?

SHARPE: Yeah, I don't care.

SIMS: Well, let's blow one . . .

Sharpe takes the first solo on alto sax, Sims the second on tenor. Sharpe and Sims are extremely mellow and loose to start off their solos, but crisp, not vague. At the five-and-a-half-minute mark, Sharpe and Sims take turns "trading fours" (taking brief, fifteen-second solos in between similarly brief bass and drum solos) for two minutes, and each exchange heightens the competitive energy. Then Sims takes another long solo, far more aggressive than his first one, and Sharpe follows suit. Sims's tenor sound is typically warm and vintage without being out of date, whereas Sharpe's alto sound is drier and more honking, clearly influenced by Ornette Coleman's blues. At the nine-minute-and-twenty-nine-second mark of the tune, with Sharpe still blowing impressively, the recording stops abruptly. Smith's reel had run out of tape.

Smith eventually turned off the recorder and put the recorded reel into its box, to be discovered many years later in his archive established at the University of Arizona after his death in 1978.

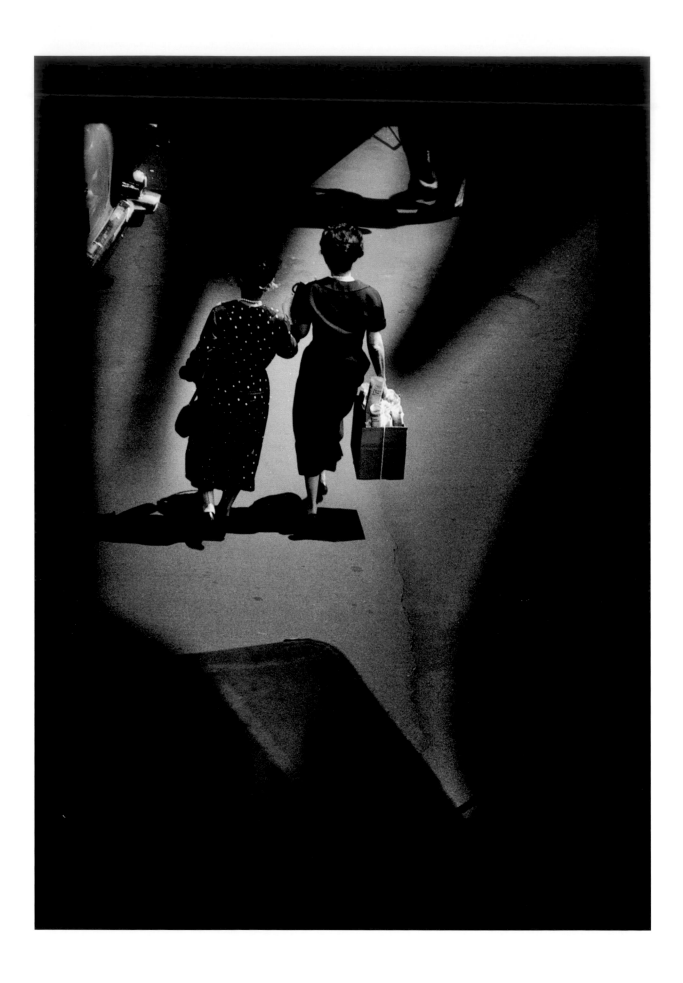

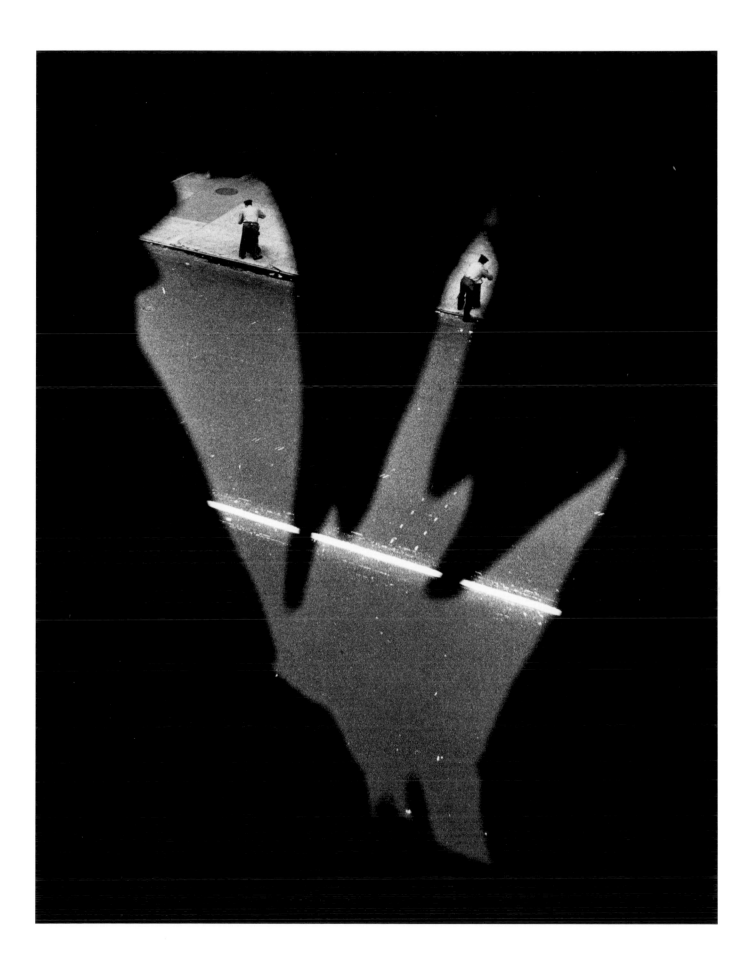

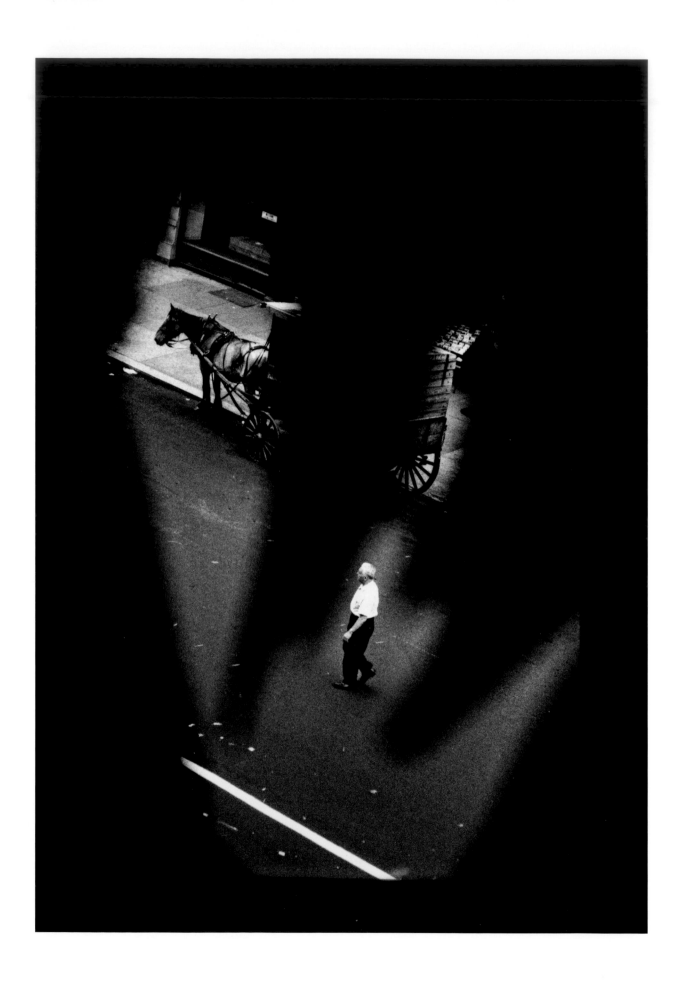

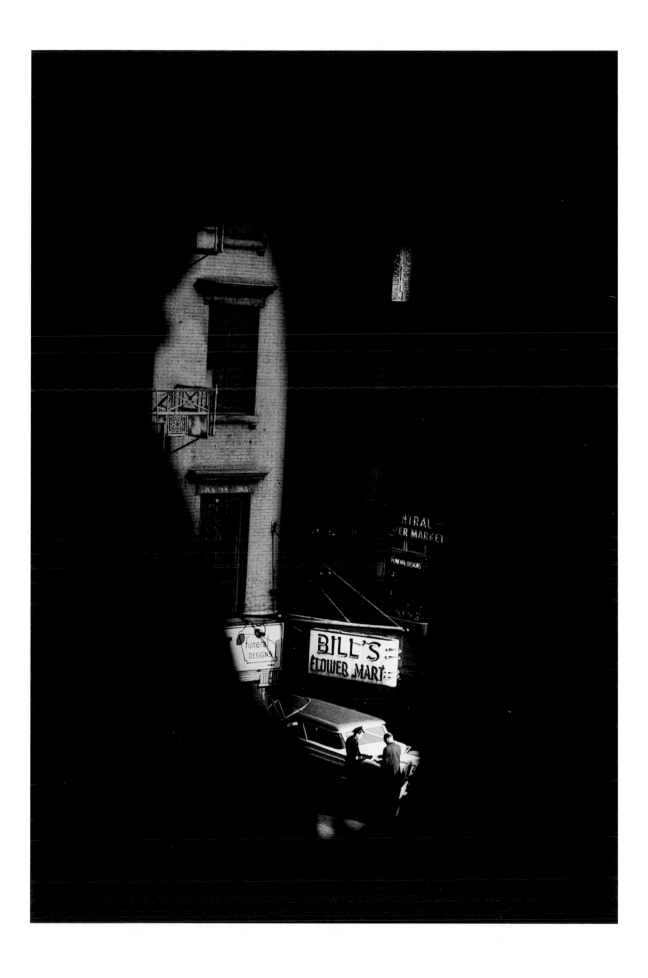

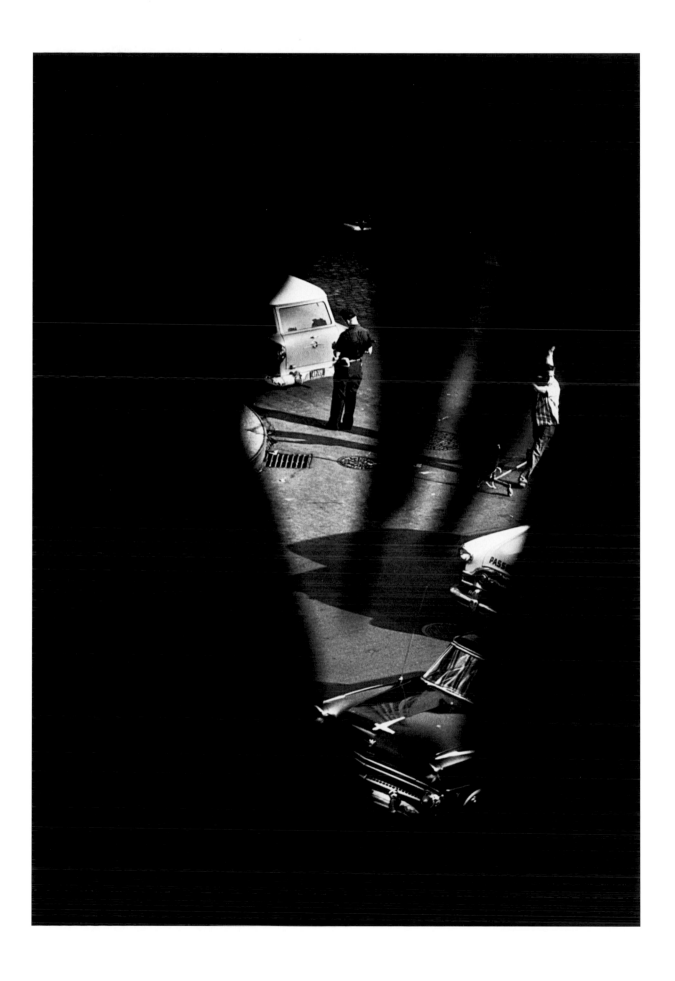

February 28, 1961

Smith is in the loft with Carole Thomas and photographer Lou Draper. He made at least four hours of recordings on this day. Most of it is random conversation, topics including Orson Welles, Smith's time in Hawaii during World War II, darkroom techniques, and Smith's recent photo assignment from the whiskey company Jack Daniel's. Street noise can be heard from Sixth Avenue, including an ambulance.

Various radio sounds can be heard, including a stock market report.

About three hours into the recording, Smith utters the Lord Byron line "There's music in all things, if men had ears."

It comes from *Don Juan*, canto 15, verse 5:

There's music in the sighing of a reed;
There's music in the gushing of a rill;
There's music in all things, if men had ears:
Their earth is but an echo of the spheres.

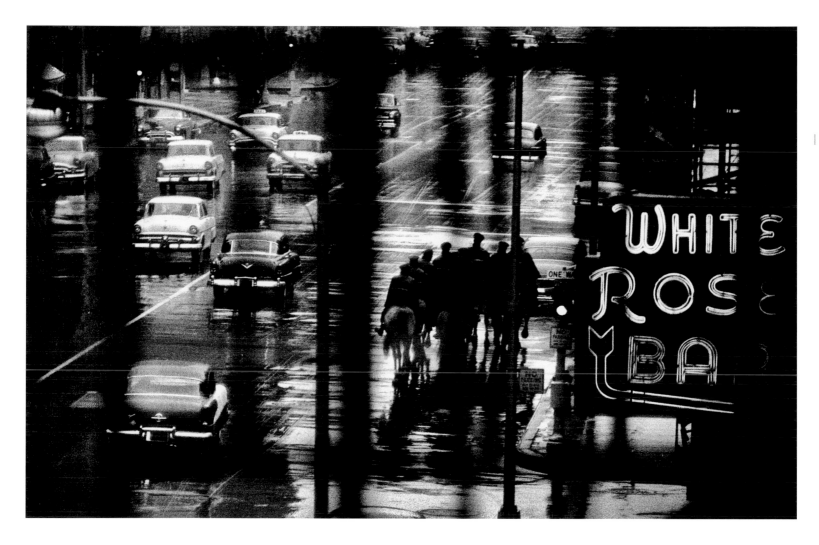

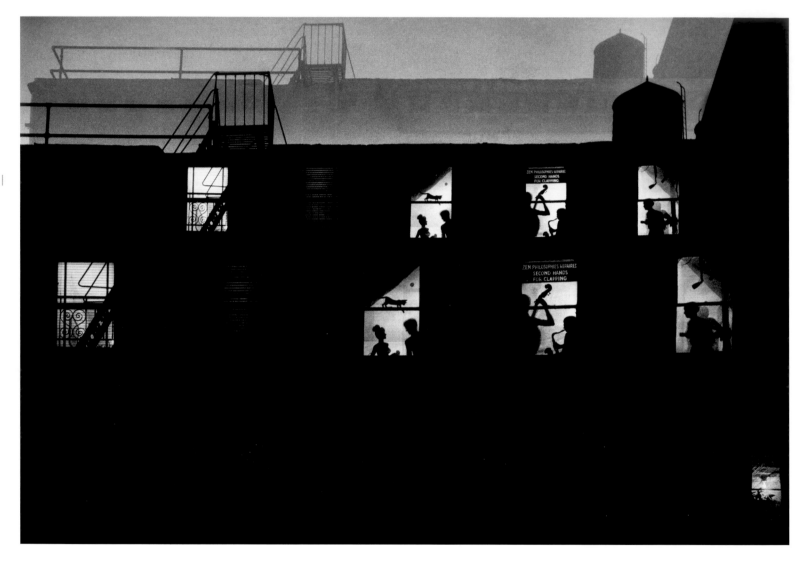

Chaos Manor: experimental image with cutouts

Circa 1963

Sidney Lumet's 1960 film, *The Fugitive Kind*—based on the Tennessee Williams play *Orpheus Descending* and starring Marlon Brando, Anna Magnani, and Joanne Woodward—was broadcast on television, and Smith recorded the audio from the movie on his tapes. In this scene Brando's character, Valentine "Snake-skin" Xavier, is in court for disturbing the peace.

JUDGE: And you started the disturbance at this party, huh?

XAVIER: Yes, sir, I did. I just was fed up, I got disgusted, I was sick, and I felt like my whole life was something in my stomach and I just had to throw it up. So, I threw it up and I started busting up the joint.

JUDGE: You smashed up the place?

XAVIER: Yeah.

JUDGE: Well, Snakeskin, if I let you go, how soon can I expect you back here again?

XAVIER: Oh, I'll never come in here again. I'll never be down in here again, Your Honor. It's about time for the pawnshop to open down on South Rampart Street. I'm going down there and get my guitar out of hoc, and I'm going to split out of this city and ah, well, for good. And all that, all the people that know me or thought they knew me are never going to see me again. And I'm all through with those parties, too, and that's the truth. That's the truth.

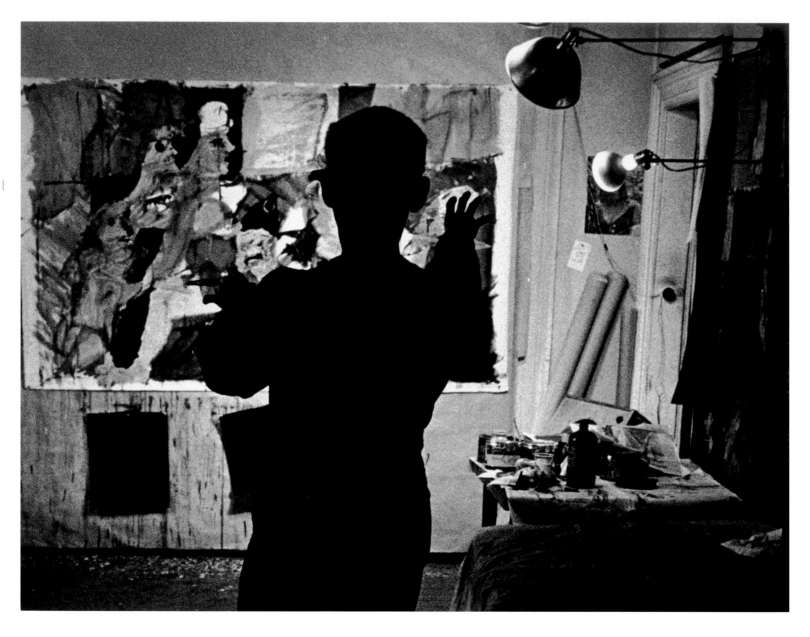

David X. Young

January 1971

CBS television hired the painter and former loft resident David X. Young to document Smith's preparations for a massive retrospective exhibition of his career, held at New York's Jewish Museum. The show opened on February 2, 1971, with 542 of Smith's prints on display, a number unthinkable in today's photography world. Young shot much of the footage at 821 Sixth Avenue as Smith and a team of helpers made prints for the exhibition. By this time, Smith occupied the entire third and fifth floors of the building, and half of the fourth floor (Hall Overton still had the other half). The jazz scene in the building was long over, having faded out around 1965. Young caught Smith in a reflective, melancholy, yet sly mood:

Before I took over so much of it [the loft building], it used to be a rather interesting and exciting place. There was this strange painter on the top floor, and a musician underneath, and my quiet and gentlemanly conduct to offset all that [laughs]. No, but we've had up to three sessions going at once around here. I used to have it pretty well miked so I could flip switches and record a session going on in any one of the places, and even while I was still printing [in the darkroom] or doing other work.

It's a wonderful firetrap. A time it caught on fire, Hall [Overton] said something about, "Do you think all our work is going to get lost in this?" He was thinking of his manuscripts, and I felt sorry for him, but I almost felt a sense of relief. I could, you know, get out from under all this responsibility of damn books and shows and things, and I could change my name to Smith and start all

over again, and have a nice, clean, intelligent little place.

I don't know. What else can you say about the loft? It's—no, it's been a warm and interesting place. Mainly, the people who have been here have always respected each and every one of the other people. Otherwise, any noise at any time of the day or night was fine. Although it does creak, for people who creep across floors, or up the steps.

The largest set of pictures I've ever made in my life is finally within the loft or out of the window. It's over a thousand rolls now. And, well, there certainly are at least a thousand hours of tape, of the sessions of, well, many other things. Like someone shooting [heroin] in the hall. Were you around that time? No, I think this was after—when Lin [Halliday] and company had taken over the top floor.* We heard this guy shooting up in the hallway, and he kept saying, "Oh, they say it's so bad, but it's so good. Oh, they say it's so bad, but it's so good."

Between thieves and the pawnshop, in recent years, I haven't had much chance to get too attached to any particular camera. So I usually use the one that's out of pawn, or, well, those that I happen to have at the moment. When I was richer I had a great luxury of cameras. I would usually work with about five cameras, two sets of cameras, each set loaded with different film.

Getting back to finances, the loft, et cetera, when we did the dummy of the Big Book,† ah [sighs], Carole and I fin-

ished it out in the hallway because our electricity was turned off. And for the last weeks of it, we lived basically on leftover fish and chips from, from a place in the Village. And I certainly got tired of fish and chips. And sometimes we would scrounge around to get the deposit on a few Coke bottles or something before we could take the subway somewhere.

As much as I needed money, and as many crises as we have gone through about money around here, very basically I . . . I hate money. I really do. Because I . . . I suppose it probably goes back to watching that money thing cause the disintegration of my father,* and situations—well, just situations that grew out of it. And it's a relief at times to have it, but I can't particularly say it's a joy.

*In Wichita, Kansas, in 1936, when Smith was seventeen, his father, Bill, committed suicide after losing his grain business in the Depression.

*Dave Young moved out of 821 Sixth Avenue in 1960.
†The "Big Book" was a massive, two-volume retrospective of Smith's career to that point, 1960–61, containing approximately six hundred photographs and intended as an epic antiwar statement.

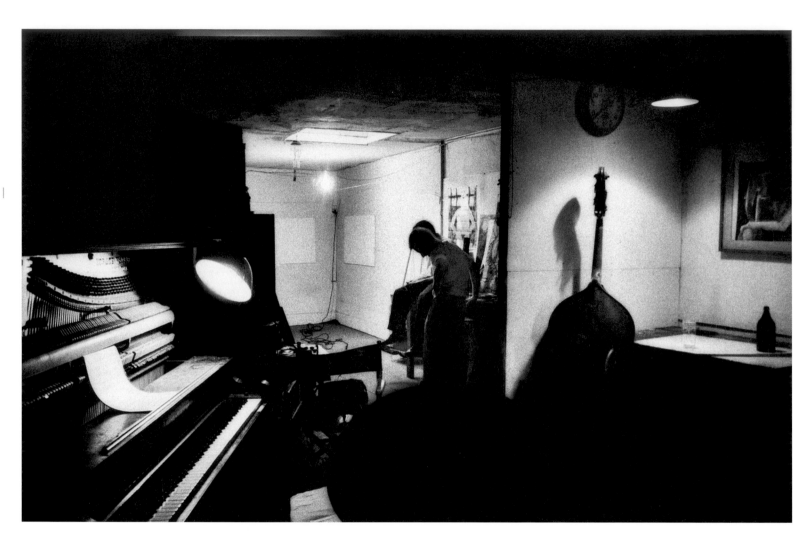

The Jazz Loft Project List of Names

As of the date of this publication, 589 people have been documented in W. Eugene Smith's photographs, tapes, or oral history interviews by the Center for Documentary Studies.

PEPPER ADAMS · Jack Agee · Toshiko Akiyoshi · Manny Albam · Calvin Albert · Monty Alexander · Roland Alexander · Gene Allen · Mose Allison · Barry Altschul · Frank Amoss · David Amram · Chris Anderson · Jose Andrea · Ron Anthony · Diane Arbus · Roberta Arnold · Mario Azzolino · **ELEANOR BACH** · Lars Bagge · Dave Bailey · Chet Baker · David Baker · Ronnie Ball · Edgar Bateman · Lucy Guerlac Battersby · Billy Bean · Ronnie Bedford · Gary Berg · Warren Bernhardt · Eddie Bert · Hal Bigler · Walter Bishop Jr. · Buddy Blacklock · Art Blakey · Carla Bley · Paul Bley · Barry Blondell · Inge Bondi · Dick Borden · Vince Bottari · Patti Bown · Henrietta Brackman · Ruby Braff · Marilyn Brakhage · Stan Brakhage · Dollar Brand (Abdullah Ibrahim) · Buzz Brauner · Bob Brookmeyer · John Benson Brooks · Roy Brooks · Sam T. Brown · Ted Brown · Ray Bryant · Dan Budnick · Nico Bunink · Vinnie Burke · Dan Burley · Jaki Byard · Donald Byrd · **JAY CAMERON** · Lionel Cantizano · Johnny Carisi · Sonny Carr · Hamilton Carson · Henri Cartier-Bresson · Dick Cary · Joe Cassettes · Dolph Castellano · Bob Cato · Teddy Charles · Don Chastain · Don Cherry · Vito Cioffera · Mike Citron · Buddy Clark · Larry Clark · Sonny Clark · Buck Clayton · Wally Cloud · Joe Cocuzzo · Gil Coggins · Al Cohn · George Coleman · Ornette Coleman · Junior Collins · Harry Colomby · Jules Colomby · Alice McLeod

Coltrane · John Coltrane · Junior Cook · Chick Corea · Arlene Corwin · Eddie Costa · Al Cotten · Clyde Cox · Bill Crow · Ronnie Cuber · Bradley Cunningham · Jean Cunningham · Wendy Cunningham · **BERT DAHLANDER** · Salvador Dalí · Sonny Dallas · Tadd Dameron · Harold Danko · Phil Dante · Ted D'Arms · Dennis Russell Davies · Charles Davis · Fred Davis · Miles Davis · Richard Davis · Walter Davis Jr. · Wild Bill Davison · Spanky Debrest · Bob De Celle · Charles Deforest · Eddie De Haas · Willem de Kooning · John Dengler · John Dentz · John Derniak · Henry DiCecco · Vic Dickinson · Dottie Dodgion · Jerry Dodgion · Eric Dolphy · Lou Donaldson · Bob Dorough · Michael Downs · Lou Draper · Ruth Draper · John Drew · Jack Duffy · Kit Duffy · Doris Duke · Frankie Dunlop · Manny Duran · John Durniak · **MARTIN EAGLE** · Jon Eardley · Norman Edge · Don Ellis · Bill Elton · Booker Ervin · Al Esformes · Bill Evans · **WILL FALLER** · Art Farmer · Joe Farrell · John Faselles · Christy Febbo · Harold Feinstein · Chris Ferdo · Don Ferrara · Ruth Fetske · Bill Fielder · Max Finstein · Warren Fitzgerald · Will Forbes · Marty Forscher · Charles Fox · Robert Frank · Ronnie Free · Art Freed · Don Freedman · Archie Freeman · Bud Freeman · Will Freil · Lee Friedlander · David Friedman · Dave Frishberg · Tony Fruscella · Curtis Fuller · Jack Fuller · **BARRY GALBRAITH** · Dick Gale · Jimmy Garrison · Mike Gelber · Herb Geller · Ruby Gerard · Jane Getz · Stan Getz · Bob Gill · John Gilmore · Jimmy Giuffre · Johnny Glasel · Jackie Gleason · Dorrie Glenn · Kent Glenn · Al Godlis · Tom Golden · Billy Goldenberg · Eddie Gomez · Daniel Gonzales · Gary Goodrow · Dick Gordon · Joe Gorgas · Dave Gould · Lennie Green

· Urbie Green · Cyra Greene · Lucy Greene · Barry Greenspon · Freddy Greenwell · Bob Gregor · Johnny Griffin · Henry Grimes · Gigi Gryce · Lucy Guerlac · Wayne Guiterrez · **CHARLIE HADEN** · Dick Hafer · Al Haig · Ed Hall · Jane Hall · Jim Hall · David Halle · Lin Halliday · Philippe Halsman · Yvonne Halsman · Chico Hamilton · Bob Hammer · John Hammond · Slide Hampton · Charlie Harbutt · Gordon Hardy · Chase Harmon · Barry Harris · Wendell Harrison · Billy Hart · Gary Hawkins · Roy Haynes · Dave Heath · Jimmy Heath · Percy Heath · Tootie Heath · Don Heckman · Bill Heine · Nehama Hendel · Joe Henderson · Nat Hentoff · Frank Hewitt · Billy Higgins · Andrew Hill · Lonnie Hillyer · Elmo Hope · Freddy Hubbard · Jim Hughes · Ralph Hughes · Lex Humphries · Joe Hunt · **PETER IND** · Frank Isola · Chuck Israels · David Izenson · **IRA JACKSON** · Bob James · Clifford Jarvis · Paul Jeffrey · Al Jeter · Tommy Johns · Gus Johnson · Ben Johnston · Buddy Jones · Elvin Jones · Philly Joe Jones · Sam Jones · Thad Jones · Clifford Jordan · Duke Jordan · **MAX KAMINSKY** · Wally Kane · Tim Kantor · James "Jim" Karales · Kenny Karpe · Sonia Katchian · Dick Katz · Linda Keen · Bill Keith · Mike Kinzer · Pat Kirby · Roland Kirk · Lincoln Kirstein · Franz Kline · Nathan Kline · Jimmy Knepper · Dick Kniss · Lee Konitz · Michael Koral · Teddy Kotick · Dan Kramer · Sandy Krell · Joel Krosnick · Steve Kursh · **STEVE LACY** · Yusef Lateef · Piper Laurie · Janet Lawson · Barbara Lea · Freeman Lee · Dave Levin · Mark Levine · Ed Levinson · Al Levitt · John Lewis · Alex Lieberman · Eddie Listengart · Ed Livingston · Lee Lockwood · Mike Longo · Joe Lopes · Dick Lord · Jimmy Loro · Jimmy Lovelace ·

Epilogue

I've been researching W. Eugene Smith's life and work ever since my wife, Laurie Cochenour, gave me a camera for Christmas thirteen years ago. When the owner of the camera shop in Raleigh, North Carolina, asked me what I'd be taking pictures of, I told him Pittsburgh. The city has captivated me since we first visited Laurie's family there in 1995, and I'd just started researching its history and landscape. "Have you ever seen Eugene Smith's Pittsburgh photographs?" he asked. The previous night he'd caught an *American Masters* documentary on Smith, and it mentioned a big project he did on the city in the 1950s. I left the shop and walked around the corner to the public library to look for more information. I've been studying Smith ever since.

On one of Smith's tapes from 1962, you can hear a neighborhood beat cop wander into the loft, and Smith, clearly familiar with the officer, says proudly, "You know, my son, Pat, got married last weekend."

Pat, now sixty-six and a retired race-car mechanic, and his sister Juanita are the protagonists of Smith's photograph "The Walk to Paradise Garden," which was made in 1946, when they were two and four years old. The photograph was chosen by Edward Steichen to close his famous 1955 show, *Family of Man*, at the Museum of Modern Art. On one of the unlabeled loft tapes there is a surreal, twenty-eight-minute monologue in which Smith breathlessly describes his efforts to maneuver his wife, mother, and elder daughter out of the house so he could set up his two younger children for the picture in the yard outside: "I kept only the younger children with me, for I believed they would comprehend least the drama that was taking place within me. How strange, how contradictory, here in the quiet of my home, with two of my beloved children peacefully playing in an adjoining room, with music the only and welcome intruding sound, how strange that in this kindly setting I could be living an emotional and physical crisis more personally terrifying in its potency than any I had ever previously encountered in a life far from tranquil. And this hinged on the mere making of a photograph."

Shortly after Pat's wedding, to his high school sweetheart, Smith began calling his son and daughter-in-law in the middle of the night, telling them good-bye, saying he was committing suicide. After each call Pat and Phyllis would race down

to Smith's flower-district loft. Finally, Pat flatly told his father he wouldn't respond to any more suicide calls.

In 2007 Pat called me and told me he was cleaning out the basement of his Pleasant Valley, New York, home. Did I want some of his father's equipment? he asked. I bought Smith's custom-made eight-foot stainless-steel loft darkroom sink, a custom-made wooden light table, two of Smith's old large-format Sinar cameras and lenses, and the high-powered long lens that Smith used to make telephoto images from his loft window. I promised Pat that I'd sell it all back to him at the same price if I ever wanted to get rid of it, or if he wanted it back. The cameras and lenses are in first-rate condition. The first exposure I made with the old 4x5 Sinar, with help from my friend Frank Hunter, was of the railroad tracks in the "Around the Y" neighborhood in Rocky Mount, North Carolina, about two hundred yards from Thelonious Monk's childhood home, which is also about sixty miles from the small town in the coastal plains where I was born and raised. That seemed appropriate. But I don't know what I'm going to do with the sink.

Not infrequently I wonder if I should be doing something else, doing my own work from scratch rather than picking up the pieces of Smith's unfinished opuses (my first project was on his Pittsburgh odyssey). In 2003 I was having lunch with Carole Thomas in a diner in Santa Monica, California, and I told her I found it uncanny how Smith always found people to assist him—to help him do what he couldn't do himself. She looked me dead in the eye and said, "He's still doing it."

I recovered from Carole's comment, but it left a mark. I feel that Smith left

melodramatic bread crumbs—like the monologue of the making of "The Walk to Paradise Garden"—for a gullible researcher to follow. But his melodrama sells him short. In 2004, when the founding director of Magnum Photo and Smith's original estate executor, John Morris, visited the Center for Documentary Studies, I asked him why so many people put up with Smith's pathologies. John paused for several seconds and said simply, "Gene was worthwhile."

In 2008 Smith's friend the legendary photographer Robert Frank said, "He was different. He was absolutely different from anybody else. When he looked at you, when he opened his mouth, there was that passion. That's how he made his mark. It's almost naive today to be like that, to think like that. And I think today the people don't have that passion that he had, that most extraordinary quality and that passion and the belief in it."

In the last thirteen years I've met more than three hundred people along the way. Some are famous, but most are unrecorded in the official annals of music, photography, or anything else. The experience has been the wonder and fortune and redemption of this work. If Smith had been less passionate, more strategic, and more ironic, then he might be more celebrated in the contemporary art world. But he would have led me in fewer obscure, wide-ranging directions. On January 11, 2006, my colleague Dan Partridge and I were in a four-hundred-square-foot room on the ninth floor of an old apartment building on the Upper West Side of Manhattan, interviewing a youthful eighty-year-old trumpet player who had lived in that room for thirty-five years. Among stacks of prostitute cata-

logs and layers of accumulated New York City apartment grit, the trumpeter had an upright piano and on top of it was a list of New Year's resolutions. Number one was "Get more gigs."

When we emerged from the interview, night had fallen and it was raining hard. As I darted down the wet subway stairs carrying digital audio equipment, my left foot slipped, snapping two bones in my ankle. I spent the night on a gurney in the emergency room at St. Vincent's Hospital. Next to me was an elderly black lady who had been hit by a taxi, and like me was filled with painkillers. "These injuries," she kept telling me, "will keep us from doing things that would have hurt us worse."

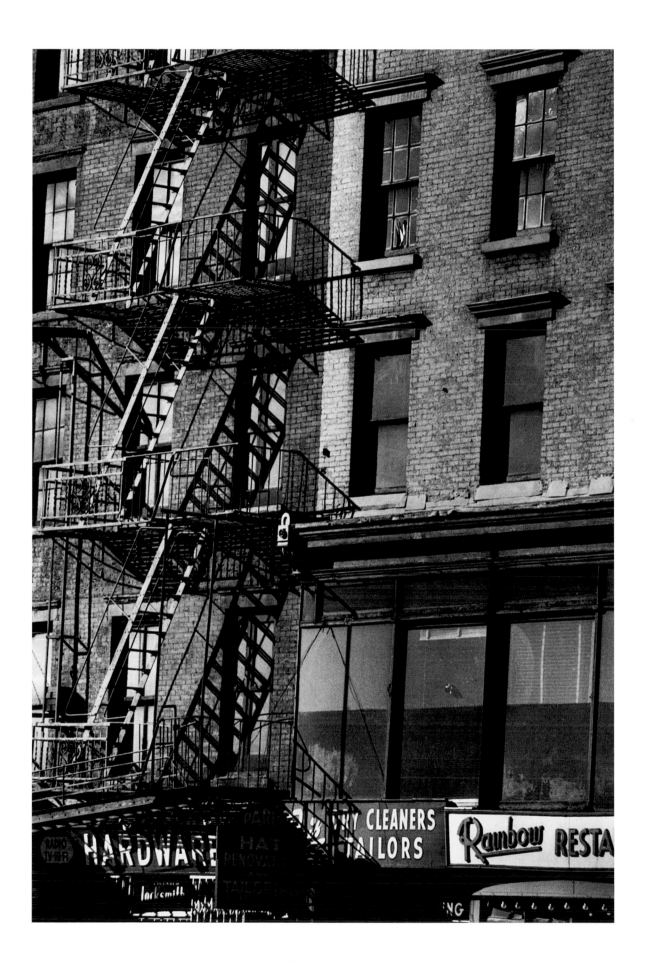

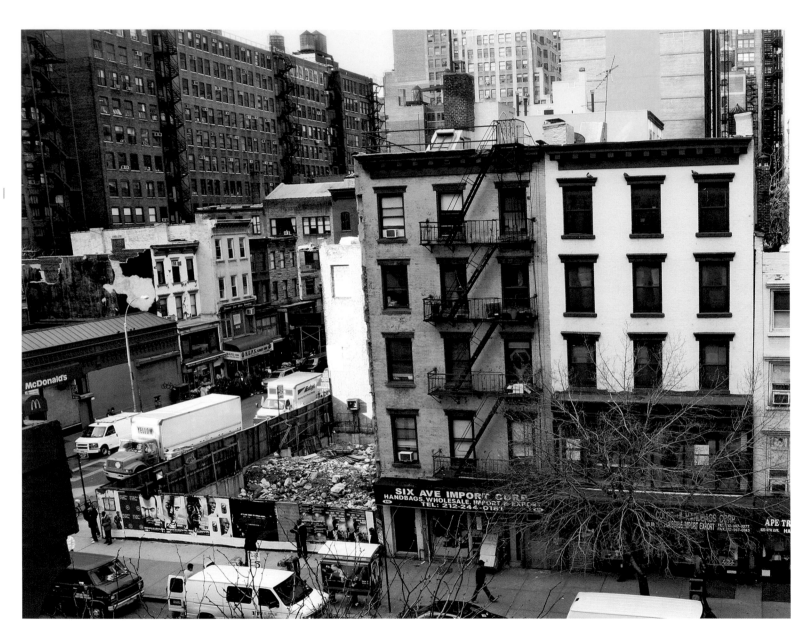

821 Sixth Avenue (white building behind the tree)

Photograph by Scott Landis, 2009

Acknowledgments

This project began as an article in *Double-Take* magazine in 1999, and for that opportunity I am grateful to Robert Coles and Alex Harris. The article was noticed by members of Chicago's Logan family, who tracked me down by telephone in my Pittsboro, North Carolina, home one ordinary evening. The Reva and David Logan Foundation became the central and ongoing benefactor of what became known as the Jazz Loft Project at the Center for Documentary Studies (CDS) at Duke University. I'll never forget them—Reva, David, Dan, Jonathan, Richard, and the whole family. Special thanks also to the foundation's key board member, Ben Rothblatt, and staff members Cecelia Simmons and Tiffany Prowell.

CDS director Tom Rankin and associate directors Greg Britz and Lynn McKnight encouraged and supported this project on levels that befit the extraordinary organization they run. In 2003 CDS research associate Dan Partridge joined the project full-time and became one of the most specialized employees at Duke University, being the first to hear the set of 5,089 compact discs that Smith's 1,740 reels of tape yielded in the preservation process and assisting with oral history interviews. The influence of his mild-mannered dedication and thoroughness has been immeasurable. Jazz Loft Project coordinator Lauren Hart came on board in August 2008, during a period of increasing chaos; she has made an insightful, unflappable, and much appreciated impact. Other integral CDS teammates have been John Biewen, Bonnie Campbell, Harlan Campbell, Alexa Dilworth, Melynn Glussman, Gary Hawkins, Iris Tillman Hill, Frank Hunter, Katie Hyde, Ava Johnson, Liz Lindsey, John Moses, Sarah Moye, Liisa Ogburn, Courtney Reid-Eaton, Margaret Sartor, Chris Sims, Charlie Thompson, Tim Tyson, and April Walton. The staff of the Nasher Museum of Art at Duke University is much appreciated for their participation, particularly that of director Kim Rorschach, who provided support and encouragement at several key times.

Special mention is due the Jazz Loft Project interns and freelancers: Mohamed Bashir, Lauren Brenner, Natalie Bullock Brown, Sarah Bryan, Sam Cieply, Sally Council, Jon Dillingham, Mike Fitzgerald, Danielle Goldstein, Margaret Hennessey, Sritha Reddy, Hank Stephenson, Beth Turner, and Han

Zhang; and in New York, Eevin Hartsough, Scott Landis, and Victoria Miguel.

This project could never have happened without the partnership of the Center for Creative Photography at the University of Arizona (CCP), where the W. Eugene Smith Archive is located. The project was convoluted from the start—archival materials in Arizona, project based in North Carolina, story about New York—but CCP generously allowed us to work through it. It has become a second home for me after two dozen trips there over thirteen years. Britt Salvesen, Leslie Calmes, Amy Rule, Denise Gose, Dianne Nilsen, and the entire staff of this important organization have helped make this project possible.

Sara Fishko, producer of the Jazz Loft Project radio series at WNYC: New York Public Radio, and her husband, Bob Gill, have become dear friends and trusted colleagues over the years. I am deeply grateful to WNYC's Dean Cappello for his engagement and leadership from an early stage, as well as to Limor Tomer, Laura Walker, Terrance McKnight, Eileen Delahunty, Noel Black, Nina Goodby, and the rest of the staff. WNYC's energy and enthusiasm for the project was palpable and invigorating each time I visited the station.

Many thanks to David Ferriero at the New York Public Library for his interest and support over the years, and to Jacqueline Davis and her staff at NYPL's Library for the Performing Arts, particularly Barbara Cohen-Stratyner and Sara Velez, and to Sara's predecessor, Don McCormick. To be aligned with the most prestigious audio archive in the world, and to be able to open our traveling exhibition in their space in February 2010, has been a source of pride for us. Many thanks to NYPL's Paul Holdengraber and David Smith for their interest and support in various ways, too.

The early grant proposals for this project were supported by a stellar team of advisers who stuck with us. I thank them immensely: Larry Appelbaum at the Library of Congress; Dan Morgenstern and Ed Berger at the Institute of Jazz Studies; Tom Carter of the Thelonious Monk Institute of Jazz, and Don and Maureen Sickler; Bruce Raeburn of the Hogan Jazz Archive at Tulane; Steve Weiss of the Southern Folklife Collection at UNC–Chapel Hill; and the inspiring writer and Monk scholar Robin D. G. Kelley. We were awarded a few critical grants from the National Endowment for the Humanities, the National Historical Publication and Records Commission, the Grammy Foundation, the Gladys Kriebel Delmas Foundation, and Amelia and Ken Jacob. In-kind support has been provided by the Bose Corporation (many thanks to Buz Laughlin) and Kimpton Hotels and Restaurants (many thanks to Steve Pinetti).

One of the fulfilling collaborations of this project took place in the fall of 2007 at Duke University with Jason Moran's seminal multimedia performance *In My Mind*, commissioned by Duke Performances director Aaron Greenwald as part of *Following Monk*, a sixteen-concert celebration of what would have been Thelonious Monk's ninetieth birthday. It led to another collaboration in February 2009: the New York premiere of *In My Mind* and a performance by Charles Tolliver's tentet at Town Hall, together in celebration of the fiftieth anniversary of Monk's original Town Hall concert, which was rehearsed at 821 Sixth Avenue.

254 |

Heartfelt thanks and gratitude go to Aaron for his dedication and friendship over the years, and to Jason and Charles, and to Jason's manager, Louise Holland. Tremendous thanks go to WNYC for broadcasting Tolliver's show and helping spring it all forward.

Our leaders at Duke—Richard Brodhead, Peter Lange, Richard Riddell, and Scott Lindroth—deserve praise and gratitude for helping to open the door to these ambitious events, plus the new jazz archive at Duke. Special thanks to Lois Deloatch for her unrelenting encouragement on these projects and to Paul Jeffrey for his sage guidance on all things related to Thelonious Monk and beyond. Warm thanks also are due many other Duke colleagues including John Brown, Bob Byrd, Karen Glynn, Chandra Guinn, Deborah Jakubs, Jim Roberts, and Jeremy Smith.

Much appreciation for the work and friendship of Steve Balcom and Lane Wurster of the Splinter Group, creators of the Jazz Loft Project Web site.

As I've traversed far-flung and crooked paths working on this project over thirteen years, many friendships have taken root. Most of these friends, participants in the original loft scene, have already been mentioned in this book; meeting them has provided the ultimate meaning of this project. I want to make special mention of a few: Ron Free; David Rothman; Nancy Overton, Harvey Overton, Dick Overton, and the rest of the Overton family; Lucy Guerlac Battersby; the family of David X. Young, particularly Eliza Young; Harold Feinstein; Dorrie Glenn Woodson; Jim Karales; John G. Morris; James Stevenson; Sandy Krell; Roy Haynes, Ted Wald, and Virginia Arnott Wald; and the family of Sonny Clark, particularly Gladys Clark Harris and Grace Clark Johnson. I also want to thank T. S. Monk, Gale Monk, and the Monk family, in particular Pam Monk Kelley, Edith Monk Pue, Erich Jarvis, Reggie Revis, and Gaston Monk and his family.

In addition, I thank Amelia and Ken Jacob, and John Evans; Jim Maher, Jean Bach, and Whitney and Nancy Balliett; Paul Weinstein and Ada Ciniglio; Don and Betty Adcock; Branford and Nicole Marsalis; Joe Henry and Melanie Ciccone; Lourdes Delgado and Jeff Ballard; Richard Rothman and Mary Hawthorne; Ben Ratliff and Kate Reynolds; Michael Cieply and Judi Bloom; H. Bryant; Kevin O'Neill, Chris Lacinak, and Matt Thompson; Brigid Hughes, Lucy Raven, and *A Public Space* magazine; Ron Keenan and the old Village House; and Allan Gurganus, who read early pieces of this manuscript and provided sage advice.

Many thanks are due my wife's treasured old friends in Tucson, Arizona—Carol Buuck and Linda, Dane, and James Armijo—who provided complimentary lodging on all my visits. Their contributions made the project possible in the early days. Key early lodging in New York, Los Angeles, and San Francisco was provided by close friends: Ward, Clara, and Maggie Hendon; Michael Goldman, Pamela Jouan, and Gabriel Goldman; Jim Gilliland; James Davidson; James and Shannon Hamrick; and Ian Williams, Tessa Blake, and Lucy Blake-Williams. In Pittsburgh my brother-in-law Troy Cochenour manned a video camera, and Jay Alley assisted me on the ground in New York. Ward Hendon walked into the emergency room at St. Vincent's wearing a cowboy hat, while my foot was

dangling from my leg, and made sure I had careful attention.

The Heirs of W. Eugene Smith—particularly Kevin Smith and Maggie Smith, Pat and Phyllis Smith, and Shana Smith Rasmus—have made this all possible and worthwhile. I can't thank them enough for their patience, indulgence, and confidence.

Sarah Chalfant came across a little-known writer and believed the work had merit, and her colleagues Andrew Wylie and Edward Orloff followed suit. I am so grateful to them.

My editor at Knopf, Vicky Wilson, has provided shrewd guidance and wisdom from the first day, and she has been a pleasure to work with, as have Carmen Johnson and Kathy Zuckerman.

Finally, over these many years—with all the disparate, topsy-turvy threads and dead ends—the unflinching love and faith in the project I felt at home from my wife, Laurie Cochenour, was the foundation. It doesn't hurt to have twelve Stephensons in eastern North Carolina and umpteen Cochenours in western Pennsylvania, either. Everyone should be so fortunate.

Archival Information and Illustration Credits

This book is an outcome of The Jazz Loft Project at the Center for Documentary Studies at Duke University. The project has been a decade-long collaboration with the W. Eugene Smith Archive at the Center for Creative Photography (CCP) at the University of Arizona, as well as with the Heirs of W. Eugene Smith. Smith's photographs and tapes from the loft building at 821 Sixth Avenue, New York City, 1957–1965, represented in this book, were generously made available by the CCP and the Smith Estate.

The CCP collects, preserves, interprets, and makes available materials that are essential to understanding photography and its history. Through its archives, collections, education programs, exhibitions, and publications, the CCP promotes research into and appreciation of the photographic medium. The archives of significant American photographers—including Ansel Adams, Harry Callahan, W. Eugene Smith, Edward Weston, Garry Winogrand, and Louise Dahl-Wolfe—form the core of the collection. The CCP has an integrated program of preservation, access, and education that celebrates the history of photography and its contemporary practice. The CCP was established in 1975 by photographer Ansel Adams and University of Arizona president John P. Schaefer. It is a special collection within the University of Arizona Libraries.

Below is a list of W. Eugene Smith's Jazz Loft prints held in the archive and master print collection at CCP, with archival accession numbers corresponding to page numbers in this book. Master prints are marked MP and archival work prints are marked WP.

Page 152: WP [ag33_WP_ e83c4_10]

Page 153: WP [ag33_WP_ e83c3_23]

Page 154: WP [ag33_WP_ e56r154_28]

Page 155: MP [82:128:016]

Page 156: MP [82:128:026]

Page 158: (*top*) WP [ag33_WP_ e81r31_16]; (*bottom*) WP [ag33_WP_ e83r106_74]

Page 159: WP [ag33_WP_ e56r614_51]

Page 160: WP [ag33_WP_ e83r108_33]

Page 161: WP [ag33_WP_ e94r28_5]

Page 162: (*top*) Audiotape box [ag33_tape594]; (*bottom*) Audiotape box [ag33_tape678]

Page 165: WP [ag33_WP_ e56r51_12]

Page 166: WP [ag33_WP_ e56r352_16]

Page 176: WP [ag33_WP_ e56r24_16]

Page 177: WP [ag33_WP_ e56r20_27]

Page 178: WP [ag33_WP_ e56r31_12]

Page 179: WP [ag33_WP_ e56r31_10]

Page 180: WP [ag33_WP_ e56r33_11]

Page 182: WP [ag33_WP_ e83c10_33]

Page 184: Audiotape box [ag33_tape119]

Page 187: MP [82:131:030]

Page 188: (*left*) WP [ag33_WP_ e56r488_16]; (*right*) MP [82:131:008]

Page 191: WP [ag33_WP_ e56r16_21]

Page 192: WP [ag33_WP_ e56r21_28]

Page 193: WP [ag33_WP_ e56r3_19]

Page 194: WP [ag33_WP_ e56r19_30]

Page 195: WP [ag33_WP_ e56r259_6]

Page 198: WP [ag33_WP_ e56r39_27]

Page 199: WP [ag33_WP_ e56r35_23]

Page 200: WP [ag33_WP_ e56r37_20]

Page 201: WP [ag33_WP_ e56r50_8]

Page 202: (*top*) Pawn-ticket envelope and list [ag33_53_3]; (*bottom left*) List of pawned equipment [ag33_53_7]

Page 203: Pawn ticket [ag33_53_8]

Page 204: WP [ag33_WP_ e56r258_9]

Page 205: WP [ag33_WP_ e56r258_5]

Page 206: Audiotape box [ag33_tape80]

Page 207. Notecard from audiotape box [ag33_tape189]

Page 209: WP [ag33_WP_ e56r489_25]

Page 210: MP [82:129:006]

Page 211: MP [82:129:004]

Page 212: WP [ag33_WP_ e83r110_34]

Page 213: WP [ag33_WP_ e56r387_34]

Page 214: WP [ag33_WP_ e56r40_8]

Page 216: (*left*) WP [ag33_WP_ e56r35_12]; (*right*) WP [ag33_WP_ e56r35_10]

Page 218: WP [ag33_WP_ e56r43_17]

Page 219: WP [ag33_WP_ e56r45_35]

Page 220: (*top*) Audiotape box [ag33_tape834]; (*bottom*) Audiotape box [ag33_tape843]

Page 221: (*top*) Audiotape box [ag33_tape109]; (*bottom*) Audiotape box [ag33_tape113]

Page 225: WP [ag33_WP_ e56r92_23]

Page 226: WP [ag33_WP_ e56r24_30]

Page 229: WP [ag33_WP_ e56r23_15]

Page 230: WP [ag33_WP_ e56r18_14]

Page 234: WP [ag33_WP_ e56r80_25]

Page 235: MP [82:128:004]

Page 236: WP [ag33_WP_ e56r76_24]

Page 237: WP [ag33_WP_ e56r78_27]

Page 238: MP [82:128:005]

Page 239: WP [ag33 WP_ e56r75_27]

Page 241: MP [82:128:028]

Page 242: MP [82:129:001]

Page 244: MP [82:129:010]

Page 246: MP [82:131:001]

Page 251: WP [ag33_WP_ e56r122_23]

Additional Credits

Page 2: 1955 Sanborn Map (Plate #55), 821 Sixth Avenue, New York, New York. The Lionel Pincus and Princess Firyal Map Division, the New York Public Library, Astor, Lenox, and Tilden Foundations. Reprinted with permission from the Sanborn Library, LLC.

Page 78: Image supplied by posteritati.com.

Index

Page numbers in *italics* refer to captions and illustrations.